Sisley

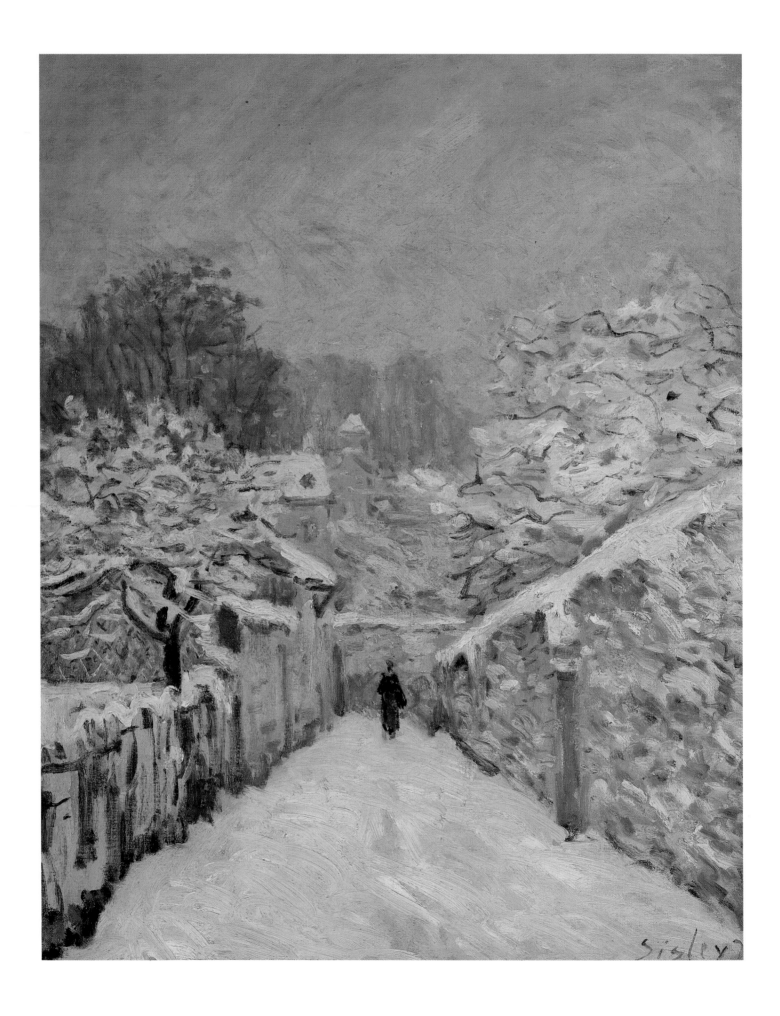

Sisley Richard Shone

BCA

LONDON · NEW YORK · SYDNEY · TORONTO

Author's note

Reference numbers in the text with
a prefix 'D' refer to the painting's entry
in the *catalogue raisonné*: F. Daulte
Alfred Sisley, Lausanne 1959.

All works illustrated are oil on canvas,
unless otherwise stated.

This edition published 1992
by BCA by arrangement with
Phaidon Press Limited

© 1992 Phaidon Press Limited

CN 5529

A CIP catalogue record of this book
is available from the British Library

Printed in Singapore

page 2 ***Snow at Louveciennes. 1878.***
61 x 50.5 cm. Musée d'Orsay, Paris.

Contents

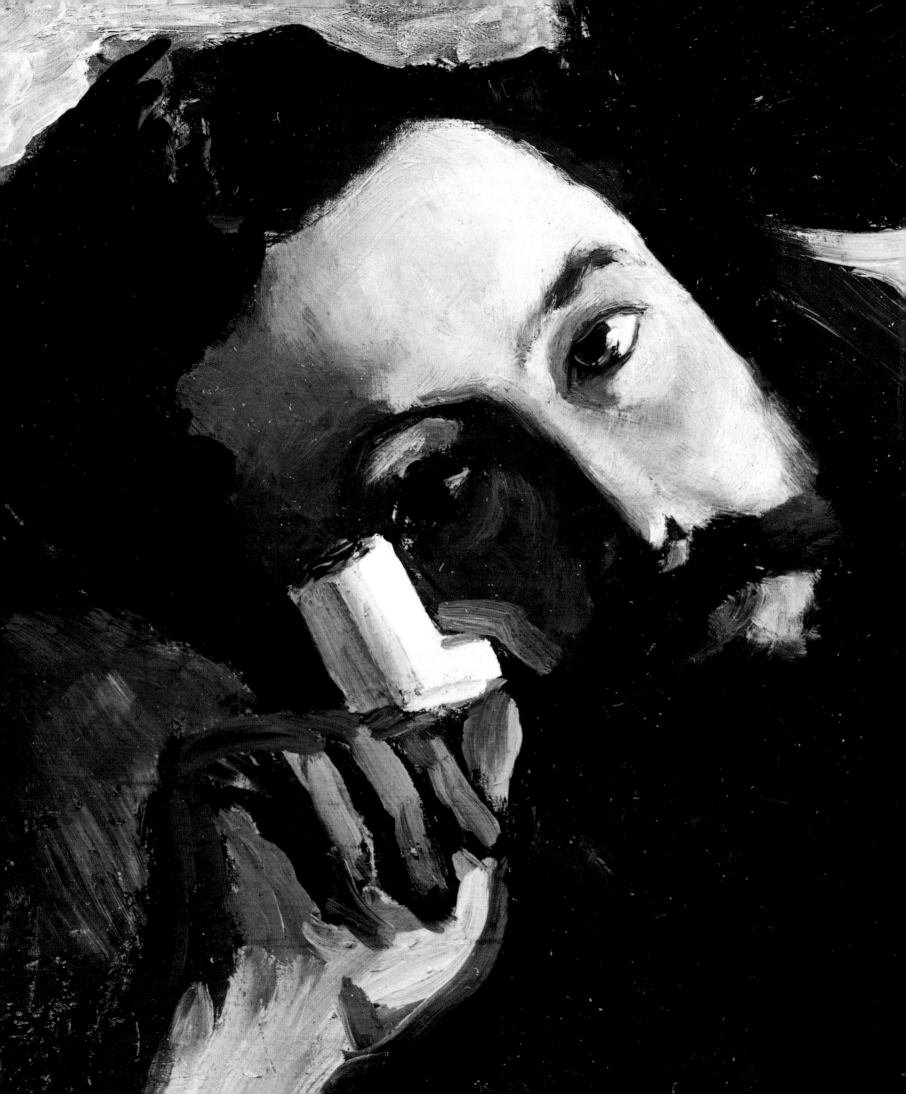

Introduction

The landscape paintings of Alfred Sisley (1839–99) occupy an inviolable position in the history of early Impressionism. His depictions of the Thames at Hampton Court, the Seine in flood, the snow-bound suburbs of Paris are indispensable to an account of Impressionist landscape painting in the 1870s. Indeed, they are so fundamentally representative of our notion of what constitutes 'pure' Impressionism, that the re-evaluation of the movement in recent years has often left Sisley stranded outside it. This has greatly added to the comparative neglect of his work. He is famous but not known, admired but little studied. Many accounts of Impressionism treat him perfunctorily; assessments run on the comfortable premise that he was a marvellous painter for two or three years but became a victim of his style and collapsed into an irreversible decline. One of the purposes of this book is to present a more balanced portrait of his achievements. While there can be little doubt that the best paintings were made in the 1870s, there are vigorous and beautiful works from the years that followed.

Other reasons exist for Sisley's shadowy reputation. Most obviously, his output appears less substantial and less clearly directed than that of his associates – Monet, Renoir and Pissarro. Their later evolutions, especially those of Monet and Renoir, drew Impressionism into the early twentieth century. Sisley's death at the very end of the nineteenth assumes a symbolic resonance. It signals the dissolution of the kind of Impressionism to which he had devoted his working life. His relatively early death put an end to the unmistakable signs of renewal in his painting of the 1890s: a late flowering, withered almost before it had begun.

Compared with that of his colleagues, Sisley's development was neither complex nor dramatic. The personality his work exudes is reticent and sober, marked, as the American painter Marsden Hartley wrote, by a 'solemn severity'. The influences digested in his early years, both English and French, served their purpose throughout his life. There are, of course, recognizable phases within his work, for Sisley was a highly conscious artist. Yet once the excitement of the Impressionist moment was over, his pace was leisurely and his evolution unforced. It is tempting to attribute this quiet self-effacement to his English origins, through which an innate insularity was transferred to the Ile-de-France. Several of his forebears, for example, were conspicuous for a plucky adventurousness followed by bourgeois consolidation. The pattern of Sisley's evolution is much the same.

Recent Impressionist studies have been devoted, for the most part, to an investigation of subject-matter and iconography. Sisley's work does not readily submit itself to such analysis. There is almost no overt social or political content in his painting, no informative celebration of contemporary people, no agrarian comment or escapist Mediterranean allure. It is true that he was not attracted to

8

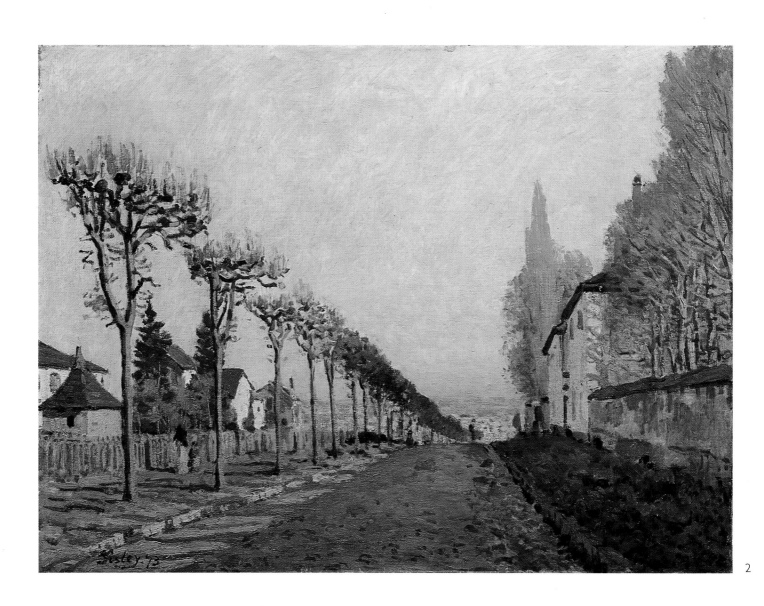

2

1 **Previous page**
Detail
Frédéric Bazille. *Portrait of Alfred Sisley.* c.1867.
(Plate 11)
2 *Chemin de la Machine, Louveciennes.* 1873.
54.5 x 75 cm. Musée d'Orsay, Paris.

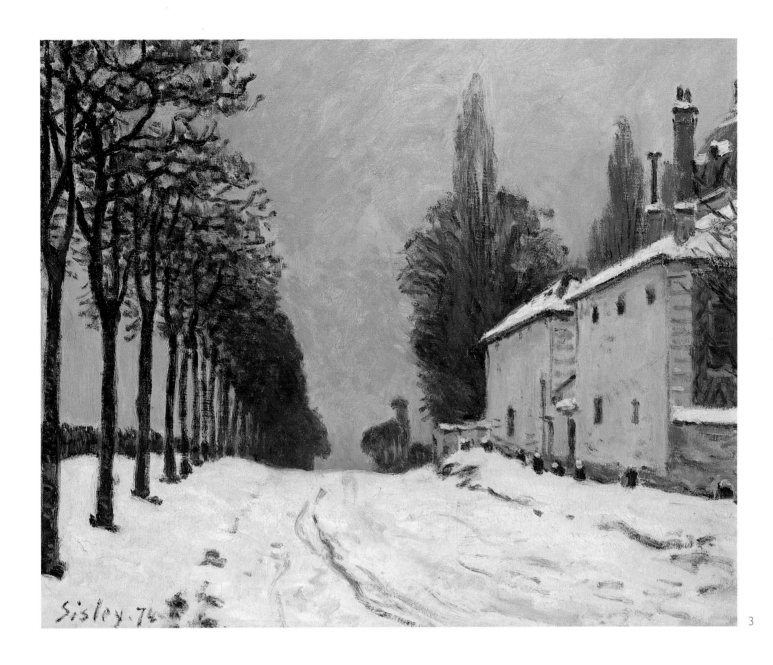

3

3 *Snow on the Road, Louveciennes
(Chemin de la Machine).* **1874.
38 x 56 cm. Private Collection.**

aspects of urban life, as found in Renoir, nor to the ideological impulses that inform, for example, much of Pissarro's work. For most of his life Sisley was content to depict the traditional activities of countryside and rural waterways as they impinged on the landscape. In the 1870s, working in all the places whose names recur in the early history of Impressionism – Bougival, Argenteuil, Marly, Louveciennes – Sisley resolutely turned his back on their social life. He concentrated instead on undisturbed or only distantly animated aspects of his surroundings. This has led to an underestimation of those elements of the everyday scene which do, in fact, appear intermittently throughout his painting. There are many moments of private leisure; there are trains, factory chimneys, pleasure-boats and barges, a forge, a flood rescue, quayside activities; there are the flags and crowds of regattas on the Thames and of Paris *en fête* at the Point-du-Jour. None of these should be omitted from an account of Sisley's role within Impressionism viewed in its social context.

No substantial biography of Sisley has yet been written. His life is not well documented and this has furthered his neglect. Although he wrote many letters, few are personally revealing or of exceptional interest. There are no journals or autobiographical writings and he died before celebrity might have sent interviewers and photographers to his door. At the same time, the change in his character from high spirits and sociability to a seemingly misanthropic and suspicious de- meanour accounts for the virtual disappearance of his name from the memoirs and letters of several of his early friends.

As a result of this *profil perdu*, the few facts about Sisley's life that have long been taken for granted have not been thoroughly examined. Since the publication in 1959 of François Daulte's *catalogue raisonné*, almost no research has investigated Sisley's life; misstatements and misconceptions abound. Several of these have been corrected in this book, and use has been made of unpublished letters and archival documents. These modify or illuminate at many points the biographical outline of Sisley and set his work in a more palpable context. New material has shaped the narrative and deepened that sense of Sisley as resourceful, proud and solitary.

In a passage on the landscapes of Ruisdael, written in 1875, Eugène Fromentin wrote of the Dutch painter as

a dreamer, one of those men of whom many exist in our own day but who were rare in Ruisdael's time – one of those lonely wanderers who flee from the town, frequent the outskirts, who love the country without exaggeration and describe it without phrases, who are made uneasy by

distant horizons but are charmed by open country,
moved by a shadow and enchanted by a shaft of sunlight.

He goes on to suggest the sombre reasonableness of
Ruisdael's melancholy, the product neither of self-indulgent
immaturity nor of the fretful self-pity of old age. No one
familiar with Sisley's painting or his character can fail to be
reminded of them by Fromentin's words.

They were written in the year when Sisley produced
some of his finest paintings, and at the start of one of the
most discouraging periods of his life. He was at the height
of his powers, superbly endowed with gifts that place his
achievements on a level with those of Renoir, Monet and
Pissarro. In particular, he faultlessly conveys those startling
moments of perception in which a scene is removed from
its surroundings, however commonplace, and steeped in an
undefinable emotion – the Marly aqueduct, the flooded inn
by the Seine, a passer-by in the snow, a girl swinging in an
orchard, a wave breaking over a rock on the shore. He has
the power of transcribing such scenes as though he had
been searching for them all along, and yet he reveals them
with an air of diffidence that disarms while it captivates.
It is at such moments that Sisley enlarges our perception
of Impressionist painting and joins the ranks of the great
European landscapists.

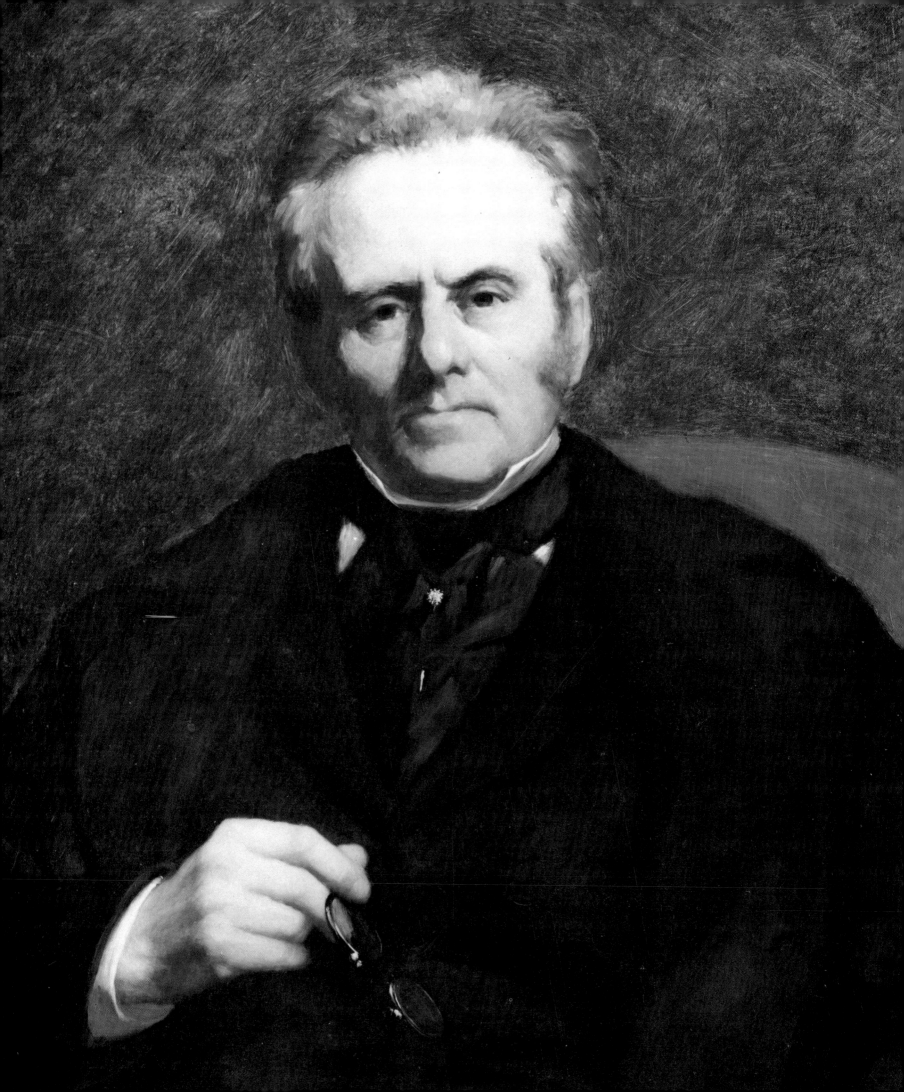

1 Between England and France

The name itself – Alfred Sisley – lacks an immediate focus; it seems not quite English, yet certainly does not sound French. So intimately associated is Sisley, however, with the Impressionist movement in France, that people are invariably surprised to hear that he was born an Englishman and retained British nationality throughout his life. His Christian name (his only one), solid and straightforward enough, appears nowhere among the names of his forebears or contemporary relations. The surname Sisley is still found in both England and France. In the rue St-Dominique in Paris, for example, a chic *parfumerie* sells expensive Sisley soap, scent and eau de toilette; the name belongs to a business begun in earlier decades by one of the painter's relatives. In England the name occurs in the telephone directories of London and the South East, and belongs to descendants of the Sisleys who were abundant in Kent from the eighteenth century onwards. Most lived in or near Lydd in that strange, flat, watery landscape known as Romney Marsh. Several were smugglers, others in local trades. When Alfred's parents, William Sisley and his cousin, Felicia Sell, were married in Dover in 1827, French and English antecedents were united, for William's mother was French. Alfred himself was born in Paris and, as far as is known, did not visit his native country until he was eighteen years old.

Because of the extreme scarcity of documentation concerning Sisley's early life some writers, to make an opening chapter of interest, approach it with fictional freedom, weaving a certain amount of well-tempered 'biography' from a few strands of verifiable fact. The French writer Raymond Cogniat, for example, expounds a quite plausible account of a childhood of material comfort, refined living and aesthetic possibilities, while managing, at the same time, to contradict even the one or two facts that are certain. Even the doyen of Sisley studies, François Daulte, describes the painter's father as from Manchester.[1]

Virtually the only source for the painter's family background is an article published in 1949 by Claude Sisley, grandson of a half-brother of William Sisley.[2] It was methodically researched and is an accurate and unspeculative summary of adventurous lives, both English and French. The account is complicated by the Sisleys' tenacious habit of marrying their cousins (as with Alfred's parents), and by the fact that William's father, Thomas Sisley (1772–1819), had three French wives, two of whom were sisters. Claude Sisley appears to have had almost no direct knowledge of Alfred himself; there was scant contact between the 'French' Sisleys and their English relations. 'Little was known of Alfred on my side of the family,' Claude Sisley wrote. 'My father was brought up in England, and he met Alfred when he visited this country. Apparently they had little in common, and all that my father ever said about his cousin was that he was difficult to get on with.' Possible reasons for Sisley's lack of

4 **Previous page**
Auguste Renoir. *Portrait of William Sisley* **(detail). 1864.**
81 x 65 cm. Musée d'Orsay, Paris.

contact with his English relatives as well as with his French Sisley relations will be suggested later.

William (sometimes called Guillaume) Sisley, known from a perspicacious early portrait of him by Renoir (Plate 4) and from a photograph (see page 15), was born in Flessingue, near Dunkerque, on 6 December 1799, the son of Thomas Sisley and the third of his French wives, Charlotte (née Dagneau). Thomas may have started life as a successful smuggler, like his father Francis (a mythical and daring figure in the annals of smuggling), between Kent and the Continent. He soon established himself, however, as a legitimate merchant in Dunkerque dealing in 'fancy goods' such as foreign silks, shawls and merinos. His sons set up similar businesses in London. The legitimization of the Sisley family's livelihood is reflected in the London commercial directories for the 1830s onwards (a Thomas Avery Sisley, for example, was a successful baker and pastrycook in Hackney, Islington and, later, Dean Street, Soho). The grandest business was Sisley & Co., Merchants, of Cheapside in the City of London. In the late 1830s the firm became 'Thomas Sisley Importer of French goods', with premises at 79½ Watling Street, behind St Paul's Cathedral, and was directed by Thomas, William's older bachelor brother. Expansion of the family business took William, who had worked in Watling Street, to the Sisley warehouse in Paris, where he successfully dealt in imported gloves and other luxury articles.[3] He probably moved to Paris

between *c*.1836 and 1839, the year in which his son Alfred was born on 30 October at 19 rue des Trois Bornes in the 11th *arrondissement*.

William Sisley's wife, Felicia Sell, was nineteen years old at the time of their marriage in 1827. Almost nothing is known of her. She is described as 'a fine tall woman', became 'quite a Frenchwoman', was known as Félicité, and is supposed to have had musical and literary tastes. Her father, from Lydd, was a saddler by trade and a smuggler by family inclination. He was caught, 'arrested, tried and imprisoned in Dover Castle. On his release, he must have obtained employment of some kind in the prison and finally held the position of Bodar of Dover Castle. This sounds very important, but actually the Bodar was the keeper of the Debtors' Prison.'[4] Whatever Felicia may have become, she was certainly not from 'an ancient, highly cultivated London family', as François Daulte asserts. She died at Neuilly on 17 August 1866 and was buried in the cemetery of Montmartre, the first occupant of the Sisley family tomb.[5]

There were four children, Elizabeth-Emily, Henry, Aline-Frances and Alfred. Alfred was the youngest and the only one to be born in Paris. The oldest was Elizabeth-Emily, born probably while her parents were living in Dover; she was twice married and twice widowed, her second husband being the painter and lithographer Antoine Rivoulin (1810–64). The Sisleys' second child was Henry, born in Dover in 1832.

The Sisley Family

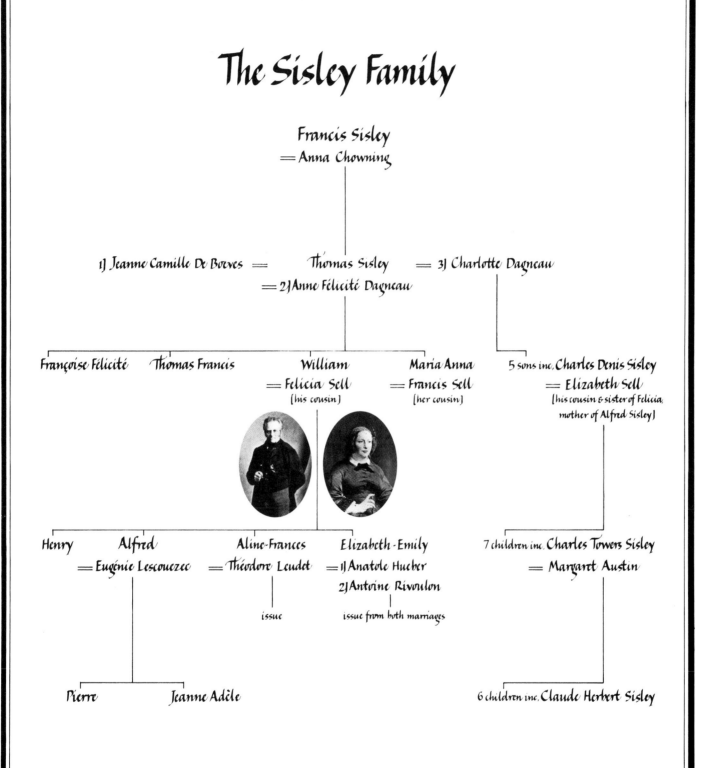

Francis Sisley
= Anna Chowning

1] Jeanne Camille De Boeves = Thomas Sisley = 3] Charlotte Dagneau
= 2] Anne Félicité Dagneau

Françoise Félicité Thomas Francis William Maria Anna 5 sons inc. Charles Denis Sisley
= Felicia Sell = Francis Sell = Elizabeth Sell
[his cousin] [her cousin] [his cousin & sister of Felicia, mother of Alfred Sisley]

Henry Alfred Aline-Frances Elizabeth-Emily 7 children inc. Charles Towers Sisley
= Eugénie Lescouezec = Théodore Leudet 1] Anatole Hueber = Margaret Austin
 2] Antoine Rivoulon

issue issue from both marriages

Pierre Jeanne Adèle 6 children inc. Claude Herbert Sisley

15

16

5

5 *Among the Vines, Louveciennes.* 1874.
 47 x 56.2 cm. From the Collection of
 Mr and Mrs O. Roy Chalk, New York.

Detail
Among the Vines, Louveciennes. 1874.

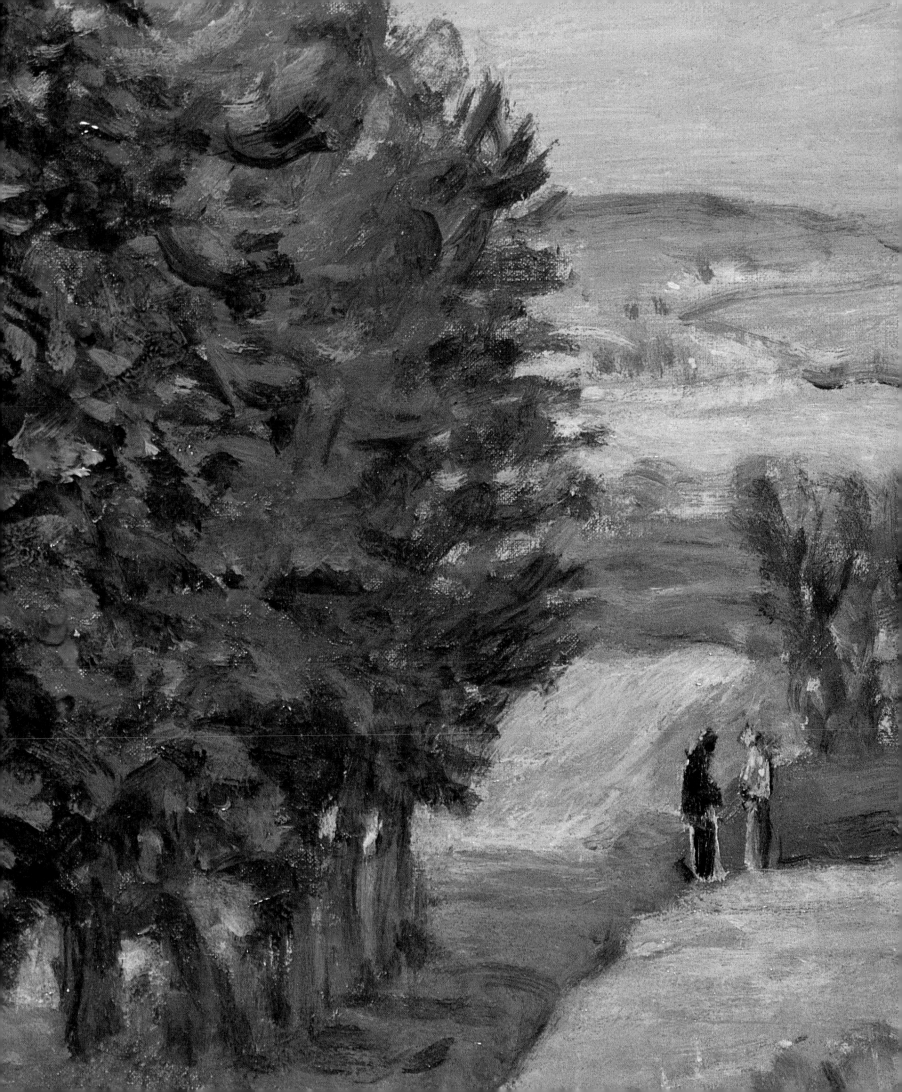

He entered the family business and lived in the rue Hauteville, the street next to his father's headquarters at 1 passage Violet. He is glimpsed in a letter of Renoir's of 1865, in which the painter outlines a journey by river, accompanied by 'Henri' Sisley, to see the regattas at Le Havre; after 1869 he entirely disappears from any official records and probably died young, as his relation Claude Sisley suggested. The third child, four years older than Alfred, was Aline-Frances, born in London in 1834; she married a well-to-do doctor, Théodore Leudet, and had four children. Her husband, awarded the Légion d'honneur, is mentioned as having attended Sarah Bernhardt in 1870 at Eaux-Bonnes, the spa town in the Pyrenees. Aline-Frances appears to have maintained some contact with her family – the Leudets, for example, were among the chief mourners in 1880 at the funeral of her uncle, Charles Denis Sisley. When she died in 1904 she was buried with her parents in the family grave, which was thereafter known as the Leudet grave (rather than Sisley). She owned Renoir's portrait of William Sisley, which her son Maurice sold in 1910.

Although many of these facts are new and confirm the Sisleys' entry into French bourgeois life, they throw little light on Alfred himself, save that he did not join his family in their social integration. His personal estrangement from them, however, is partly explained by events at a later stage in his life.

Alfred's 'Englishness' is little documented. He certainly spoke the language – fluently, according to his friend Théodore Duret – and he came to paint in England (and Wales) on three occasions in later life. This fluency probably explains the number of English-speaking art students (particularly Americans) who became his friends in Paris in the early 1860s. On the other hand, he wrote perfect French and was entirely French 'in his habits, attitudes and tastes'.[6] In 1897, two years before he died, he attempted to become a French citizen, but missing documents prevented the completion of a step he had first contemplated in 1888.[7]

Several first-hand accounts mention his English origins. In an article in the *Gazette des Beaux-Arts* published a month after Sisley's death, Julien Leclercq wrote:

His earliest education, which had of course been English, left only one characteristic: even in the worst afflictions, he maintained a certain correctness of appearance and impeccably white collars. It has to be said that his father, English as he was, was no different from most fathers, and – displeased with his son's preference for painting rather than serious business activities – had abandoned him to the vagaries of a Bohemian existence. When he was grown up, Sisley visited England. He felt as if he were in a foreign country rather than his own native land.

Another friend, Eugène Murer, singled out Sisley's habitual 'gentlemanly correctness'; and the painter Pierre Prins remembered how Sisley would tease him about being of English descent (though knowing that the Prins family in fact came from Bavaria, and that Prins found the English rowdy): 'Surely you and your family have had English blood at some stage; you look like an English gentleman, you have the same eyes, the same looks and behaviour, and the same sense of decency.'[8]

It seems likely that if Sisley's life had been less poverty-stricken, in later years his visits to England might have been more frequent, although Théodore Duret wrote that 'he felt very out of place in England'. On the first and the last of the three occasions on which he visited England in adulthood, his expenses were paid by benefactors, and the last visit, at the end of his life, was more than a simple painting trip, as will be shown. His second visit was to the Isle of Wight in 1881, but no work survives from what turned out to be an abortive journey (see Chapter 9). These were Sisley's only travels beyond the Ile-de-France and Normandy; there is no record of his ever having travelled on the Continent, and in his later years he was rarely induced to move from his home town of Moret-sur-Loing. His vision of landscape painting was entirely developed in, and conditioned by, his experience of the Forest of Fontainebleau, of the country along the Seine to the west of Paris, and by Moret and its surroundings south of the capital. Like Pissarro, he never saw Italy and, it seems, never went to Holland whose landscape painters, such as Hobbema and Ruisdael, exerted a quietly persistent influence throughout his work.

Almost nothing is known of Sisley's life until he became an art student in the Atelier Gleyre in Paris in the early 1860s. In 1857, at the age of eighteen, he was sent to London for four years to embark on a commercial career and perfect his English. At first, no doubt, he stayed with his relatives. His father's married half-brother, Numa Sisley, lived in London, and by 1864 had the comfortable address of 22 Thistle Grove, Fulham; there were several other Sisleys who may have housed their 'Frenchified' young kinsman as he went about learning the business of imports and exports. Later, Sisley's friends confirmed that it was in London that his interest in painting first developed. Gustave Geffroy, for example, mentions that his friend 'above all learnt much there about painting from Turner and Constable and about literature from seeing the plays of Shakespeare'.[9]

Certainly these years of apprenticeship extinguished any initial desire Sisley might have had for a career in commerce. He returned to his family in Paris and, according to a statement made years later in a letter to a friend, he became a student in 1860 in the atelier of Marc-Charles-Gabriel Gleyre.[10]

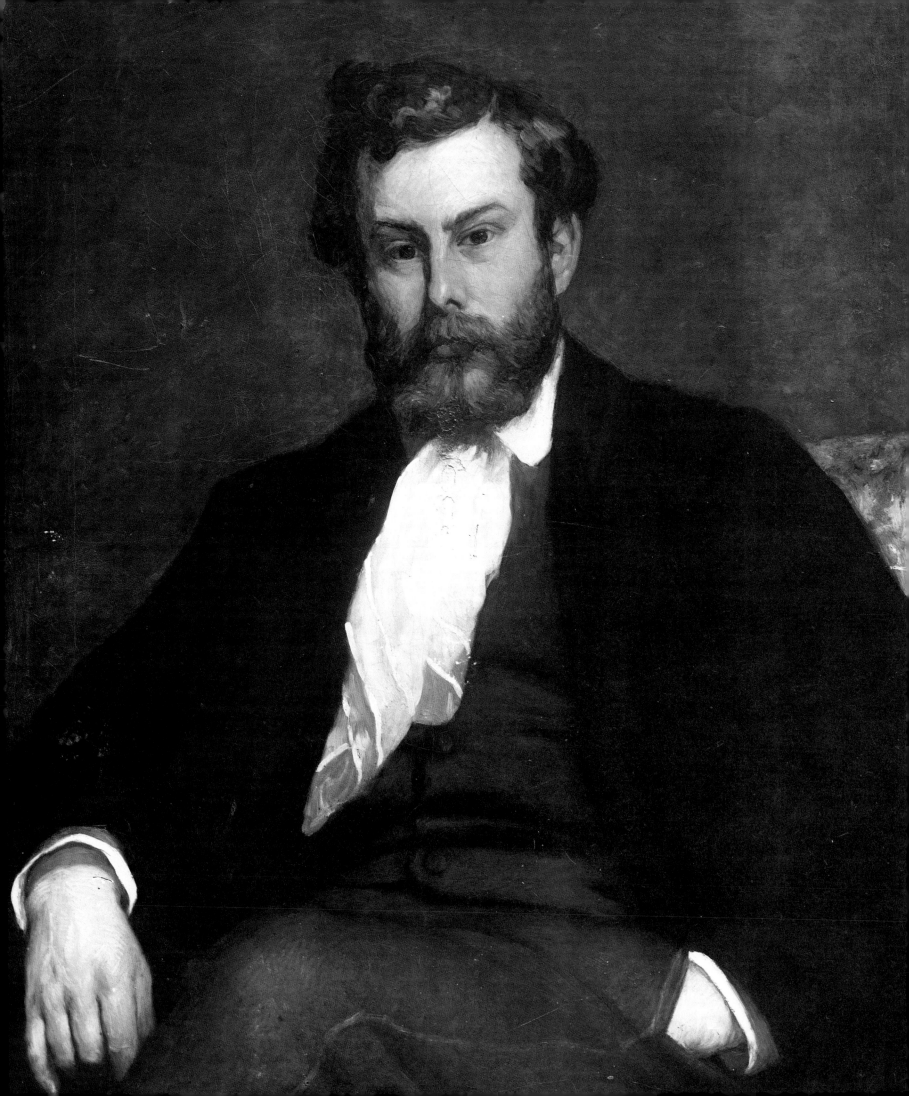

2 Elève de Gleyre

An entry in the register of the Auberge Ganne in Barbizon for 1861 reads: '*Sisley esq., vingt-deux ans*'.[1] Sisley was 22 at the end of October that year, and the Anglo-French style of the entry suggests the young man's sense of having two nationalities. The Auberge Ganne, described in the Goncourt brothers' novel *Manette Salomon* (1865), was one of several inns popular with painters in the Forest of Fontainebleau. It would have been a natural place of pilgrimage for a young art student, already interested in landscape and eager to explore the familiar stamping-ground of the artists of the Barbizon School.

No enrolment records survive of the Atelier Gleyre, but it can be assumed that Sisley was working there by 1861. By the time he left the studio, in 1863, he had become a close friend of three younger fellow students – Frédéric Bazille (1841–70), Claude Monet (1841–1926) and Auguste Renoir (1840–1919) who, with Sisley, were to change the direction of French painting. Bazille, originally intended for the medical profession, studied both art and medicine simultaneously; he started in Gleyre's atelier in November 1862, at the same time as Monet. Bazille's description in a letter to his parents in Montpellier of his arrival *chez* Gleyre is worth quoting, for it is likely to have been representative of Sisley's own first attendance:

I started at the atelier without too many problems; I had to sing; I was forced to stand on one leg etc. etc., all tedious incidents, but I am left in peace now; I have started in a drawing class, and I have observed with satisfaction that there are many pupils as good, or rather as bad, as I am.[2]

Renoir began to work under Gleyre in 1861 for examinations at the Ecole des Beaux-Arts. Serious students studied under a well-known artist affiliated to the Beaux-Arts before taking their *concours des places* in France's premier school of art. It is not known if Sisley originally had ambitions to attend the Beaux-Arts, but it appears to have been the forceful young Monet who set him on course. From that time onwards, Monet and Renoir remained Sisley's closest friends, embattled colleagues in the evolution of Impressionism.

The young painters' frustration with what they found at the Atelier Gleyre was memorably recalled by Monet in an interview he gave in 1921.

At the Atelier Gleyre I found Renoir, Sisley and Bazille . . . As we were working from a model, a superb one at that, Gleyre criticised my work: 'It's not bad, but the flesh is

6 **Previous page**
Auguste Renoir. *Portrait of Alfred Sisley* (detail). **1864.**
81 x 65 cm. Foundation E.G. Bührle Collection, Zurich.

7 **Frédéric Bazille.** *The Improvised Sick-room*
(The injured Claude Monet at the
Hôtel du Lion d'Or, Chailly). **1865.**
47 x 65 cm. Musée d'Orsay, Paris.

8 *Students of the Atelier Gleyre. c.*1862-3.
117 x 145 cm. Musée du Petit-Palais, Paris.

7

22

heavy, the shoulder too powerful, and the foot's too big.'
'I can only draw what I see,' I replied timidly. 'Praxiteles
borrowed the best elements from a hundred flawed
models to create a masterpiece,' Gleyre replied dryly.
'When you create something you need to keep the ancient
world in mind!' That same evening I took Sisley, Renoir
and Bazille aside: 'Let's get out of here fast,' I said to them.
'This place stinks: there's no sincerity here.'
We left after a fortnight of lessons of this kind . . . And it
was a good thing we did so, for I know of no one who
was good in the atelier who ever did anythig worthwhile.[3]

The timidity Monet here ascribes to his answer to Gleyre
was not characteristic. He was already single-minded, 'lordly',
a leader. Sisley followed. To do so at that time showed true
independence of judgement and an adventurous spirit. A year
younger than Sisley, Monet already had considerable
experience of art schools, had worked with Boudin and, just
before he entered Gleyre's, with Jongkind, two artists
intimately associated with the origins of Impressionsim. At
the Académie Suisse in 1859 he had made the acquaintance of
Camille Pissarro. Landscape painting had already become his
overriding interest, though not, unlike Sisley, to the exclusion
of portraits, figures and the urban scene. At the same time he
had already tasted the bitterness of family opposition to his
chosen career. All this, as well as his personal appeal,
captivated Sisley. From then onwards his friendship with
Monet remained for the rest of his life the most influential
and enduring relationship among his fellow painters.[4]

Sisley studied in Gleyre's studio for three years at the
most, and might be considered to have passed through the
school to no great acclaim. On the other hand, he appears in
a large 'group-portrait' canvas, added to over a period of
several years, of Gleyre's more prominent students (Plate 8).
Renoir is seen in right profile facing Laporte, each painted by
the other; Sisley is shown full-face, already bearded, above
Renoir. Significantly, Monet, Gleyre's most famously
uncooperative student, makes no appearance.[5]

Gleyre (1806–74) has recently received attention for
being a more sympathetic teacher than his reputation
suggested.[6] A plain, stocky Swiss, intelligent, moody, but
kind, Gleyre took over many of the pupils of Paul Delaroche
in 1843 and opened his own studio in the rue de l'Ouest,
Montparnasse. He lived and worked on the top floor of
94 rue du Bac, a meeting place of like-minded painters,
writers and highly favoured students. Gleyre had achieved
fame with his *Evening. Lost Illusions* of 1843, its 'immaculate
surface' and elegiac mood a perfect expression of his divided
sensibility. By the time Sisley entered his studio, Gleyre was
an increasingly outmoded figure, stranded between academic
classicism and romantic yearning. Neither was to prove of
interest to the independent young Englishman.

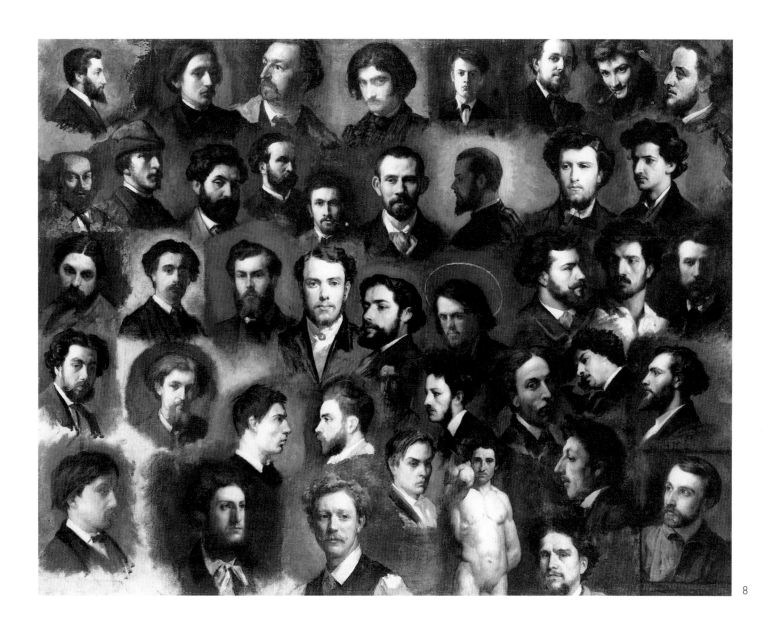

8

9 **Frédéric Bazille. *Self-Portrait. c.*1867-8.**
 54 x 46 cm. Minneapolis Institute of Arts.

24

Remembering his own early years of hardship in Paris, Gleyre waved aside teaching fees for his students and charged only a modest sum for studio rent and models; about thirty or forty assembled at the school, which Gleyre would visit twice a week to give personal criticism. There was rigorous instruction in drawing, but Gleyre showed a certain leniency to his students' individuality. Although Renoir, for example, called Gleyre 'a second-rate teacher but a good man', he was still styling himself '*élève de Gleyre*' in the 1890s, and spoke of him with respect. The study of the figure was paramount in his teaching, but he did not discourage working out of doors and painted landscape intermittently throughout his life; however, he believed nothing should interfere with or supplant the drawing of the human body. Gleyre's own characteristic subjects were drawn from mythology, history and literature for works such as *Hercules and Omphale*, 1863, and *Sappho Preparing for Bed*, 1867–8 – elaborate and polished resurrections of a once-vital tradition. Ironically, Gleyre's name is now most often mentioned in connection with those painters who revolutionized landscape painting. Perhaps his most loyal disciple was Edward Poynter, later President of the Royal Academy, whose experience under Gleyre informed his overhaul of art teaching in England and whose opposition to Impressionism was implacable.

Gleyre's atelier is amusingly evoked as the Atelier Carrel in George du Maurier's novel *Trilby* (1894). His cast of characters mirrors contemporary accounts of the wide range of students found there; they ran from rich young dilettantes, such as the son of Vicomte Lepic (later a painter and friend of Degas), to a freckled English girl who, according to Renoir, was all for free love, Courbet, and the removal of the male model's drawers. Renoir also remembered the usual appalling practical jokes of the school, typical of the period. In *Trilby* the character of Joe Sibley was based on that of the young American, J. A. M. Whistler, who worked under Gleyre in the late1850s (at Whistler's behest, Sibley became simply 'Antony, a Swiss' in later editions). Whistler acknowledged his debt to Gleyre's methods and several of his own teaching precepts reveal that influence, particularly on the preparation of the painter's palette. Gleyre recommended that all tones should be mixed and assembled before work began in order to facilitate the quick and spontaneous laying-in of the *ébauche*, the vital first stage towards the completion of a composition.

Of Sisley's student work nothing survives. There is, however, one painting, *Lane near a Small Town* (Plate 10), which may well date to *c.*1864 and count as Sisley's first extant work.[7] As such, it must bear that burden of scrutiny so often loaded upon an artist's earliest efforts. The crude statements of later themes, correspondences of handling, early influences ill- or well-digested, later to be developed or discarded, can rarely sustain such interrogation. But the

Lane, a modest view of a road, bordered by trees, passing through fields to the distant outskirts of a village, finds Sisley in characteristic voice. Nearly thirty years later, paintings of the tree-lined towing path of the river Loing are similar in composition and in the reticence of their mood. The *Lane* is sober, a little tentative, nods to Holland, hints at Constable, bows to Corot. It announces Sisley's taste for cultivated country rather than for the wilder or more remote aspects of landscape, and for the constantly recurring motif of open foreground receding, via road or path or river, to a low horizon. The people working in the fields are prototypes of hundreds of such figures in innumerable later paintings.

However, in comparison with the early works of his Gleyre contemporaries, Sisley's are decidedly quiet and unadventurous in key. Where Renoir, Monet and Bazille have superb paintings to their credit from the 1860s, Sisley's few pictures hardly presage the creative confidence and achievements of the early 1870s onwards. In some senses, Sisley was still a gentleman-amateur. Living on an allowance from his father, he could feel his way at a more leisurely pace than, for example, Monet who was poorer and thus more obsessively ambitious. But it is dangerous to draw any emphatic conclusions, when much of the evidence for Sisley's early period may have been destroyed.
It is not known either how well off Sisley was or how productive he might have been. But several hints as to the

10 *Lane near a Small Town. c.1864.*
 45 x 59.5 cm. Kunsthalle, Bremen.

26

kind of life he led in these early years are contained in a batch of unpublished letters lodged in the Archives of American Art in Washington.[8] The letters were written to Joseph R. Woodwell (1843–1911), a Pittsburg painter who studied in Paris and came to know Sisley. Among their circle was a group of American artists who included Daniel Ridgeway Knight (1839–1924) from Philadelphia, Joseph Foxcroft Cole (1837–92), Albion Harris Bicknell (1837– 1915) and the less-known figure, John Ware of Boston. Ware exhibited a Barbizon subject, *Courtyard at Marlotte*, at the 1868 Salon, as well as a *Beach at Villerville*, and continued to paint landscapes, last showing at the Salon in 1890. Bicknell, from New York, was also a landscape painter; Cole painted rural subjects and showed *Pasture in Normandie* (*Honfleur*) in the 1875 Salon. Knight, who lived near Poissy, became 'an extremely successful' genre painter in later life, regularly exhibiting at the Salon between 1873 and 1899. In the 1860s, however, he had been impelled to return to Philadelphia because of the Civil War, and it is in Knight's letters to Wood-well, who remained in Paris, that there appear a few valuable glimpses of Sisley (one of the letters, dated 17 January 1864 is, in fact, jointly addressed to Woodwell and Sisley).

The young American fondly remembers his life in Paris, contrasting evenings playing billiards in the Café Mazarin, for example, to his empty evenings in Philadelphia, once his day's painting was over. If the three young men were not in the Mazarin or the more modest Crêmerie Jacob, he recollects Sisley and Woodwell as being 'in the quiet of your several domestic circles with your 2 wives on your knees' (although neither artist was married at that time). It seems that Sisley lived at home but rented his own studio soon after leaving Gleyre's school. He invited his friends to meet his family, and Knight asks him

> not to forget to enclose the photograph of your mother, she promised me one. I should like to have pictures of the whole family. I can never forget the real English hospitality of your house and the kindness of your father to a stranger. God bless you all.

He mentions Sisley's regular pipe-smoking, his enjoyment of card-games and billiards (and being beaten at 'Seven-up' by another American painter, Frank Scott).

There exists also an early note from Sisley to Woodwell, written in slightly awkward English, asking him to bring some tubes of paint (three of ultramarine, one of 'vermillon *chine*') from his colour merchant Carpentier in the rue Halévy. Woodwell was obviously about to join Sisley outside Paris (probably in Fontainebleau) on one of the group's frequent painting excursions. The summit of happiness for the students in *Trilby* is a 'heavenly' week around Barbizon 'among the painters, Rousseau, Millet, Corot, Daubigny',

10

11 **Frédéric Bazille.** *Portrait of Alfred Sisley.* **c.1867.**
28 x 31 cm. (Painting destroyed in Second World War.)

12 *Still Life with Heron.* **1867.**
81 x 100 cm. Musée Fabre, Montpellier.

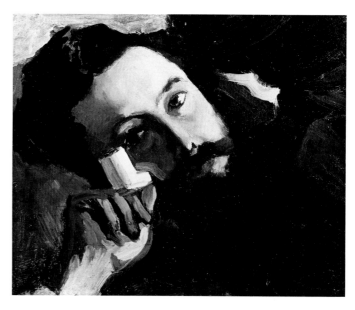

11

28

attempting to paint 'the forest as it is' and leading 'a healthy outdoor life of simple wants and lofty aspirations'.

The only connection between this group of American friends and Sisley's fellow French students at Gleyre's is found in a brief note from Renoir to '*Mon cher Woodwell*' excusing himself from a proposed meeting one evening. None of the Americans is mentioned elsewhere and certainly none appears in accounts of Sisley after c.1868. He seems, however, to have kept in touch with Mark Fisher (1841–1923), the Boston-born landscape painter who later made a considerable reputation as an English 'Impressionist'. Fisher was given a letter of introduction to Woodwell by Bicknell (21 December 1863) when he came to Paris and studied briefly in 1864 under Gleyre. Significantly, he later said that he did not remember Sisley at the school at all, although he owned Sisley's *The Farm at Trou d'Enfer*, an 1874 landscape apparently exchanged for a work by Fisher.[9] Years later Lucien Pissarro wrote to his father from London that Fisher was one of the only two painters worth looking at in the Royal Academy's 1883 exhibition (the other was Millais); Camille Pissarro told his son that Fisher, from having worked in France, was 'un de nos imitateurs'.[10]

In addition to these few tantalizing glimpses of Sisley there are Renoir's reminiscences related in his old age to his son Jean, and a few comments in contemporary letters, such as those written by Renoir's friends the Le Cœur family. '[Sisley]

was a delightful human being', Renoir recollected. 'He could never resist a petticoat. We would be walking along the street, talking about the weather or something equally trivial, and suddenly Sisley would disappear. Then I would discover him at his old game of flirting.' It is easy to imagine Sisley and a young woman as being the flirting couple underneath the wall in his own early painting *On the Edge of the Forest of Fontainebleau* (1868; D 11).

Renoir and Sisley saw each other constantly in Paris and, frequently joined by Bazille, painted together in the Forest of Fontainebleau, particularly at Chailly and Barbizon. In these impoverished years Renoir was greatly helped by his more affluent friends Bazille and Sisley. He shared the former's studio in Paris, sold pictures through Bazille's well-to-do connections and visited his family home in Montpellier. He came to know Sisley's family and in 1864 he painted Sisley *père*. The portrait, doubtless commissioned by the business man to help his son's friend, was shown as *Portrait of M.W.S.* in the 1865 Salon, and remained in the Sisley family (Plate 4). A contemporary photograph of the sitter shows that Renoir had at least captured a convincing likeness of this soberly dressed merchant, with his tie-pin and spectacles, a tenacious but not unkindly expression on his face. Renoir's portrait of Alfred (Plate 6) must date from the same time (though it has been assigned in the past to c.1867–8). He is seen full-face, bearded, in dark clothes set off by a white shirt-collar and

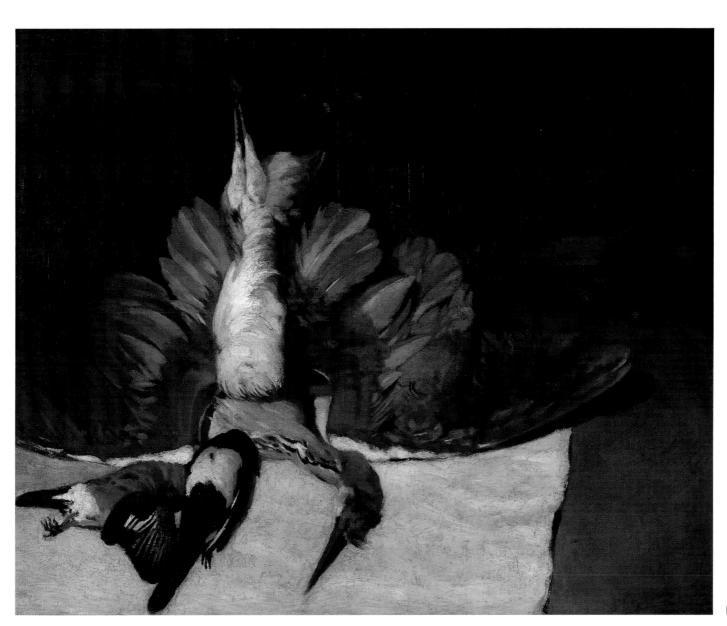

12

30

13

13 *Village Street in Marlotte.* 1866.
 50 x 92 cm. Albright-Knox Art Gallery, Buffalo.

 Detail
 Village Street in Marlotte. 1866.

32

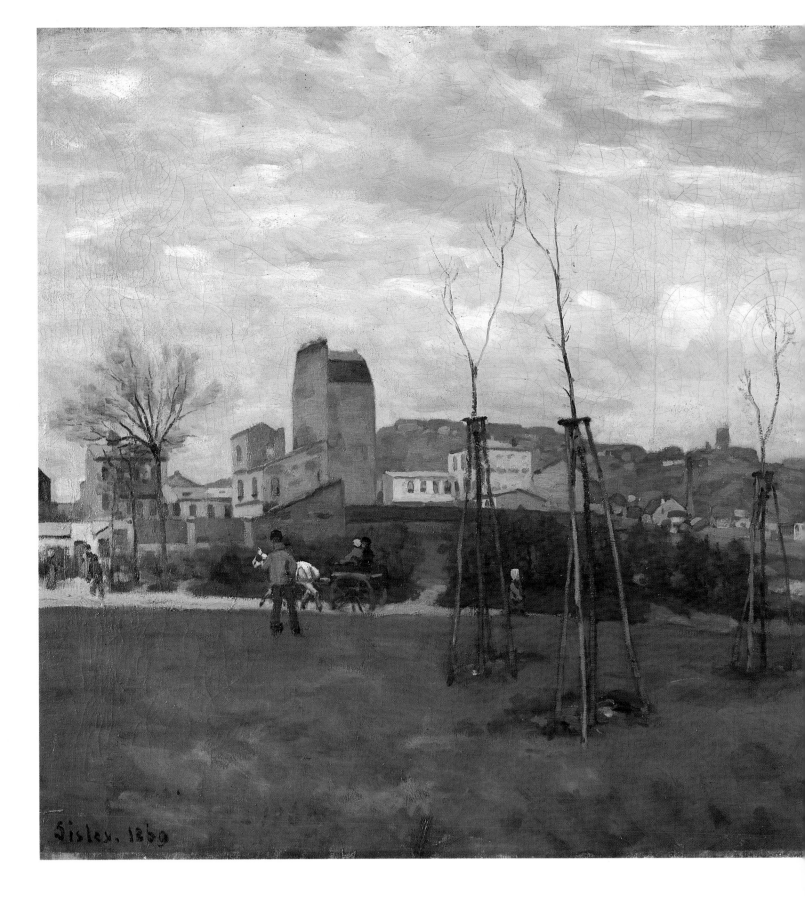

33

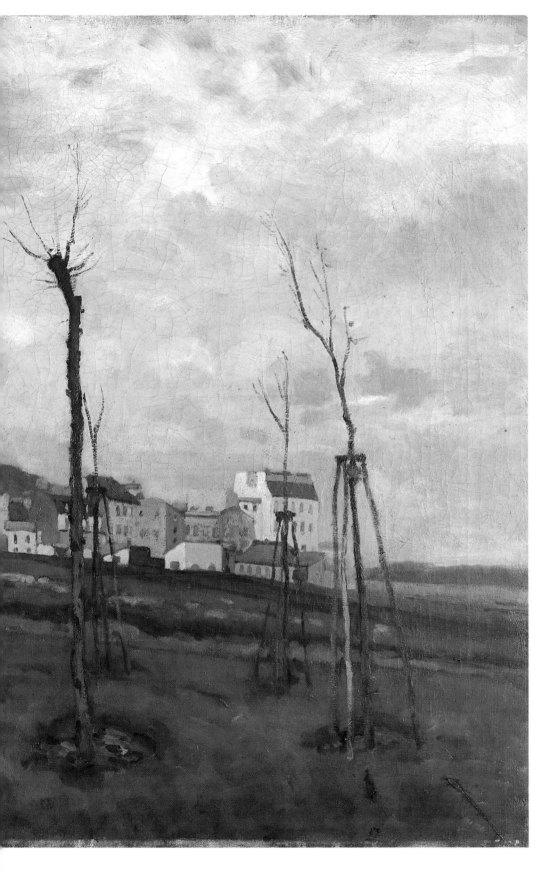

14

14 **Previous page**
View of Montmartre from the cité des Fleurs. **1869.**
70 x 117 cm. Musée des Beaux-Arts, Grenoble.

34

filmy cravat. Sisley appears rather solid and serious, though the pose, with one hand in the pocket and legs crossed, is informal. Sisley kept the picture all his life.[11]

Up to *c.*1867 Sisley's life appears, on the surface, to have been little different from that of any relatively affluent young man with a passion for landscape painting. Although commendably independent in his choice of friends at Gleyre's, his work was unexceptional and he seemed to be in no hurry to make an early name for himself. He had his own studio in Paris and congenial company with whom he could paint in the Forest of Fontainebleau and elsewhere. In April 1865 he is recorded as being with Renoir in Marlotte and later in Chailly; early the following year he was at Milly and Courances with Renoir and Jules Le Cœur (see note 15).

It was probably on a late autumn visit in 1865 or during the first months of 1866 that Sisley began two modest but prescient paintings whose qualities have not diminished with the years. *Village Street in Marlotte* (D3; Plate 13) and *Village Street in Marlotte – Women Going to the Wood* (D4) are both dated 1866 and were accepted for exhibition at the May Salon that year, though they suggest that the season shown is autumn. Although they must still be accounted as juvenilia and are inferior to the contemporary achievements of Monet and Bazille, they have that 'objective detachment from the scene depicted' that was fundamental to Sisley's

vision.[12] They bring to mind works by Dupré and Corot, but they also indicate, more strongly than the *Lane near a Small Town*, that Sisley's knowledge of Constable, from his stay in England, had emerged to influence his own practice. He has a similar self-effacement and allows his reactions to the scenes before him to evolve their own significance. Unprepossessing as his subjects are, he invests them with dignity through his 'infallible instinct for spacing and proportion'.[13]

Of the older generation of French painters whom Sisley admired, Corot remained paramount, the artist to whose sensibility his own most closely approximated. In his one known pronouncement on painting (a letter of 1892 quoted by the critic Adolphe Tavernier; see Appendix B), Sisley approaches some of Corot's own notes on his work: both agree that the sky should be painted first; that it is important that the work's construction should be established as simply as possible – its formal point of departure; and that the whole ensemble should be enveloped in a consistent atmosphere.[14] Similar motifs excited both painters and in Sisley's early works Corot emerges as the guiding presence.

Echoes of other Barbizon painters such as Daubigny and Rousseau find their mark more noticeably in Sisley's later work, Rousseau especially in trees and fields on hot, tranquil days. Sisley also lists Millet (in the same 1892 text) as an admired precursor, but his influence is less detectable;

although there are inevitable similarities of composition and imagery, their apprehension of rural life emanates from opposing sensibilities.

The influence of Corot, however, runs throughout Sisley's work. Both pitch their easels at the edge of a wood (Plate 16) or by the side of a road entering a village (Plate 13); both place country figures in an intimate but undramatic relation to their surroundings. They share a similar pleasure in the contrast of sunlit buildings – overlapping rectangles of ochre, naples yellow, grey-blues with darker accents of windows and doors (D31; Plate 15) – seen against massed foliage below skies that fill nearly half the canvas. Some of the more complex aspects of Corot's design were later appropriated by Sisley when he became the infatuated painter of the Loing and the Seine, of the town of Moret viewed across its river, and of the high network of paths on the slopes above the Seine affording plunging perspectives, as well as close-to fore-ground observation. Sisley's first views of Moret, its church and river seen from a hillside (D351–4), are in accord with Corot's views of Soissons and the Château de Pierrefonds.

In the 1860s Sisley remained in the Forest of Fontainebleau or in the woods at St-Cloud nearer Paris. He must have known, but appears not to have painted then, the river-banks bordering the forest at its eastern perimeter – the landscape that, in his last twenty years, became almost his entire world. Thus he was familiar from the beginning with all those sites of the forest, its clearings, massive rocks, paths and villages, that are an inextricable part of the imagery of the Barbizon School. At the same time, through friends such as Renoir and Monet, he must have met some of the older artists – Daubigny, Diaz, Corot and Courbet – who extended helping hands to the younger 'school'.[15]

While so many points of contact exist between Sisley and Corot (at least, the Corot up to the late 1840s), the place of Courbet in Sisley's development is much less easily accounted for. The younger artist could hardly avoid the older's powerful example as both colourist and pure landscape painter. Courbet's *View of Ornans and its Bell-tower* of *c.*1858 may lie behind Sisley's *View of Montmartre* (D12; Plate 14) of a decade or more later. It is hard to escape the conclusion that, if Sisley ever saw it, Courbet's magisterial *View of Frankfurt am Main* (1858) influenced his later paintings of Moret, seen from across the multi-arched bridge over the Loing, the river afloat with islands that break its weft of reflections. But Sisley was no match for the gargantuan appetites of Courbet, the reverberant symbolism of his seascapes, rocks, caves and cliffs. Sisley's undemonstrative nature side-stepped such romantic findings; his snow scenes are suburban, his villages low-lying; even his deer emerging on to a path to sniff the autumn air (D9; Plate 18) is infinitely restrained in its poetry compared to the huntsman Courbet's harassed prey.

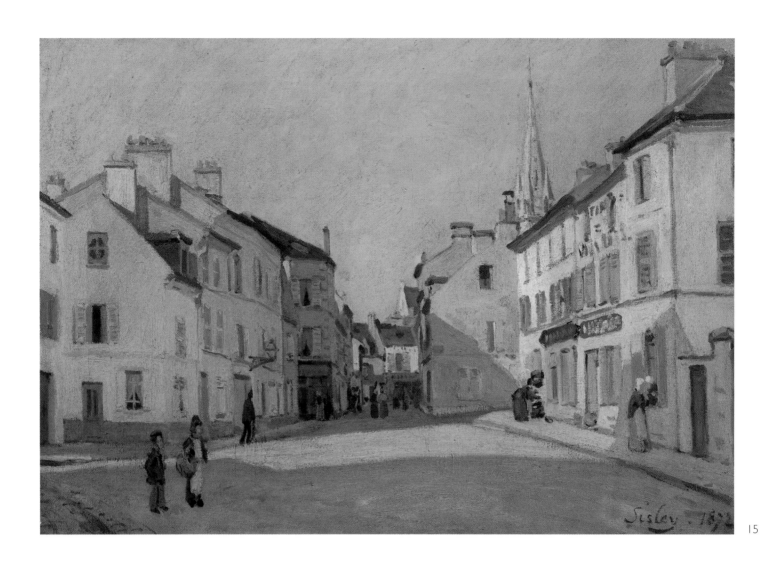

15

36

15 *Square in Argenteuil (Rue de la Chaussée).* 1872.
46.5 x 66 cm. **Musée d'Orsay, Paris.**

16

16 *Avenue of Chestnut Trees near La Celle-Saint-Cloud.* 1865.
 125 x 205 cm. Musée du Petit Palais, Paris.

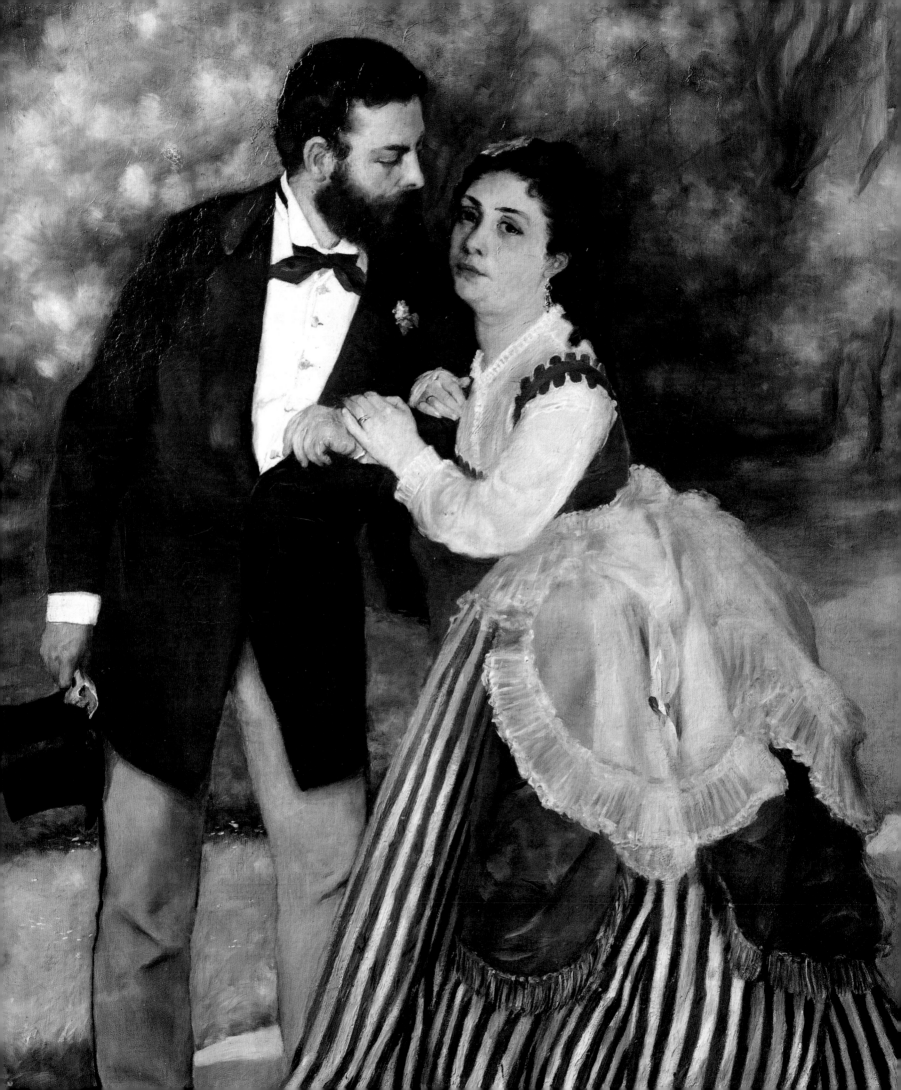

3 Family Affairs

In Renoir's celebrated early masterpiece *The Engaged Couple* (Plate 17), widely known as *The Sisley Family*, the painter shows his friend Sisley, then in his late twenties, giving his arm and full attention to a young woman wearing a brilliantly striped red and yellow crinoline. The man's look is solicitous, tender, even deferential; the woman turns almost appealingly to the viewer, prominently displaying her engagement ring, mindful perhaps of propriety yet entirely captivated by her fiancé's protective demeanour.

It was long supposed that Renoir had depicted Sisley with his 'wife', Marie Louise Adélaïde Eugénie Lescouezec, although the painting only gained the title *The Sisley Family* shortly before the First World War. It now seems certain that the young woman in the picture was in fact Lise Tréhot, Renoir's mistress and his frequent model between 1865 and 1872.[1] There is no surviving photograph of Eugénie Lescouezec to compare the likeness but there are enough paintings of Lise Tréhot to show her similarity with the woman in *The Engaged Couple*. Two further pieces of evidence confirm the identification. First, in a letter to Bazille, Renoir mentions that he has put 'Lise and Sisley on show at Carpentier's' (*c.* September 1869); no other painting fits this description.[2] Secondly, perhaps clinching the identification, the young fiancée wears the same coral and gold earrings worn by Lise Tréhot in at least four known depictions of her by Renoir.

By *c.*1868, when *The Engaged Couple* is thought to have been painted, Sisley's life bore little correspondence to the flirting, carefree image of Renoir's painting. Not only was he closely involved with Mademoiselle Lescouezec but he was also, by then, the father of Pierre, the first of their two children. Eugénie Lescouezec was five years older than Sisley, born on 17 October 1834 at Toul (Meurthe et Moselle) in the Vosges. This is the date given on her birth certificate but, as with so much else concerning Sisley, confusion surrounds the simplest of facts.[3] Eugénie seems to have been less than forthcoming about her actual age, even within her family circle. Her death certificate, the details of which were supplied by her son Pierre, records that she was 58 when she died (8 October 1898), thus making 1839 the year of her birth. On her grave 1835 is inscribed. To add to the confusion, when Sisley registered the birth of Pierre (17 June 1867), he gave Eugénie's age as 28 and his own as 26, thus making their birth dates 1838 and 1840 respectively.[4] Further mistakes were made on the birth certificate of their second child. Nothing quite accounts for this tissue of errors, save perhaps Eugénie's natural reticence over the five years difference between Sisley and herself, and the all-too-common haze, to be found in many families, surrounding dates of birth and death.

Little is known of this woman who shared Sisley's life for over thirty years and who died just a few months before him.

17 **Previous page**
Auguste Renoir. *The Engaged Couple* (detail). c.1868.
106 x 74 cm. Wallraf-Richartz Museum, Cologne.

18 *Avenue of Chestnut Trees near La Celle-Saint-Cloud.* **1867.**
95.5 x 122.2 cm. Southampton City Art Gallery.

40

Her father was Jean-Marie Lescouezec and her mother's maiden name was Colson (*prénom inconnu*, according to Eugénie's death certificate). Lescouezec was a military officer, supposedly killed in a duel when Eugénie was a child; according to Renoir's recollections, she became an artist's model when 'her family had been ruined in some financial venture'.[5] That she later became a florist is confirmed in the tenants' register of the apartment she shared with Sisley in the Batignolles quarter, to the west of Montmartre.[6] Renoir also mentions that she 'had a very sensitive nature and was exceedingly well-bred', with 'a lovely little face'. No photographs or paintings of her are known; her occasional appearances in Sisley's paintings are no more than as a 'figure-in-a-setting'. In a work by Marie Bracquemond of the Sisleys at the dinner table, Eugénie is in *profil perdu* with her back to the viewer;[7] another picture by Bracquemond, *In the Boat* (c.1882), also purporting to show the couple, is a highly suspect identification, the man's face bearing little resemblance to the few certain images of Sisley.[8]

When Sisley's first child was born in Paris on 17 June 1867, he gave Eugénie's address as 27 cité des Fleurs, and his own as St-Siméon, Honfleur. For a long time, Honfleur had been a favourite resort among painters, combining seaside motifs with lush countryside and spectacular views of the sea and the Seine estuary. Courbet, Boudin, Jongkind, Diaz all painted there, and had attracted a younger generation to the town. Monet and Bazille were in Honfleur in 1864, Monet spending most of the second half of the year there. Bazille wrote to his mother that the place was paradise, adding that, though lodged with a baker in the town, he and Monet took their meals at the farmhouse inn, St-Siméon, run by a Madame Toutain and situated on the cliffs above the town; Boudin and Jongkind were there at the end of the summer.

Three years later, in 1867, Monet wrote to Bazille from nearby Ste-Adresse mentioning that 'Sisley is at Honfleur'. The letter is dated 9 July, three weeks after the birth of Pierre Sisley, and shortly before Monet's own first child, Jean, was born; his mistress Camille Doncieux gave birth to the boy in Paris. Thus, within a month both the young painters, unmarried and with financial difficulties (particularly Monet), became fathers, thereby increasing their responsibilities and aggravating their relationships with their families.

Two hitherto unpublished letters, written by Sisley from Honfleur to his friend Joseph Woodwell in Paris, throw light on his situation. The first is simply headed 'Honfleur, mercredi', but can probably be dated to 28 May 1867 or to a week earlier.

I want to ask a favour of you. I desperately need 150 francs. My wife is ill and I have nothing to get anything for her, not a sou. I think that if M. Wolff were in Paris, you could persuade him to buy one of my pictures a seascape,

18

Sisley

42

landscape, or houses and roads in the town of Honfleur; I have several in progress and one nearly finished.[9]

Sisley continues with the inevitable complaints of poor weather which has severely held up his work – the eternal cry of the *pleinairiste*. Eventually Woodwell, who had been painting at Marlotte, replied, probably enclosing money and giving the news that Monsieur Wolff would indeed buy a painting.[10] Sisley wrote on 6 June that he would set to work at once. Again the weather was bad, but he had several canvases on the go:

1 small study of a cow
1 picture of the orchard
(beneath the apple trees almost finished)
1 road in Honfleur (in progress)
1 small seascape. begun
1 large study of la rue Haute. begun not counting a study of a street that I did and then painted over in a moment of anger.

He finishes by saying that he will shortly be returning to Paris.

These two letters are important in several ways, particularly as there appear to be no others (beside the brief note to Woodwell mentioned earlier) from the formative years of Sisley's life – none to Renoir or Monet, none from Sisley's lengthy stay in England in 1874, none from the period of the first Impressionist sales and exhibitions. Nor do any family letters appear to have survived. Sisley's progress as a painter is charted entirely from his works; as a man he is glimpsed in other people's letters (though there is nothing in the correspondence of Bazille, his close friend in the 1860s); and there are the few confirmations of his Paris addresses from the catalogues of the Salon exhibitions of 1866 and 1870.[11] The documentation of his life is as scarce as the number of paintings that exist, until the abundant flow begins in 1872–3. While this paucity of evidence may be partly attributable to a later loss of personal possessions, it certainly suggests someone living on the margins of an otherwise articulate and comparatively well-documented group of friends. It is also worth taking into account the quiet modesty of Sisley's character and his increasingly retiring nature.

In Sisley's first letter to Woodwell, he refers to 'my wife'. He obviously maintained, even among his boon companions – in Paris, on the coast and in Fontainebleau – the fiction that he was married at the time of the birth of his children. This was not so. In the registration of his children's births, he is recognized as their natural father but Eugénie is distinctly described as 'unmarried florist'. The second point of interest is that he begs for 150 francs as he has not a sou to send her.

This goes against all earlier accounts of Sisley. He was always believed to have been financially independent through a family allowance that only came to an end in 1870–1, when the Franco-Prussian War ruined his father. Of course, there is the possibility that he had simply spent his allowance, and that the pre-natal illness of his wife (or was the money intended to pay midwifery fees for the birth of their son?) was an extra burden on his pocket – especially with the expense of a long visit to Honfleur.

It seems that the only explanation is that his father, having somehow learnt of his son's liaison, refused him further financial support. In conversation Sisley once said that his father, 'displeased with his son's preference for painting rather than serious business activities, had abandoned him to the vagaries of a Bohemian existence'.[12] This can be understood as indicating a definite break between Sisley and his father, not during his attendance at the Atelier Gleyre but obviously at the time of his liaison with Eugénie. A similarly irregular liaison appalled Monet's parents; Cézanne's father was long kept in ignorance of his son's relations with Hortense Fiquet and of the existence of their child, Paul; and there were family lamentations when Pissarro's mistress, Julie Vellay, produced their first child, Lucien. Thus Sisley followed the pattern of his closest associates and was not, as has hitherto been believed, the well-heeled gentleman-amateur, married with two children.

Further evidence supports the conjecture that Sisley was cut off by his father. A letter written by a relative of the Sisleys, Jeanne Bach Sisley, to her investigative cousin Claude, underlines the fracture in the family's private life. Among several interesting details, she writes, 'As to Alfred … on account of his irregular liaison, one did not mix with him.'[13] Although her letter contains some genealogical muddle, much of what she reports proves to be true and there is no reason to doubt her allusion to Sisley's ostracism.

In addition, she makes the startling statement that Sisley *père* died mad ('*fou*') at Congy. Family documents and William Sisley's death certificate show that he did indeed die alone and outside Paris; his death is recorded in Epernay (Congy is a village close to this town in Champagne, east of Paris) as having taken place on 5 February 1879.[14] Until now, all accounts of Sisley's life have assumed that his father died in *c*.1871, his health undermined by reversals in business brought about by the interruption to trade during the Franco-Prussian War.

That William Sisley's business was ruined is almost certainly true; from at least 1872 until his death seven years later, he lived on a modest income from an English life assurance policy. Marie Collard, the woman in whose house he lodged in Congy, was described as a 'relative', quite possibly a purely fictitious appellation for the benefit of the census commissioner. She died a year before Sisley *père*, who

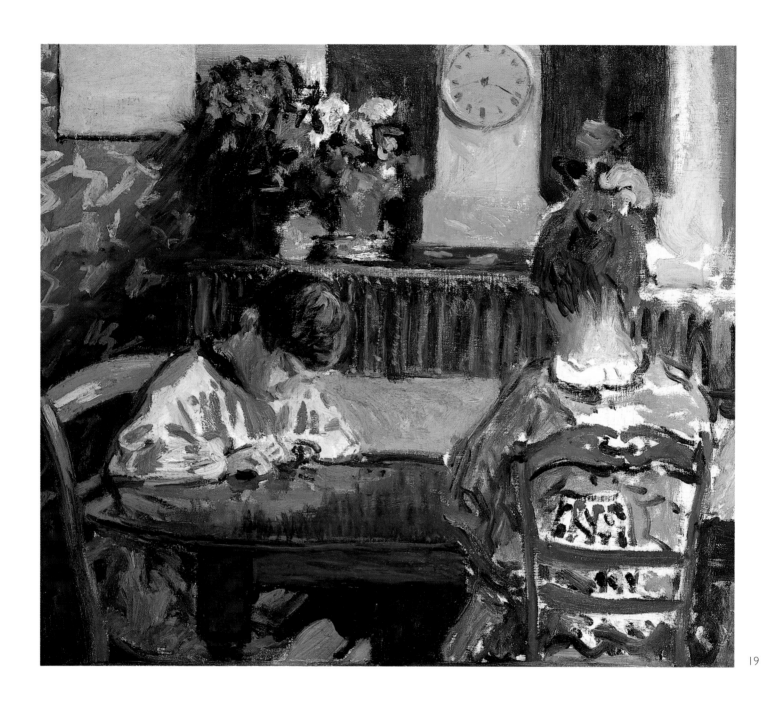

19

19 *The Lesson. c.*1874.
41.3 x 47 cm. Private Collection, Texas.

Detail
*The Lesson. c.*1874.

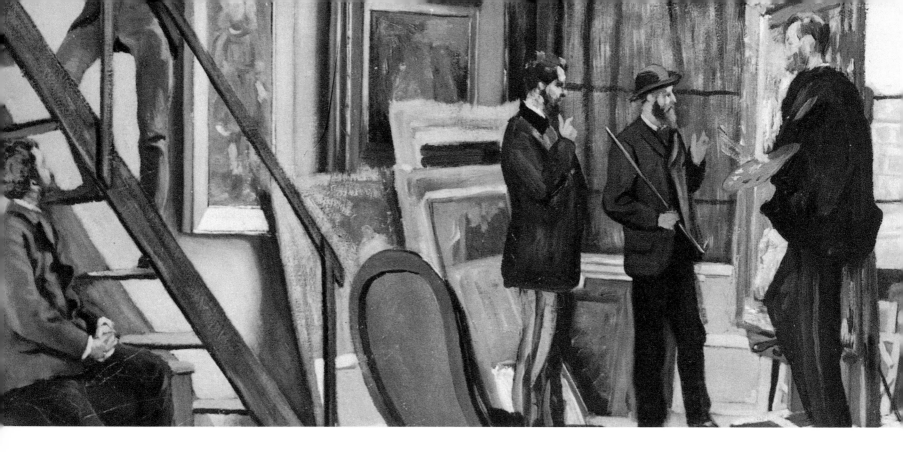

was then looked after by her brothers, workers in the local vineyards. In his will he had left his goods not to his children but to his elderly and fussy bachelor brother, Thomas, his one-time business associate; by the time of his death, however, all William had to leave was his policy and one piece of furniture worth 170 francs. It had obviously been a terrible come-down for the wealthy, shrewd-eyed merchant of Renoir's early portrait.[15]

Alfred Sisley's precipitous fall from relative affluence to poverty has always been ascribed to his father's ruin. Théodore Duret's account of the painter made this widely known: 'In 1870, during the war, his father fell ill, and – incapable of overcoming the crisis in his own business affairs – suffered losses which led to his ruin and, shortly after, to his death.'[16] With variations, this has been repeated ever since. Aside from William Sisley's personal deterioration, it is highly likely that his business was indeed seriously affected by the rapid decline in trade during the Franco-Prussian War. It particularly affected the market for the kind of 'unnecessary and frivolous' articles, redolent of Second Empire society, upon which the Sisley business was founded.[17]

Knowledge of Sisley's family relations and financial position at this time is further complicated by a remarkable statement in an unpublished letter from the painter to Adolphe Tavernier, written over twenty years later (see Appendix B). In a brief outline of his life he says that in 1870 he was living in Bougival and 'during the war' lost everything that he owned and took refuge in Paris. No further details of this personal catastrophe have emerged. Presumably, his rented house was occupied by Prussian troops at the start of the Siege of Paris in mid-September 1870. Bougival was especially hard hit. In a hopeless move to stem the Prussian advance, the French military blew up the two bridges connecting Bougival on the left bank of the Seine with Croissy on the right, across the Ile-de-Croissy in the middle of the river; the Prussians arrived, nevertheless, in swift disorder (shelled by the French from the Fort Mont-Valérien) to land on the population of Bougival. Three thousand troops, both infantry and cavalry, caused terrible damage in this small riverside suburb, a favourite resort of Parisians for weekend boating and picnics, and one of the shrines of the early Impressionist movement.[18] Nearby Louveciennes suffered similarly, as did Chatou and Le Vésinet over the river, all village-suburbs vulnerably close to, but outside, the French fortifications.

Sisley's statement that he lost everything that he possessed might well account for the fact that very few works by him exist from these early years, though this has usually been attributed to his having independent means, which allowed him to work at a leisurely pace (unlike his less well-off friends Renoir, Monet and Pissarro). As we have seen, this was only true until c.1867. Nevertheless, it has always struck a curious

note that only seventeen paintings are listed in the *catalogue raisonné* up to 1870.[19] The early provenances of these works are in most cases unknown; their survival suggests that they either had left Sisley's hands by the autumn of 1870 or were in his apartment in the cité des Fleurs. Among them were his two Salon exhibits of 1870, both of the Canal St-Martin in wintry Paris weather (D16 and D17).[20]

From the *View of Montmartre* of early 1869 (Plate 14), with its echoes of Corot and Courbet (though already highly personal in feeling), to the two Canal St-Martin canvases, there is a remarkable advance in painterly handling and variation of colour. It is doubtful if such a leap was made without intermediate pictures and the Bougival calamity perhaps explains the scarcity of Sisley's known output. Equally, however, only one work can be placed within the bracket of early 1870 to early 1872.[21] An explanation is less forthcoming for this virtual absence of paintings between the Siege of Paris and the real start of Sisley's career in 1872 in Louveciennes.

Of Sisley's experiences during the Paris Commune nothing is known. Like everyone he must have suffered some of the privations of the time – restrictions of travel (though his English nationality may have worked in his favour) and shortages of food. He was now the father of two small children, his daughter Jeanne having been born on 29 January 1869.[22] Among his friends, Monet and Pissarro

had taken refuge in England and were absent throughout the war. (The persistent assertion that Sisley also fled to England is based on a misstatement made many years later by the dealer Durand-Ruel.) Renoir had been mobilized in a cavalry regiment but saw little action; he was back in Paris during the Commune and must surely have seen Sisley at this time. Both must have been overwhelmed by the loss of their friend Bazille, killed on 28 November 1869 during a muddy skirmish at Beaune-la-Rolande as the French army retreated.

One of Bazille's last paintings, his famous *Studio in the rue de la Condamine* (Plate 20), celebrates the companionship found there among painters and writers. At different times, the studio became a refuge for both Monet and Renoir during moments of financial crisis, and Sisley gave its address for his Salon submissions in early 1868 (when the street was called the rue de la Paix – its name was changed shortly afterwards). The accommodation consisted of a spacious studio and an adjoining room on the third floor of number 9. It was conveniently located for Bazille's friends and social life. Sisley's flat in the cité des Fleurs was a few streets to the north, also off the avenue de Clichy, in the 17th *arrondissement*; just to the south was the Café Guerbois, the great meeting place at this period (up to *c*.1872) of Manet, Degas, the future Impressionists and their circle.

In Bazille's painting Manet faces Bazille, whose tall figure, palette in hand, one foot on his easel, was painted in by

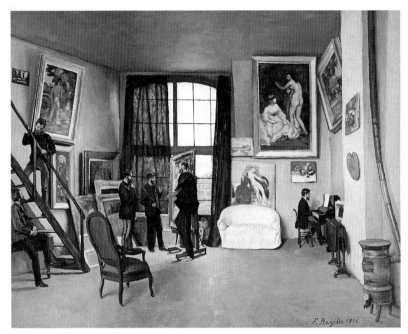

20

Manet himself; Monet stands close by, smoking a pipe. Several attempts have been made to identify the remaining three men. It seems that the young musician and writer Edmond Maître (1840–98), inseparable friend of Bazille, is seated at the piano. The two men conversing over the banister have often been identified as Emile Zola (on the stairs) and Renoir (seated on a side-table). But this latter figure bears no resemblance to Renoir, who was slighter in frame and less heavily bearded. Sisley is a more likely contender, especially if the profile is compared to Renoir's view of him in *The Inn of Mother Anthony* (Plate 21). Bazille's painting remains a charming testimony to the camaraderie of this group and to the prominent position occupied by Manet as exemplar, mentor and friend.

Facts from two unpublished documents alter the received chronology of Sisley's life at this time (1870–3). First, he states in his letter to Tavernier that after losing everything at Bougival he took refuge in Paris and only moved from the capital to the village of Louveciennes in 1872 (see Appendix B). Secondly, Eugénie Lescouezec's name is entered in the tenants' register for 27 cité des Fleurs until 1873.[23] Thus, two crucial years in the development of Sisley's painting and in the formation of the Impressionist group were spent by Sisley in Paris. It has long been known that he was introduced at this time to the dealer Paul Durand-Ruel and first showed pictures publicly, outside the Salon, in Durand-Ruel's gallery in the rue

Laffitte; and his paintings were included in shows at the dealer's London gallery at 168 New Bond Street.[24]

However, there are no contemporary sightings of Sisley himself and it is not possible to gauge his contribution to the climate of discussion that was to lead to the First Impressionist Exhibition of 1874. Doubtless he had been among the group of 'a dozen talented people' (mentioned by Bazille in a letter of 1869 to his parents), who had decided 'that each year we will rent a large studio where we will exhibit our works in as large a number as we wish'.[25] Bazille's death in the following year, however, the Commune of 1871 and the consequent disruption to every aspect of life in the capital all contributed to the delay in putting the group's ideas into practice. It was only in 1873 that concerted efforts were made, meetings held, articles published; Sisley was central to the group and became a founder member of the proposed exhibiting society, constituted on 27 December 1873 and styled the 'Société anonyme coopérative d'artistes-peintres, sculpteurs, etc.'. Its membership was wide, ranging from the now famous names of the Impressionists to the obscure still-life painter Antoine-Fernand Attendu, the enamellist Alfred Meyer and the sculptor Auguste Ottin and his son.

By the time of the 'Société anonyme's' first exhibition in 1874, Sisley's work and life had undergone an astonishing transformation. No longer was he the comparatively carefree

20 **Frédéric Bazille.**
Bazille's Studio in the rue de la Condamine. 1870.
98 x 128.5 cm. Musée d'Orsay, Paris.

Detail previous page
Bazille's Studio in the rue de la Condamine. 1870.

21 **Auguste Renoir.** *Inn of Mother Anthony.* 1866.
195 x 130 cm. Statens Konstmuseer, Stockholm.

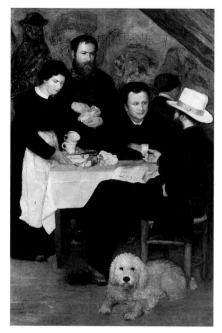

21

figure of Renoir's later recollections. As the father of two children and a man who had been used to the comforts of life, he needed a stable income to combat, as his friend Geffroy wrote, 'the terrible difficulties of making sufficient to live on'.[26] At first, Eugénie may have provided some money through her work as a florist and as occasional model to Renoir and Bazille. But Sisley's own determination to provide for his family is reflected in the growing body of work he produced after the war and the Commune, his increasingly profitable association with Durand-Ruel from 1872 onwards and his active participation in the formation of the 'Société anonyme'.[27]

One of Sisley's first considerations, however, was to find somewhere to live that was conducive to his family, commensurate with his likely income and suited to the kind of landscape painting he wished to pursue. Paris no longer seemed to offer him the opportunities he needed. It is surely significant that the paintings of 1869 and 1870, respectively, show the still semi-rural aspects of the capital (Plate 14) and the backwaters of the Canal St-Martin, in which industrial suburban Paris is pushed to the horizon. In *The Seine, Paris, and the Pont de Grenelle* (D15), also of 1870, the city has almost disappeared into the wings, leaving water and sky at centre-stage.

Sisley was to find his ideal landscape in the villages close to Paris. They were familiar to him from his painting visits to the area and from his stay in Bougival, and they were already, 'colonized' by his Impressionist colleagues such as Pissarro and Monet. These villages offered him a continuous interaction between open and cultivated country, busy through-roads and silent garden paths, suburban streets and rural isolation. He became, during his years at Louveciennes and Marly-le-Roi, 'the greatest painter of suburbs since suburbs evolved'.[28]

49

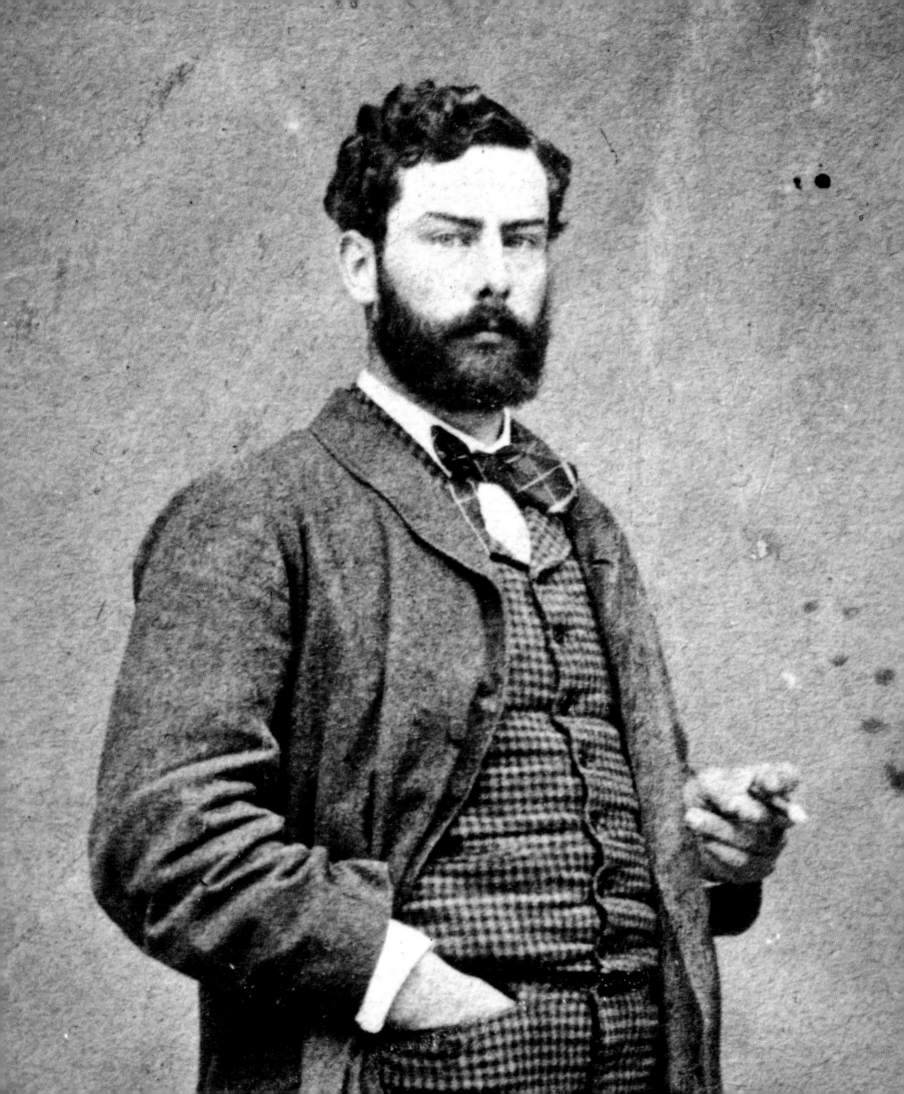

4 An Impressionist in the Suburbs

It is likely that Sisley moved to Louveciennes in late 1872, at which time his paintings of the area became numerous.[1] He knew the district well, and the subjects of several of his works up to his move include views of nearly all the famous Seine-side villages that occur in the titles of paintings by Pissarro, Monet, Renoir and Berthe Morisot. There are yachts at Argenteuil, the striking new bridge at Villeneuve-la-Garenne, the river-bank at St-Denis and Bougival, and the Seine in flood at Port-Marly. Most, however, are of Argenteuil, where Monet had been living since December 1871, and at least two pairs of paintings show that the artists set up their easels side by side. They have frequently been reproduced together – Sisley's *Square in Argenteuil* (D31; Plate 15) with Monet's *Rue de la Chaussée* (1872; formerly Landrin Collection, Paris), and Sisley's *Boulevard Héloïse* (D44; Plate 23) with Monet's work of the same title (1872; Yale University Art Gallery, New Haven). In both cases, Sisley's paintings appear superior, especially *Square in Argenteuil* with its Corot-like tonality and air of desultory, late afternoon sun, its perfect green shutters and shy, gawping children.

The church at Argenteuil (omitted by Monet in his *Rue de la Chaussée*) appears again in Sisley's *La Grande-Rue, Argenteuil* (D269; Plate 26), the spire, rising against a damp, cloudy sky, wedged between houses and the superbly disruptive horse-drawn vehicles. The *Footbridge at Argenteuil* (D32; Plate 24) of the same time introduces a favourite motif

– a bridge jutting or even leaping towards the centre of a painting, giving a dramatic intensity to the mixed perspectives and superimposed planes that result. Sisley's inspiration here may have come from Hokusai, especially his series of prints of bridges (*c.*1827–30). Although there is no documentary evidence of Sisley taking a particular interest in Japanese art, with enthusiastic friends such as Monet, Duret and Bracquemond, he could have hardly ignored it. The influence seems especially powerful in the 1870s, above all in the snow scenes of Louveciennes and later of Marly; but it persists throughout Sisley's work, never overt or unqualified, but subtly present, transformed by the intelligence of a true painter. Even Hokusai's small figures, going about their business and dwarfed by the landscape, are echoed by Sisley, sometimes with an arresting, even slightly comic accent – the staring man, for example, in the *Footbridge* (whose figure is repeated walking along the bridge), or the elderly couple on the pavement in *Boulevard Héloïse*.

If Monet was Sisley's chief companion in painting expeditions at this time, Renoir was perhaps his closest friend. It may well have been Renoir's frequent presence in Louveciennes that drew Sisley to settle in the village. It was probably there that Renoir made the small portraits of Sisley's children . On one of these visits Renoir accompanied Sisley on a perfect spring day into the fields outside Louveciennes, and both painters produced

22 **Previous page**
Alfred Sisley. c. 1872–4.
Photograph. Archives Durand-Ruel, Paris.

23 *Boulevard Héloîse, Argenteuil.* 1872.
 39 x 61 cm. National Gallery of Art, Washington.

24 *Footbridge at Argenteuil.* 1872.
 39 x 60 cm. Musée d'Orsay, Paris.

52

23

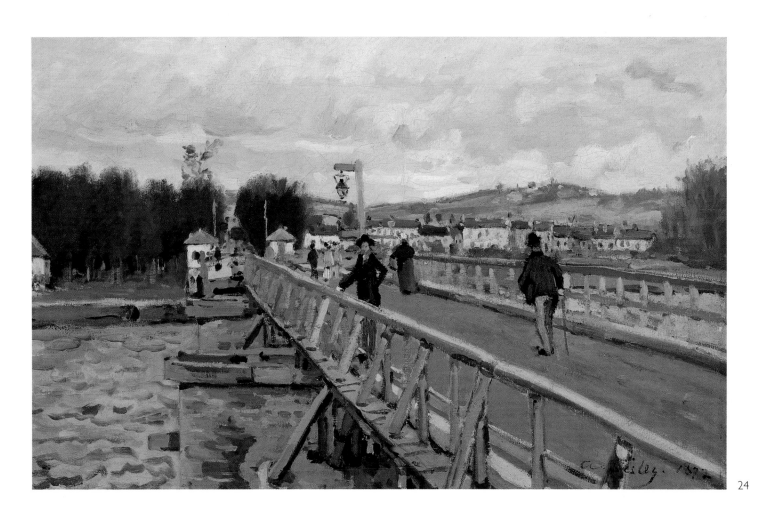

53

24

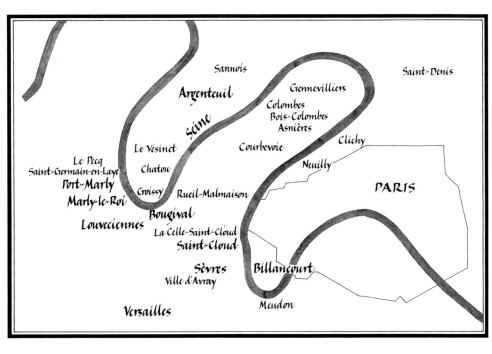

25 **La Grande-Rue Argeuteuil, in about 1900.**

26 *La Grande-Rue, Argenteuil. c.1872.*
 65.4 x 46.2 cm. Castle Museum, Norwich.

25

54

characteristic views, though where Renoir adds a country boy lying in the grass, Sisley has added Jeanne and Pierre – one of the few images of his children to be found in his work.[2] By then they were experiencing rural village life for the first time.

The attractions of Louveciennes, practical and aesthetic, were several, and Sisley quickly took advantage of them. It was only seventeen kilometres from Paris. The capital was easily reached by coach, or by taking the omnibus from the village centre to nearby Chatou station and then the train to the Gare St-Lazare. Friends were in the neighbourhood, there were good village shops, an excellent postal service, the pleasures of the nearby river, the Forest of Marly, and a handful of properties that gave distinction and contrast to the network of streets, bordered by modest, vernacular houses. Thus it was rich in subjects of the kind that, over the following years, drew from Sisley some of his most characteristic work. Louveciennes saw the making of him as a painter.

The Sisleys settled in Voisins, a hamlet attached to Louveciennes but retaining some individual flavour. Its close-packed centre, dominated by the Château de Voisins, gradually gave way to meandering paths which, becoming steeper, wound their way down to the Seine. This varied and congenial landscape had attracted painters for years – local inhabitants as well as occasional visitors working for Madame du Barry who from 1771 to 1793 lived in the château that

bore her name. She was a friend and patron of the painter Madame Vigée Lebrun who, after the Revolution, eventually settled in Louveciennes and died there in 1842. In her memoirs Vigée Lebrun continually praises the advantages of life in Louveciennes after the melancholy of years of exile abroad. She was completely seduced

> by this spacious view that unfolds, as the eye follows the long course of the Seine, by the splendid woods at Marly and the delightful orchards, so well tended you could believe yourself in the Promised Land; in short, by everything about Louveciennes, one of the most charming places on the outskirts of Paris.[3]

Such idyllic descriptions of Louveciennes continued to fill pages of guidebooks throughout the nineteenth century, and the paintings of Renoir, Pissarro and Sisley confirm them. Nevertheless, it should be remembered that when Sisley moved to Louveciennes the village was still convalescing from the ravages of occupation during the Franco-Prussian War.

The worst was over, but even in 1872–3 the scars were not entirely healed. More than 3,000 Prussian troops had been billeted in the village during an extremely harsh winter. Houses had been commandeered and in consequence many were ruined – from the imposing Château du Pont to the

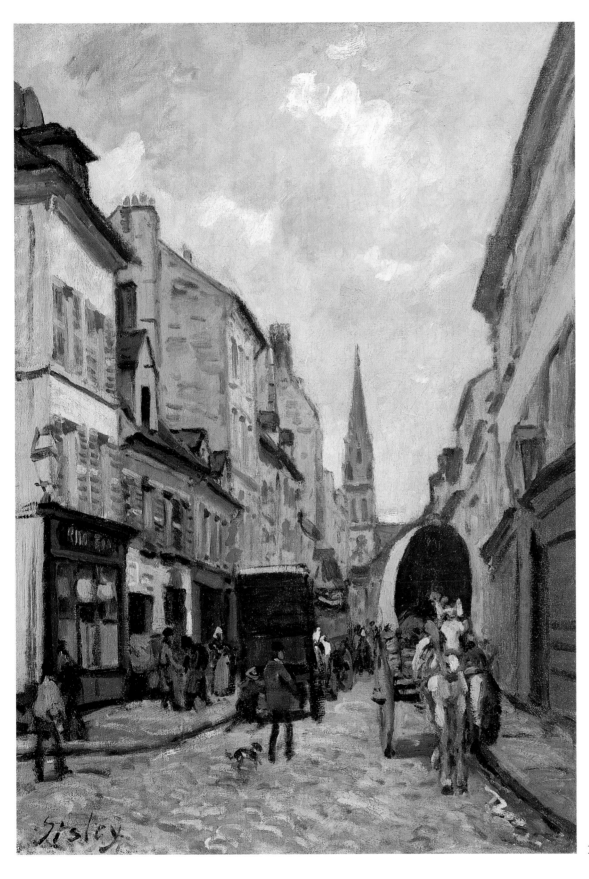

56

27 ***Rue de la Princesse, Louveciennes
(formerly Street in Ville d'Avray). 1873.
55.9 x 47 cm. Private Collection.***

ordinary village home. Pissarro's house at 22 route de
Versailles was occupied throughout the hostilities; he and
his family had fled leaving their furniture and clothes and,
according to the painter, 1,500 canvases. The place was
ransacked, and an abattoir set up on the ground floor, with
soldiers' quarters above. Only about forty paintings were
saved. In March 1871 Pissarro's sister-in-law walked from
Rueil to Louveciennes to inspect the damage; she reported
in a letter that the roads were 'impassable to wheeled traffic,
houses are burnt, window panes, shutters, doors, staircases
and floors, all had disappeared.' The grand avenue of trees
bordering the route de Versailles and seen in Pissarro's and
Monet's pre-war paintings, had nearly all been cut down,
as had many trees on neighbouring estates and in the Forest
of Marly.

The occupation hit hardest the livelihoods of the
gardeners and smallholders of the area, but free hand-outs
of seed in 1871 helped save the situation. By 1873 the fruits
of intense post-war reconstruction were being yielded, and
Louveciennes was swiftly regaining its position as one of
the leading market gardens for Paris.

Properties were being repaired but many were still
cheap to rent. Sisley, now in straitened circumstances,
took advantage of this. He leased a two-storey house at
2 rue de la Princesse, on a bend of this gently descending
street, bordered on one side by the park of Madame du

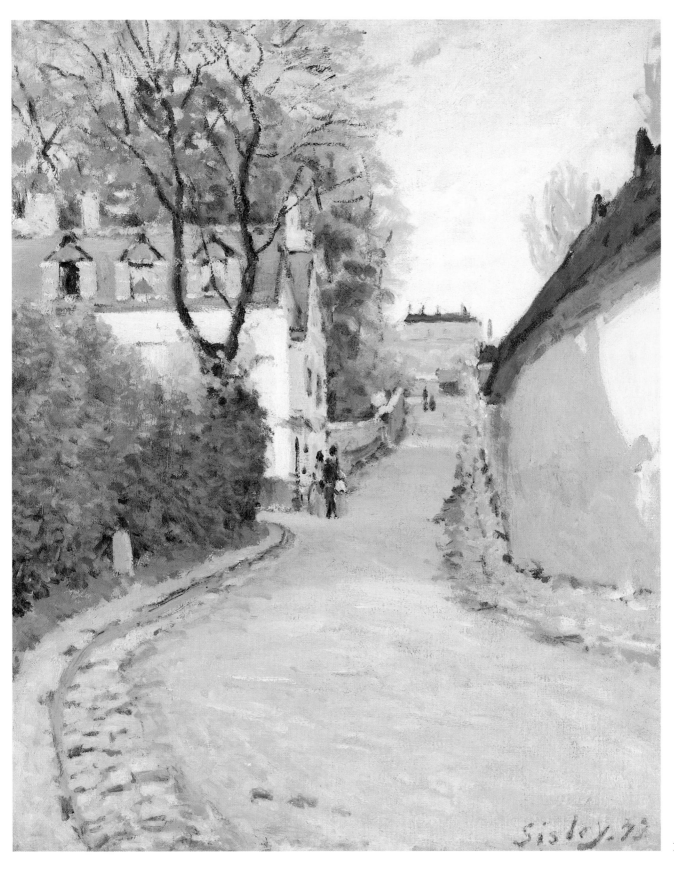

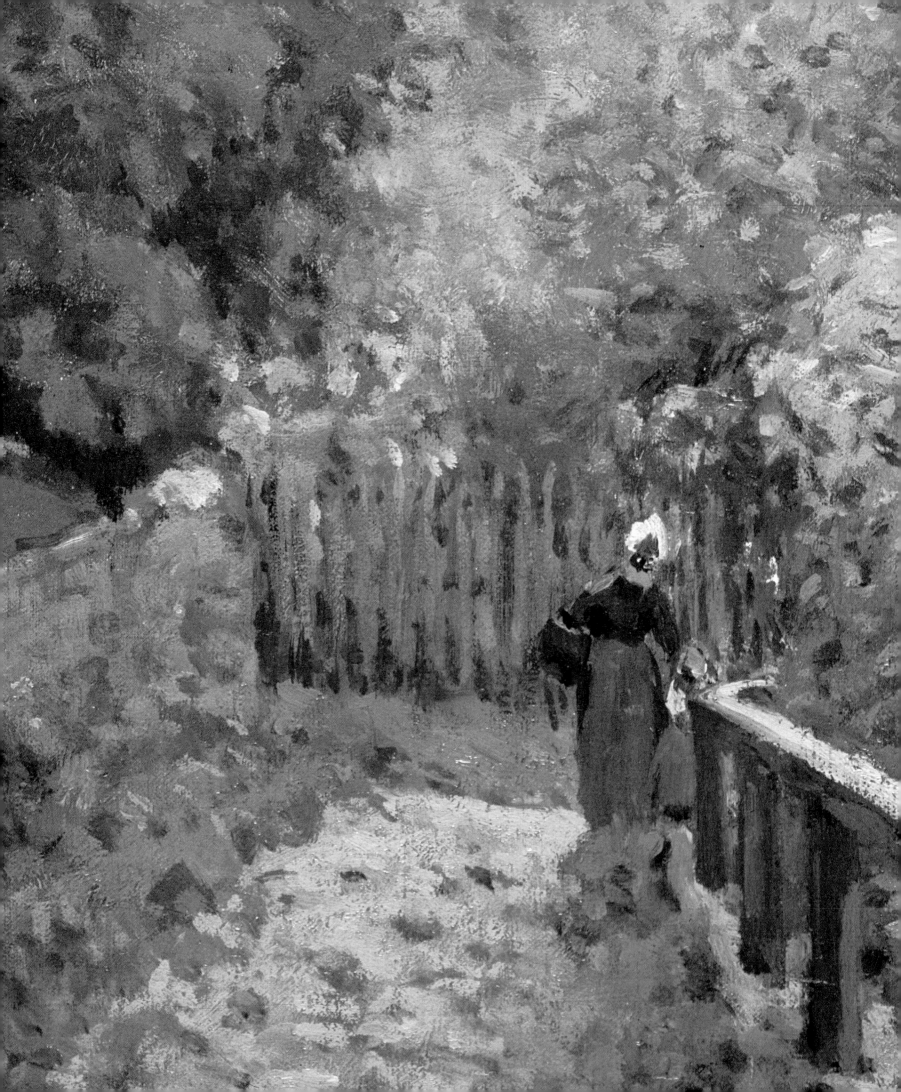

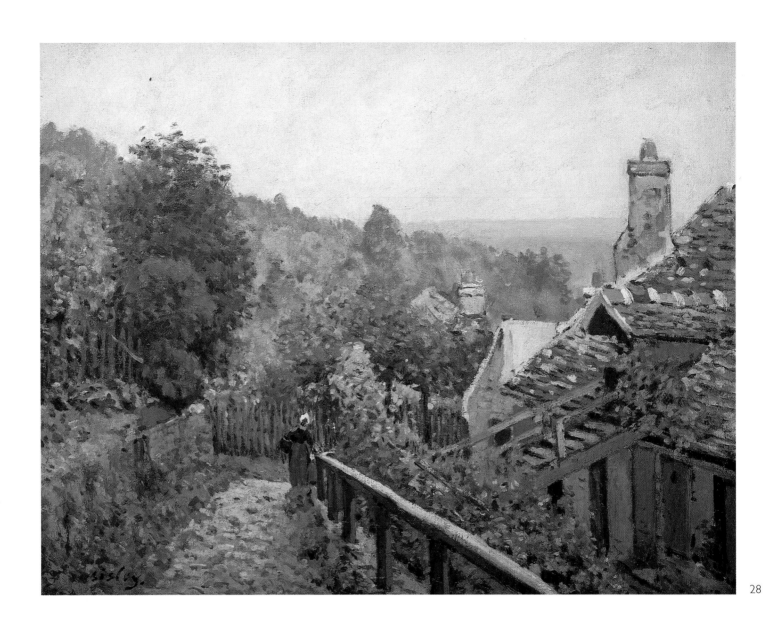

28 *Sentier de la Mi-côte, Louveciennes.* 1873.
38 x 46.5 cm. Musée d'Orsay, Paris.

Detail previous page
Sentier de la Mi-côte, Louveciennes. 1873.

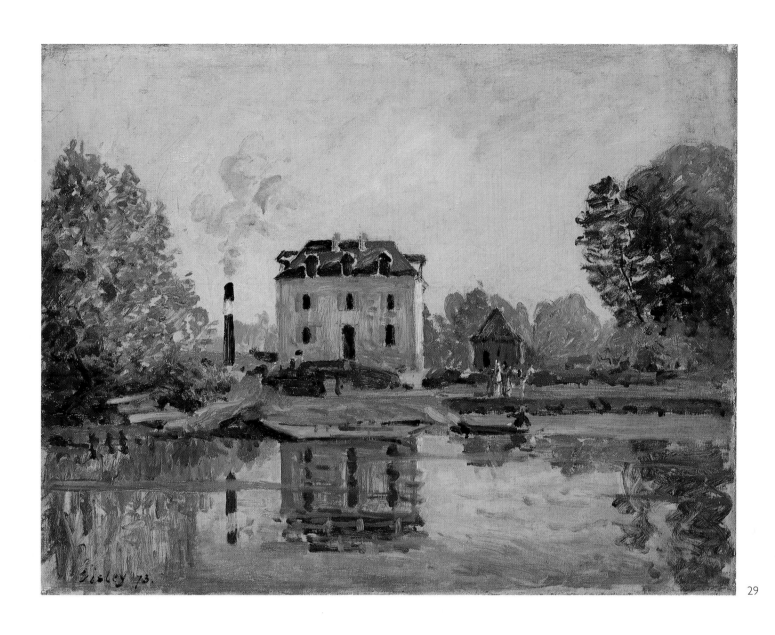

29

29 **Factory in the Flood, Bougival. 1873.**
50 x 65 cm. Ordrupgaard Collection, Copenhagen.

30 *Street in Louveciennes (Rue de la Princesse).* **1875.**
38 x 54 cm. The Phillips Family Collection, USA.

31 *Ferry to the Ile-de-la-Loge – Flood.* **1872.**
46 x 61 cm. Ny Carlsberg Glyptotek, Copenhagen.

62

Barry's château, on the other by cottages, orchards and vegetable gardens.[4]

There has long been some confusion over the exact location of Sisley's house. François Daulte has written that 2 rue de la Princesse was only briefly occupied by Sisley; elsewhere he mentions it as Sisley's address from 1871 to 1875. More recently, Richard Brettell has stated that number 2 was actually the Café Mitte and draws the conclusion that Sisley's paintings of the house celebrate the convivial hospitality found by visitors out from Paris for 'a day in the country'. In fact, Mitte's wine shop and 'bar' was in the nearby impasse de Voisins.[5] The evidence for believing that Sisley rented the house from about 1872 to early 1875 rests on the following facts: first, 1872 was the date given by Sisley for his move to Louveciennes in his letter to Tavernier; secondly, in 1874 this was his address in the catalogue of the First Impressionist Exhibition; and thirdly, a number of paintings between 1873 and 1875 show not only the house itself (Plate 30), but also views from its first floor balcony (Plate 68) and of the narrow chemin de l'Etarché, immediately across the road from its door. Several other Voisins paintings were obviously done within a moment's walk of Sisley's home.

The sudden abundance of Sisley's work in Louveciennes, its high quality, freshness and confident innovations all coincided with his complete identification with the emerging Impressionist movement. Sisley's reactions to what was happening are unrecorded, and there is nothing to illuminate his thought or activities during the crucial period leading to the First Impressionist Exhibition, held in the studios of the photographer Nadar at 35 boulevard des Capucines from 15 April to 15 May 1874.[6] However, what clearly emerges is the fact that, during the exhibition, Sisley was frequently overlooked in the press and roused little of the splenetic abuse heaped on some of his fellow exhibitors. At the same time, his admirers – and he had several – seemed to treat him more perfunctorily than his colleagues. When Sisley is mentioned at all, the same mildly complimentary phrases are repeated, best illustrated perhaps by Durand-Ruel's summary that Sisley 'expresses his personality through charm, the gentle use of colour, his serenity of vision and depth of expression'.[7]

The subject-matter on which Sisley resolutely turned his back – scenes of everyday urban life, interiors with figures, bustling Paris streets, the whole panoply of *la vie moderne* – was just what attracted attention in the works of his fellow exhibitors. Sisley was a landscape painter *tout court* and almost absurdly modest in the selection of his motifs. Even alongside the 'pure' landscapes of Monet and Pissarro, his works look shy and retiring. Although his range of colour was light, varied and undisguised, it was neither greatly removed from the range of Boudin, for example, or of some

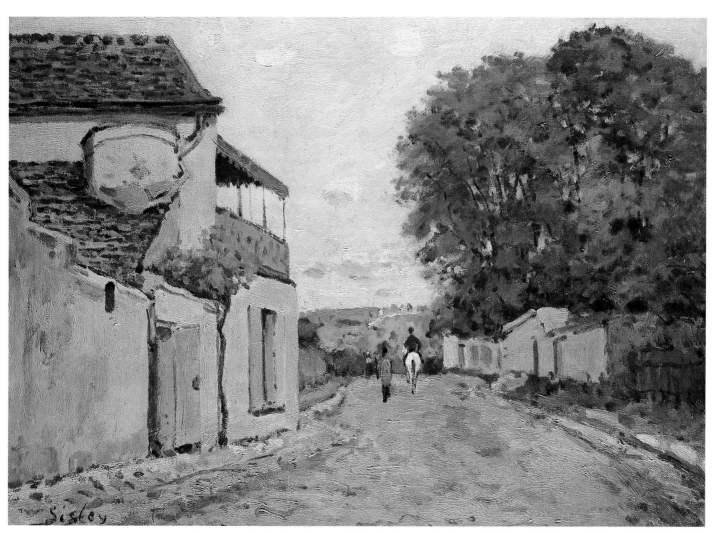

30

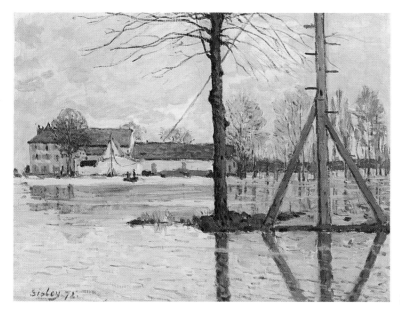

31

32

64

of the older Barbizon painters, nor yet as audacious or inventive as that of his colleagues. With this in mind, it is perhaps easy to understand Sisley's comparative neglect, a situation that continued for most of the rest of his life. When Durand-Ruel writes of him that he was a 'more than any other a victim of incomprehension', it was an incomprehension born of indifference rather than of intractability.[8]

The meagre references to Sisley in contemporary press reviews, and the characteristically summary nature of the exhibition's catalogue, prevent our knowing exactly which paintings he showed. Five are listed and one was *hors catalogue – Autumn: Edge of the Seine near Bougival* (D94; Museum of Fine Arts, Montreal). Almost certainly another of the exhibits was *The Ferry to the Ile-de-la-Loge – Flood* (D21; Plate 31), looking from the left bank of the river at Bougival across to the farm buildings and ferry mooring on the island. It is one of four recorded paintings of the Seine in flood in 1872 and was a view Sisley painted again three years later (ex-Daulte; Chicago, private collection). The tree and mooring post mirrored in the floodwater, and the swoop of rope across to the ferry house, increase the distance of the far bank and suggest the calamitous implications of the scene. But Sisley's unrhetorical temperament forbids him from emphasizing this element, as a painter of the previous generation might have done.

It is exactly this serene contemplation that lies behind the group of flood paintings of 1876, which are among his most enduring works.

Although the exhibition catalogue lists only one *Seine at Port-Marly*, a title that might suit any number of works of 1872–4, it is likely that *The Machine at Marly* (Plate 51) was the painting included. It is one of Sisley's undoubted masterpieces, daring in composition, perfect in its tonal control. It shows his increasing mastery in the painting of water, his judicious use of black, his love of repeated elements (windows, buttresses, barrage posts) to underline spatial recession and, in the warm, 'blond', tonal harmony of the central structure, his continuing devotion to Corot. It should not be forgotten, however, that Sisley was here painting a modern building, not, like Corot, the old houses of Volterra or the churches of the Ile-de-France.

The new machine house at Bougival had been completed a few years before in 1867 and was a popular site for Sunday visitors, who would marvel at its construction and picnic on the nearby river-banks. The 'Machine de Marly' was originally part of the great system of waterworks built for Louis XIV to provide aquatic spectacles at Marly and Versailles. Elements of the works (the machine, the aqueduct and the 'watering-place') were to provide Sisley with numerous motifs in the following years.

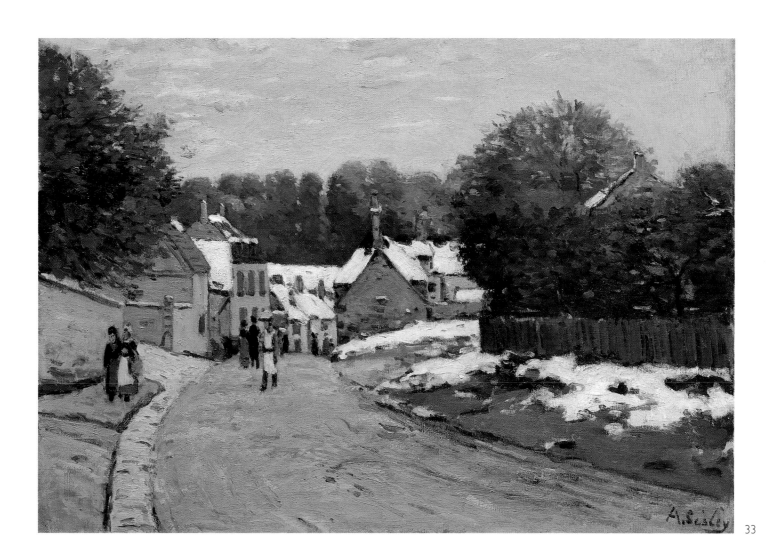

33

32 *Early Snow at Louveciennes. c.1871–2.*
 Pastel, 18.3 x 30 cm. Museum of Fine Arts, Budapest.

33 *Early Snow at Louveciennes. c.1871–2.*
 54 x 73 cm. Museum of Fine Arts, Boston.

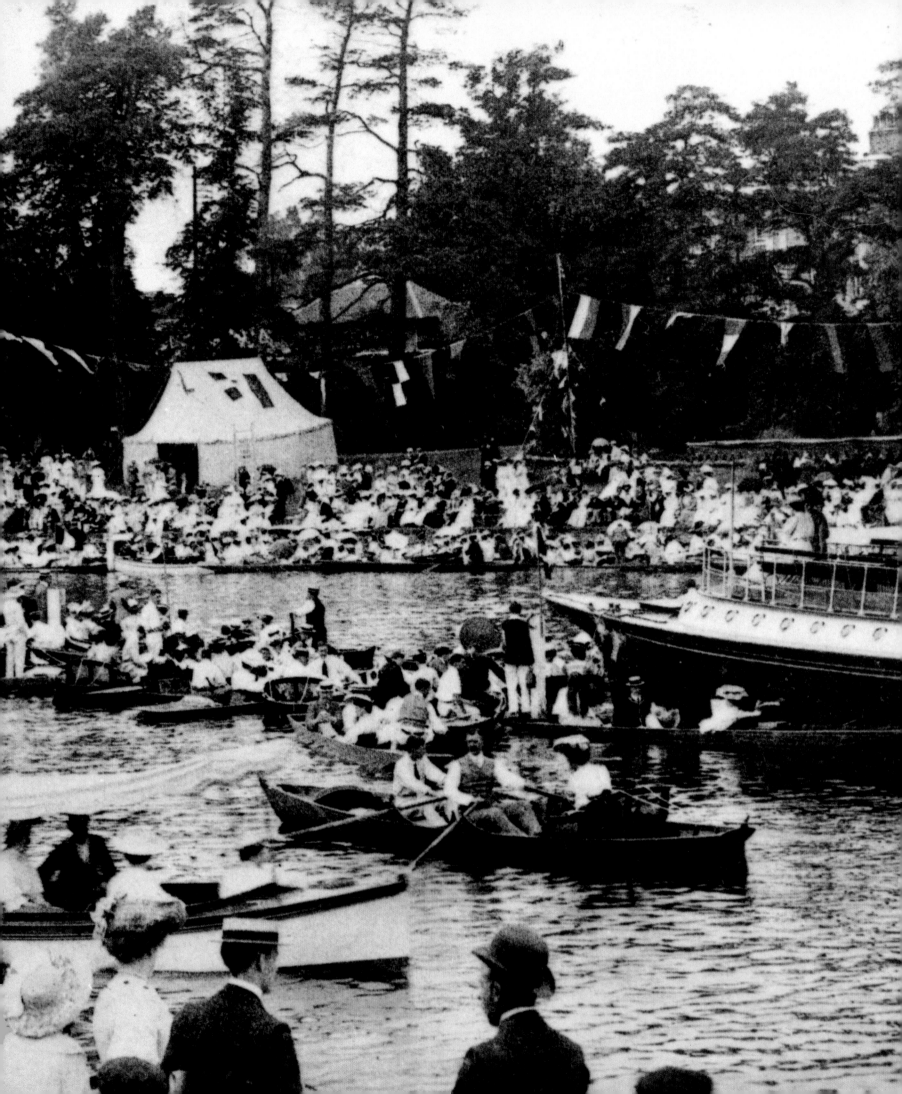

5 Hampton Court

Some weeks after the First Impressionist Exhibition closed, Sisley made his second visit to England. According to Théodore Duret, he was taken by the celebrated singer Jean-Baptiste Faure, who had engagements in London where he was a popular performer. It appears that the arrangement involved an exchange of a number of paintings in return for the expenses of Sisley's visit. Beyond the existence of seventeen paintings of Hampton Court and one of the river in central London, there is only one 'contemporary' reference to this productive visit. Sisley chose to mention it in a letter to Tavernier, surveying his career: 'I spent several months at Hampton Court, near London, where I did several important studies. I am not sure if you know it, it is a charming place.' (See Appendix B.) Faure's enlightened patronage paid off: in the Hampton Court series Sisley achieved, as Kenneth Clark was later to write, a 'perfect moment of Impressionism', paintings probably unmatched for their 'complete naturalism and truth to a visual impression, with all its implications of light and tone'.[1]

Jean-Baptiste Faure (1830–1914) was one of the great early supporters of Manet and of the Impressionists, especially Sisley, whose work he continued to purchase into the 1890s. In 1859 he was appointed principal baritone at the Paris Opéra and over the following years established himself as a singer of international fame. His earliest purchases were works of the Barbizon artists, many of which he sold in 1873;

he had become captivated by the new painters on the books of his friend Durand-Ruel – during the Franco-Prussian War they had been neighbours in Brompton Square, Knightsbridge – and he began to buy his first paintings by Monet, Pissarro and Sisley. He bought Sisley's *The Bridge at Villeneuve-la-Garenne* (Plate 35) for the respectable sum of 360 francs from Durand-Ruel on 15 April 1873.[2] In the later 1870s, when times were particularly hard for his favoured artists, Faure could often be relied upon to stave off a pressing financial crisis. At the end of his life, Monet told an amusing story which illustrates Faure's generosity and the terrible straits of the painters:

> I rang his doorbell one morning, with my landscape under my arm. The servant opened the door and said to me: 'You're out of luck, Monsieur Monet has just left.' He took me for Sisley. At that time we were often mistaken for each other, and Sisley and I were amongst Faure's most persistent visitors and he paid us 100 francs for a painting.[3]

Eventually Faure owned nearly sixty paintings by Sisley from all periods of his career, the proof of his admiration and, it must be added, his shrewd speculation.

Sisley's visit to England probably lasted from sometime in June to early October. On either side of this period are early

34 **Previous page**
East Molesey regatta in 1913.

35 *Bridge at Villeneuve-la-Garenne.* 1872.
49.5 x 65.4 cm. Metropolitan Museum of Art,
New York.

68

summer and autumn paintings of Louveciennes; and one of the London paintings is traditionally subtitled *First Days of October* (D122). No doubt Sisley visited relations while he was in England, such as his cousin Charles Towers Sisley who was living in Lewisham. It was almost certainly on this visit that the younger cousin (a lawyer) found that Alfred was 'hard to get on with' and that 'they had little in common'.[4]

Apart from one painting of the Thames in central London, all the rest of Sisley's subjects were found at Hampton Court and its immediate riverside vicinity of East Molesey.[5] From the viewpoint adopted in at least two of Sisley's paintings (D123 and D125; Plates 37 and 41), it is possible to deduce that he stayed in the old-fashioned Castle Inn with its long riverside terrace and landing-stage (its side is shown in Plate 39; ex-Daulte). The view from the terrace of the inn looked across the river to Hampton Court Palace, screened by trees, and the substantial Mitre Hotel (as seen in D123 and the photograph on page 70).

While Sisley was surrounded mainly by seventeenth- and eighteenth-century buildings and open country along the East Molesey bank, the bridge at Hampton Court was flagrantly modern, even to its castellated approaches at either end (Plate 39). Its five spans of wrought-iron girders supported by paired brick and cast-iron columns (seen close-up in Sisley's most radical composition, D124; Plate 44) had been designed by a well-known engineer, E. T. Murray; the

bridge had been opened on 10 April 1865, nine years before Sisley's visit; 'ugly' was the word most frequently used to describe it. In style and relative date it was comparable to some of the new Seine bridges painted by the Impressionists in the 1870s in Argenteuil and Chatou.

In *Bridge at Hampton Court* (Plate 37) Sisley viewed it along its downstream side, thrusting into the painting, its mass balanced on the right by the great clump of trees echoing the cumulus clouds of the summer sky; two double sculls emerge from under the shadow of the bridge where boats have been propped against the furthest arch; strollers and sightseers watch from the bank, some of the women holding parasols in the breezy sunshine. The composition is close to the view of *Villeneuve-la-Garenne* (Plate 35) of two years before, but the surface of the earlier painting is smoother and its contrasts of colour more biting. In *Bridge at Hampton Court* Sisley is even more succinct in his dashed-in, impetuous handling of figures and boats, the river more complex in its reflections. An overall simplicity informs the whole design – from the minutiae of his motif through to the spatial allure of its grandly conceived components. It is among his great achievements.

Throughout this unfaltering period Sisley is often at his most convincing when a substantial, man-made structure contrasts with a surrounding fluidity of foliage, water and sky. He can situate such features with a breadth of formal

35

36 **The third bridge at Hampton Court, in the 1920s.**

37 *Bridge at Hampton Court.* 1874.
45.7 x 61 cm. Wallraf-Richartz Museum, Cologne.

36

70

control, retaining their weight and solidity, and at the same time allow them an existence that is purely dependent on light and air. He holds in suspense the physical permanence of buildings and the transitoriness of their immediate conditions, lightly suggesting all the symbolic overtones of so fragile an equation. He never shouts or dramatizes, never tries to appear more interesting than he is (as Courbet and Monet sometimes do). Sisley possesses those qualities of lyrical detachment and frank regard for the visual purity of his subject that substantiate his position alongside Constable and Corot in nineteenth-century landscape painting.

At the same time, it is obvious from the Hampton Court paintings that Sisley was celebrating, in his fastidious way, aspects of up-to-the-minute daily life that delighted him. The pair of regatta paintings (D125 and D126; Plates 40 and 41) are brilliant contributions to early Impressionism in their unusual design, striking contemporary note and synoptic handling of paint. In *Regattas at Molesey*, which appears to show the start of a rowing-eights' event opposite the new hotel on Tagg's Island in mid-Thames, spectators have gathered on the bank or in launches moored alongside; yachting ensigns, a Union Jack and rowing-club colours are among the flags (the black-and-white of the Molesey Boat Club can be seen on the nearside flag at the left). White-clad officials are in attendance, one of them looking at his watch before the start. The traditional perspective of Sisley's design

is countered by the three flags strung across the sky, a bold spatial device throwing the composition into animated relief. Such an idea was first adumbrated among the Impressionists by Monet in his paintings at Ste-Adresse (1867) and Trouville (1870); it is here carried off by Sisley with exuberant panache against his mobile green and violet sky.[6]

A further aspect of Sisley's work which is at its freshest in some of these Thames-side paintings is his continually varied approach to an emphatic geometric division of his canvas. Below a conventionally placed horizon line, allowing two-thirds sky, one third land and water, Sisley compresses a finely segmented design of river, path and bank with an engaging counterpoint of fences, bollards, mooring posts and flag-poles (Plate 47). The foregrounds are frequently wide open (allowing Sisley scope for the beautiful peach-ochre colour of the sandy tow-path); perspectives rush backwards, animated by these man-made demarcations and briskly annotated figures. They work on the surface as spatial markers and accents of colour; at the same time, they act as abbreviated pointers to organized sport and leisure, around which flow the more spontaneous ingredients of a society at ease.

These paintings of the Thames were almost the last Sisley made of a river as a place of conspicuous leisure. In physical terms Hampton Court and Molesey were to London what Bougival and Port-Marly were to Paris. However, the festive holiday mood of several of the English paintings finds little

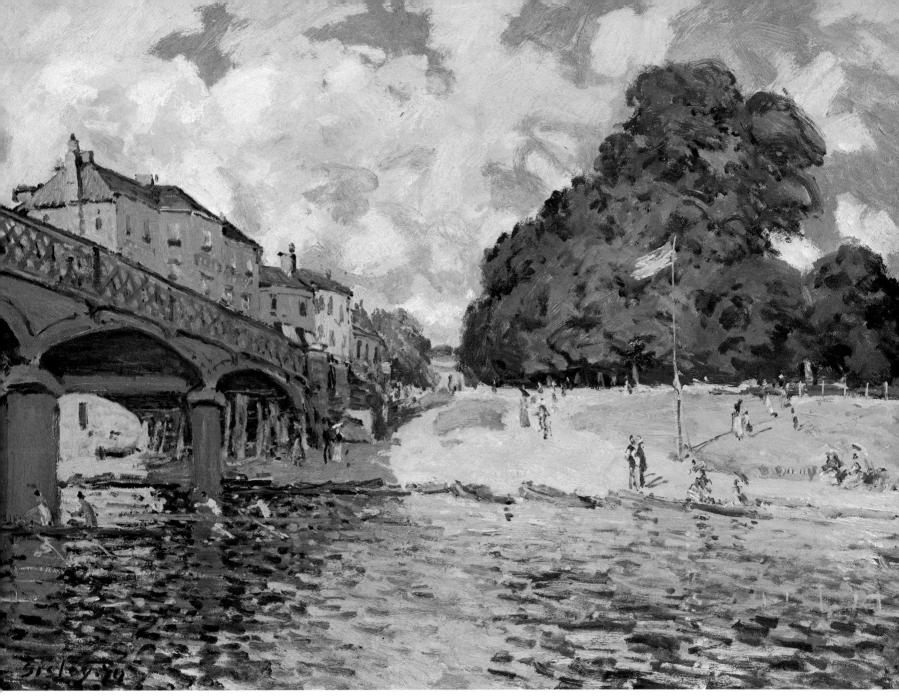

38 **Tagg's Island and Hotel, East Molesey, 1901**

39 *Inn at East Molesey with Hampton Court Bridge.* 1874.
 51 x 68.5 cm. Private Collection.

40 *Regattas at Molesey.* 1874.
 66 x 91.5 cm. Musée d'Orsay, Paris.

 Detail following page
 Regattas at Molesey. 1874.

41 *Regatta at Hampton Court.* 1874.
 45.5 x 61 cm. Fondation E.G. Bührle Collection, Zurich.

38

72

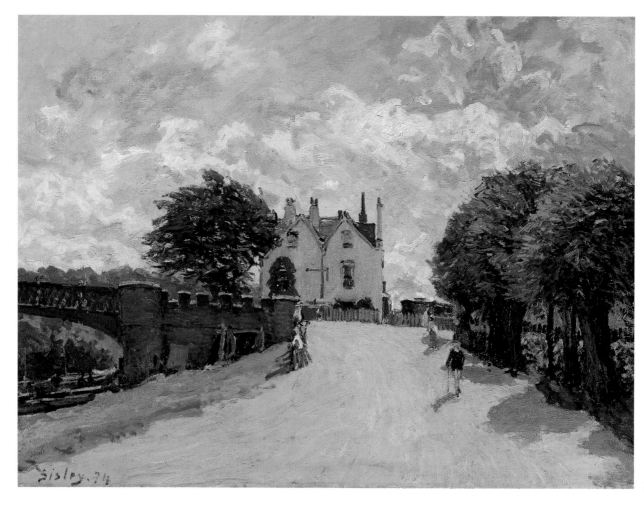

39

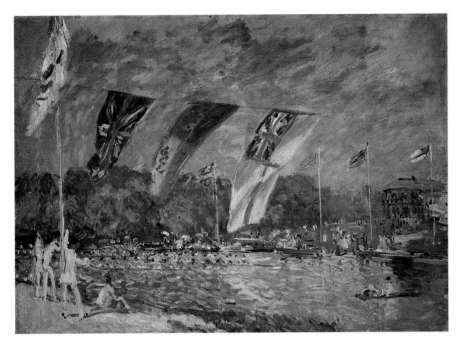

40

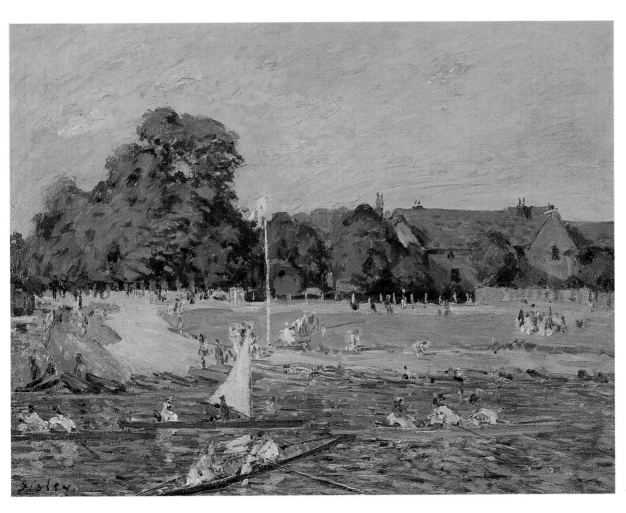

41

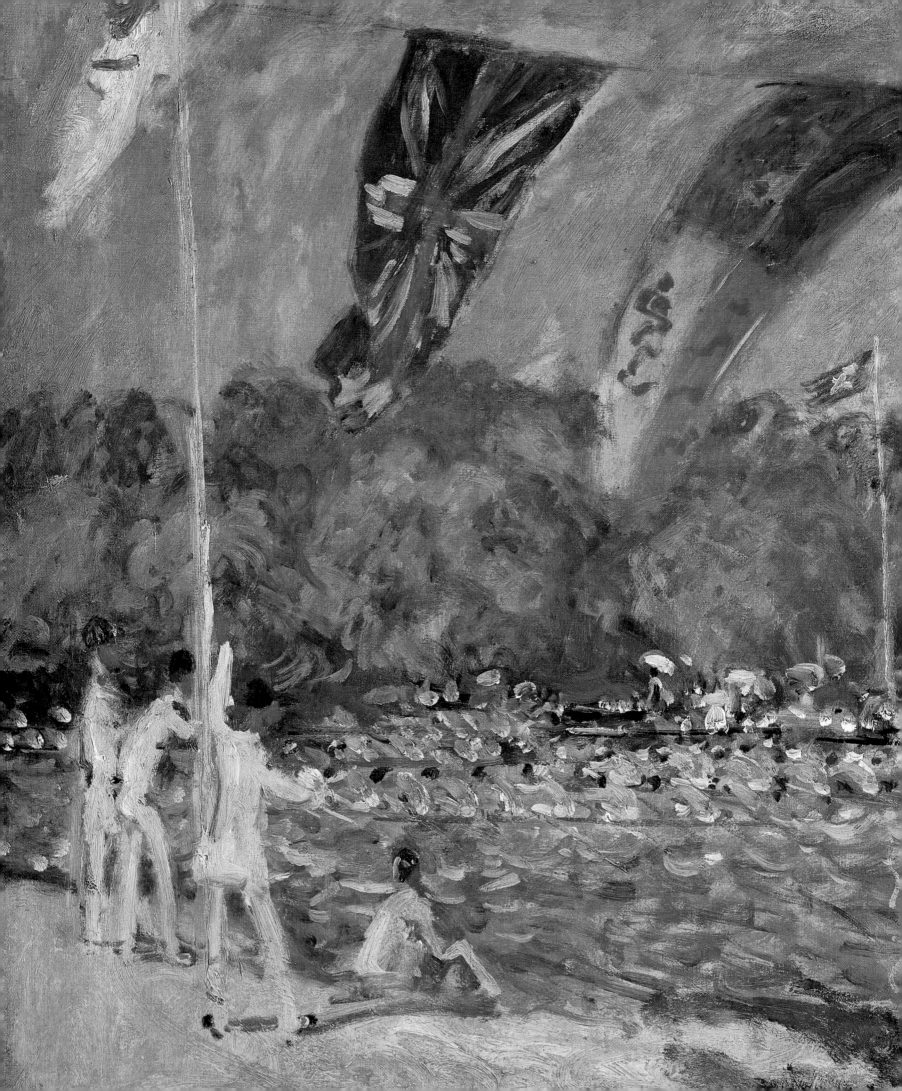

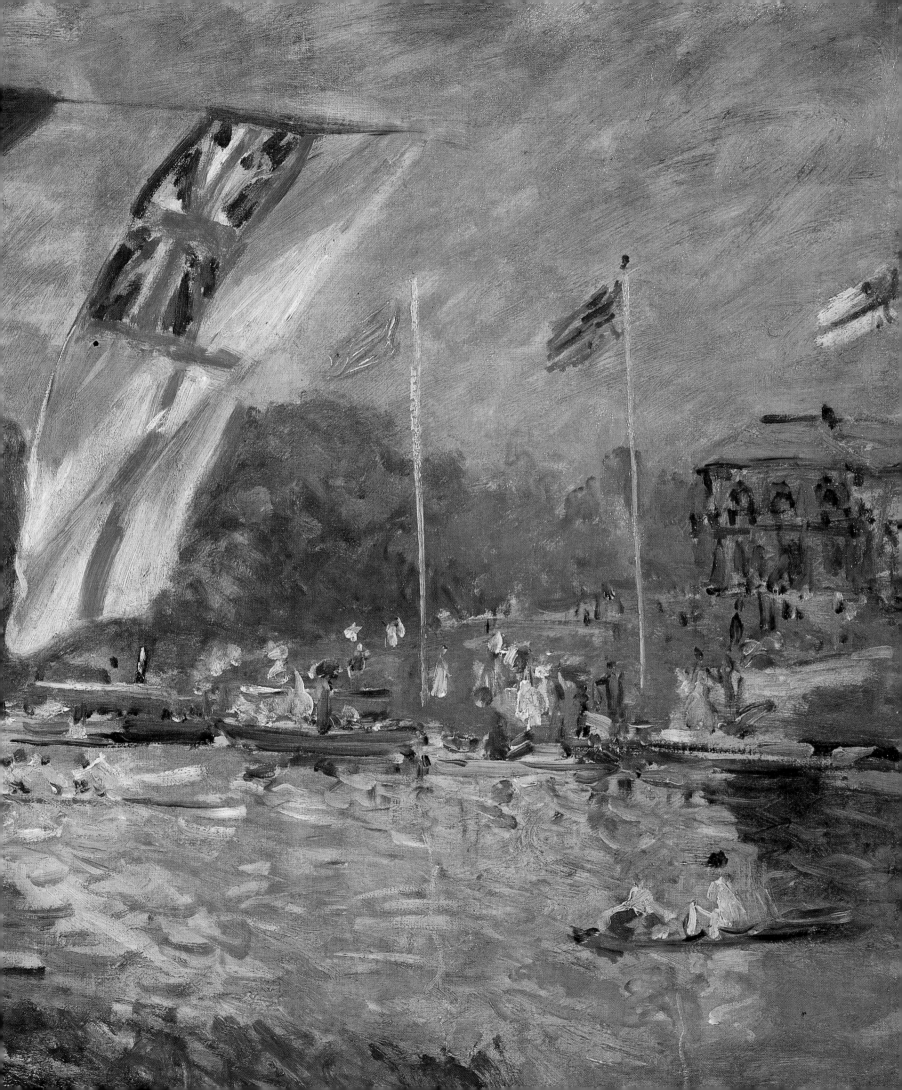

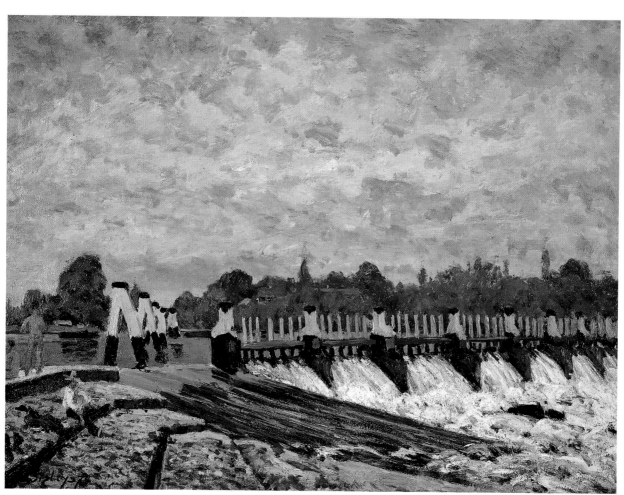

42

Molesey Weir. 83

43

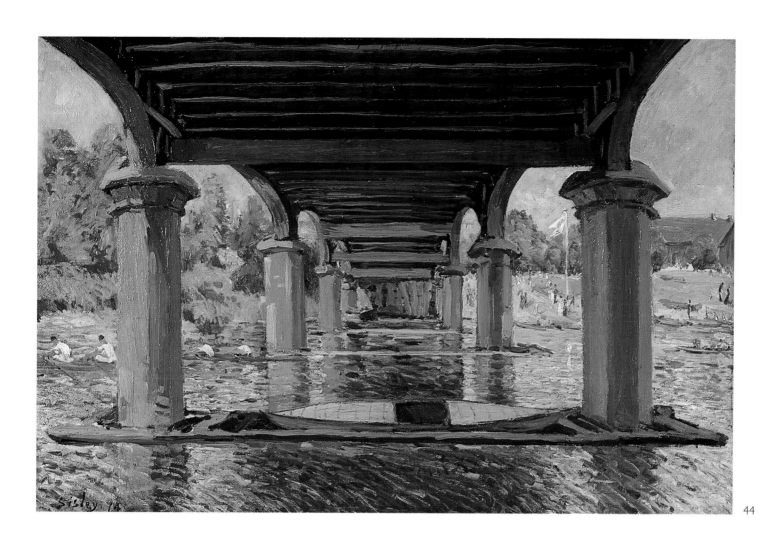

44

77

42 *Molesey Weir – Morning.* 1874.
 50 x 75 cm. National Gallery of Scotland, Edinburgh.

43 **Molesey Weir**

44 *Under the Bridge at Hampton Court.* 1874.
 50 x 76 cm. Kunstmuseum, Winterthur.

78

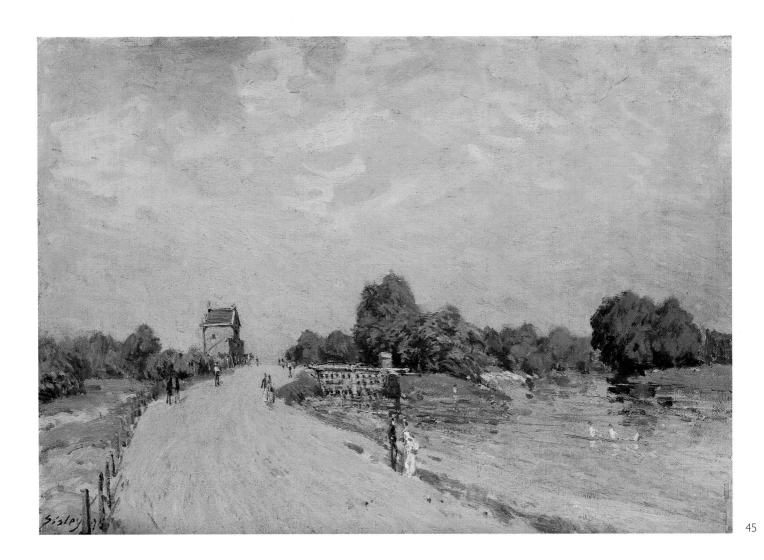

45

46

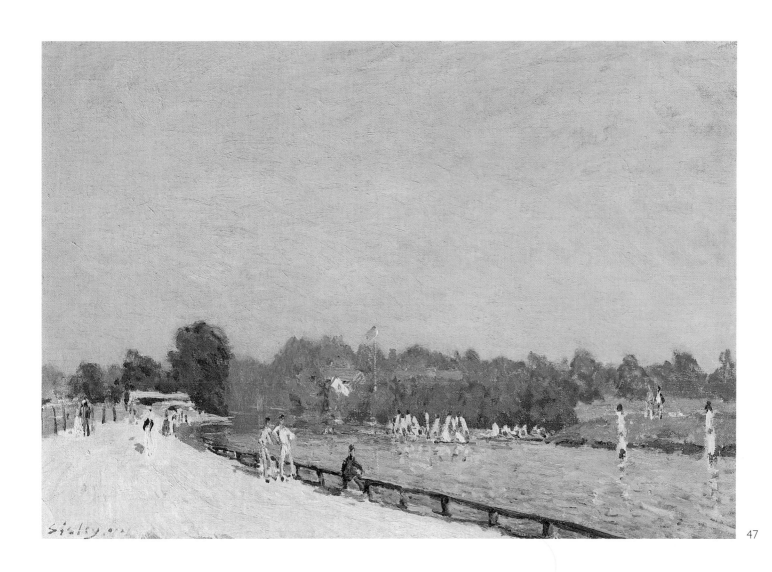

47

45 *The Road from Hampton Court*. 1874.
 39 x 55.5 cm. Neue Pinakothek, Munich.

46 *The Thames with Hampton Church*. 1874.
 50 x 65 cm. The Earl of Jersey.

47 *The Road from Hampton Court*. 1874.
 38.5 x 55.5 cm. Private Collection.

48 **Pierre-Denis Martin.**
View of the Château de Marly. c.1700.
Musée National du Château de Versailles.

48

80 reflection in his views of the Seine, even though it was synonymous with weekend boating, picnics, riverside restaurants and sightseeing. Sisley was far more drawn to the arterial commerce of the Seine and its quayside activities, from sand-dredging to boat-building, from fishermen drying their nets to the moored wash-houses for the village women.

As a painter of landscape rather than people, Sisley shied away from the essentially figurative subjects that entranced Renoir at La Grenouillère or inspired Manet in his Argenteuil paintings; on the other hand, he did not have a professional interest in yachting and pleasure boats, as had his friend Gustave Caillebotte. But in this context it is worth remembering Sisley's ancestors, and their long association with cross-Channel smuggling and trade, in which boats were an essential ingredient in their risky way of making a living. Sisley himself was obviously both visually enamoured of day-to-day riverside life as well as being knowledgeable about all its aspects. Visiting him years later the critic Gustave Geffroy noticed, as they spent time by the river near Moret, the painter's response to 'the life of people along the riverside, the boatmen, and all who passed in their heavy vessels pursuing a nomadic and Bohemian existence on the water' – all commented on with 'such insight and flair'.[7]

When Sisley returned to his family in Louveciennes in autumn 1874, one of the first paintings he made was *The Aqueduct at Marly* (D133; Plate 50); this structure was

a reminder, like the 'Machine de Marly', of the days when much of the area was dominated by court life and the visual splendours of the Château de Marly and of nearby Versailles.

The aqueduct was part of a complex system which channelled water from the Seine to furnish the pools, fountains and cascade in the park of the Château de Marly. It makes an appearance in innumerable Impressionist paintings and had, indeed, been pictured frequently in the past. As a stupendous hydraulic undertaking, it had long been a spectacular attraction of the area. It was built between 1682 and 1684 to a design by Arnold de Ville, and was thus contemporary with the Machine, serving Versailles as well as Marly. Water from the Seine was pumped through the Machine, and conveyed by pipes up the steeply wooded hillside above Bougival to the aqueduct, whose thirty-six arches carried the water in conduits to the route de Marly. Here the flow went underground to emerge as a great aquatic spectacle, from the 'Grande Cascade' behind the château to the descending pools and fountains of the park in front.

At the height of their operational glory, the aqueduct and the waterworks in the Parc de Marly were depicted in panoramic paintings that combined royal homage with topographical information. One of the finest of these is Pierre-Denis Martin's aerial view (Plate 48), with the 'Abreuvoir de Marly' (the 'watering-place') in the foreground, just outside the park itself, the mechanics of the spectacle

49 **J.M.W. Turner.** *The Machine de Marly. c.*1831.
Watercolour. British Museum, London.

49

being kept well out of sight. In the early nineteenth century foreign visitors flocked to see the remains of the enterprise. Thomas Girtin was among them, and drew both the aqueduct and the Machine in 1803. Later, Turner made a watercolour of the Machine with a fashionable crowd of people on the bank of the Seine (*c.*1831; British Museum; Plate 49). In early works by Renoir, Monet and Pissarro, the aqueduct straddles the distant hills, just one element in a landscape famous for reminders of its royal past.

By the time Sisley moved to Louveciennes, the aqueduct had been out of action for several years – since 1866 in fact; the demolition of the Château de Marly earlier in the century by its owner, a business man who found he had a massive white elephant on his hands, was followed by the relative neglect of the park. The old machine building had been replaced in the early 1850s by Dufrayer's pumping house (seen in at least eight of Sisley's paintings, including D67; Plate 51), which continued to draw visitors to the area (even Queen Victoria came from Versailles to see it in 1855).[8] The park and aqueduct had assumed an air of forlorn abandonment, although the latter's important strategic role in the recent war (the Prussians had installed artillery on the Tour de Levant at the eastern end of the aqueduct – seen at the right in Sisley's painting) had boosted its attraction for tourists.[9]

Sisley positioned himself on the main road, the route de Versailles, a ten- or fifteen-minute walk from his home. His vision of the receding arches against a very blue autumn sky eschews all the aqueduct's complex historical associations. A lone cuirassier passes by among the long evening shadows. Sisley refuses to force the note and presents a view of the structure, as though seeing it for the very first time. Simultaneously, through his contrast of brilliant blue and pinkish-ochre, offset by the dark trees, their foliage beginning to turn with the season, Sisley impressively suggests the physical splendour of the structure with its 'beautiful arcades, which give a distinct Italian quality to the landscape', as well as its solitary neglect at the edge of Louveciennes's populous market gardens.[10]

82

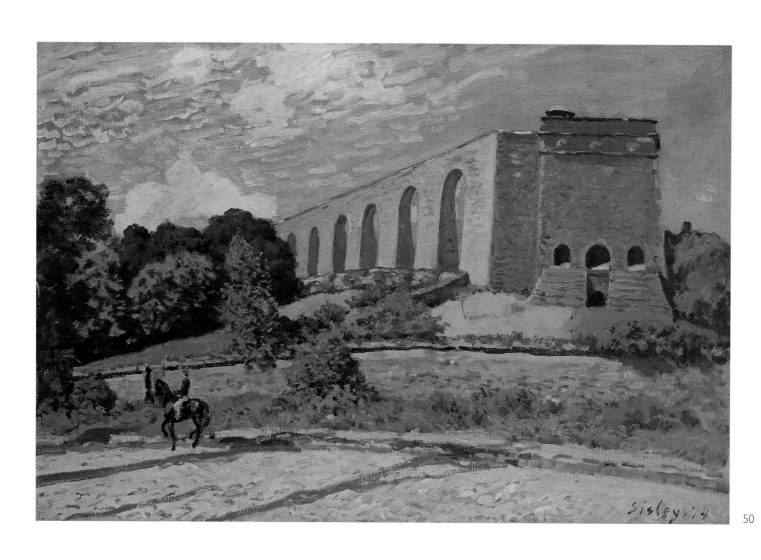

50

50 *The Aqueduct at Marly.* 1874.
 54.3 x 81.3 cm. Toledo Museum of Art.

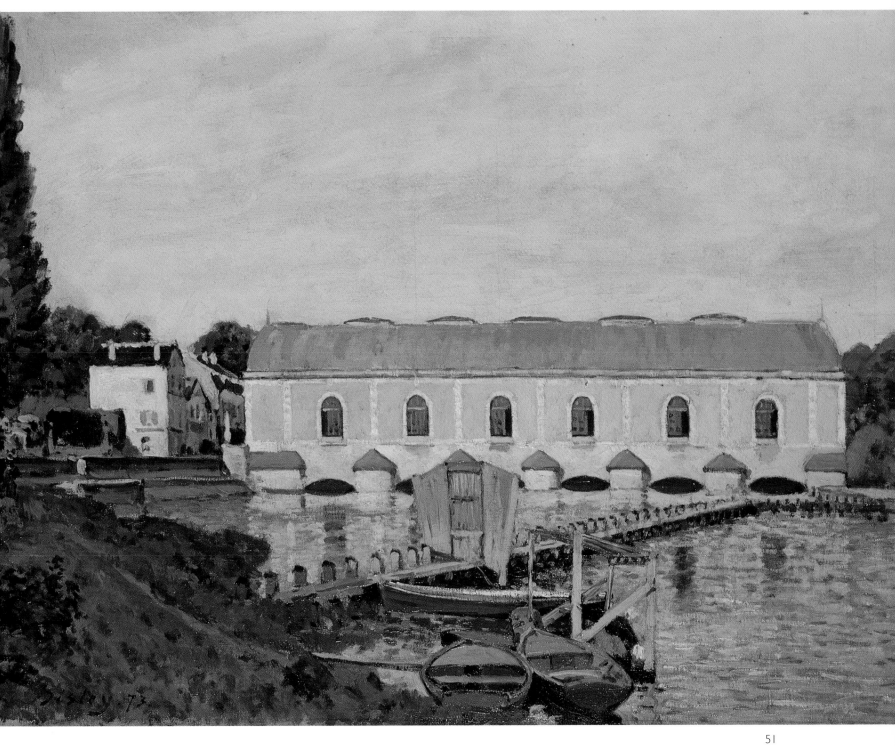

51

51 *The Machine at Marly.* 1873.
45 x 64.5 cm. Ny Carlsberg Glyptotek, Copenhagen.

6 Marly-le-Roi in Snow and Flood

'Leaving Louveciennes, I made my home for two years at Marly, a stone's throw from Louveciennes, where I made some studies of the watering-place and the Park.' These few words of Sisley's to Tavernier (see Appendix B) summarize, in the artist's characteristically modest way, his work at Marly-le-Roi, the period of some of his greatest landscapes. He maintained an extraordinary level of achievement, culminating in the 1876 series of the flooded Seine at Port-Marly.

During these years the Impressionists produced a sequence of dazzling masterpieces – Monet's series of the Gare St-Lazare, Renoir's *The Swing* and *Dance at the Moulin de la Galette*, Morisot's *In the Wheatfield* and Pissarro's paintings of Pontoise such as *The Red Roofs*. Sisley's views of the watering-place (Plates 53, 55 and 56) and the flooded riverside street of Port-Marly (Plates 76, 77 and 79) belong unquestionably by their side.

Although the date of Sisley's move from Louveciennes to the nearby village of Marly-le-Roi is not known, it is signalled by a group of paintings of his new neighbourhood made in the first wintry weeks of 1875. Perhaps he had tired of Louveciennes, or come to the end of the lease of his house, or found cheaper accommodation in Marly. Whatever the reasons, the family moved to 2 avenue de l'Abreuvoir, where they stayed for the next two years.[1] No documentary evidence confirms this address but there are at least two paintings made from an upper window of the house, which was set back from the busy avenue, looking towards the nearby watering-place.

Over the following two years Sisley painted almost every aspect of his surroundings, from the high spire of Marly's twelfth-century church to its encircling woods. The lie of the land and its network of roads provided a consistent backdrop to the minutiae of walls and shutters, passers-by, birds in the snow, geraniums in a window-box. He was an indefatigable walker, and must have become a familiar figure in every quarter of the district, setting up his easel in the streets and paths of the village, under the high walls of the Parc de Marly, by the main road or in the place de l'Abreuvoir. He was undeterred by snow and ice, though in such conditions he tended to stay within a stone's throw of his house. Early in 1875, for example, he painted on the avenue de l'Abreuvoir (e.g the mistitled painting, now in the Courtauld Institute Galleries, D150). Looking in the opposite direction, he painted the frozen watering-place and the snow-covered côte du Cœur-Volant running along the edge of the park (D152; Plate 55).[2] In *Winter's Day at Marly-le-Roi* (D154; Plate 54), Sisley looks more to his right, over the watering-place and up the avenue des Combattants skirting the buttressed wall of the park to its left.

In the spring and summer months he naturally went further afield, particularly to Bougival (D176, D177; Plates 61 and 62), the hillsides above the river (D180; Plate 65) and,

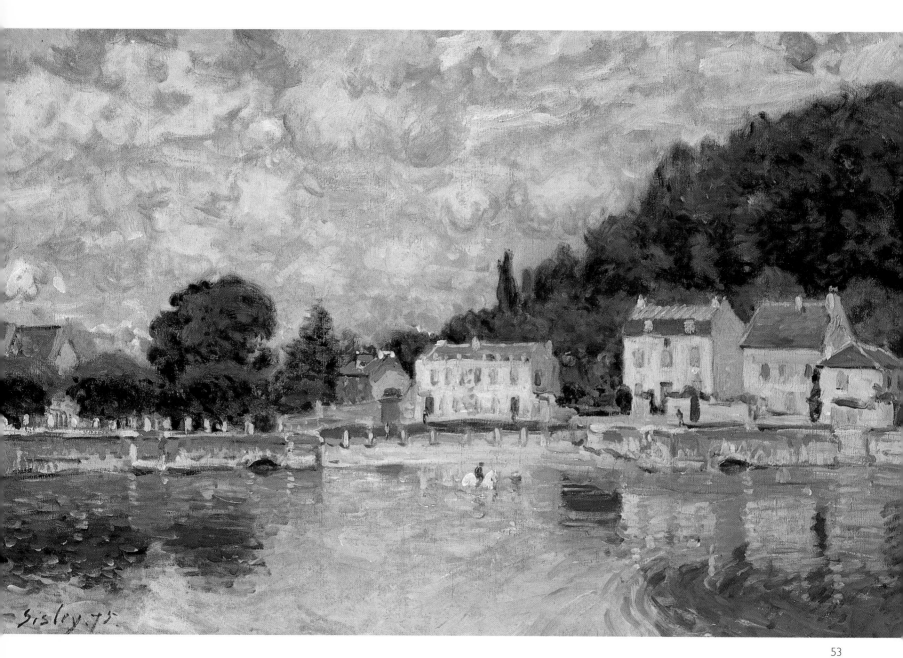

52 **The Watering Place at Marly-le-Roi, in about 1900.**

53 *Horses Being Watered at Marly-le-Roi.* 1875.
38.5 x 61.5 cm. Foundation E.G. Bührle Collection, Zurich.

54 *Winter's Day at Marly-le-Roi.* 1875.
50 x 65 cm. Private Collection, New York.

55 *Watering-Place at Marly-le-Roi.* 1875.
50 x 65.5 cm. National Gallery, London.

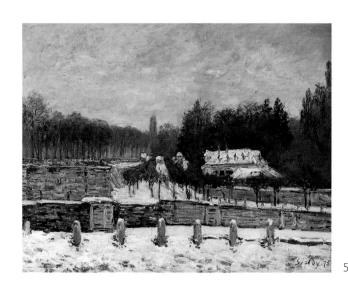

54

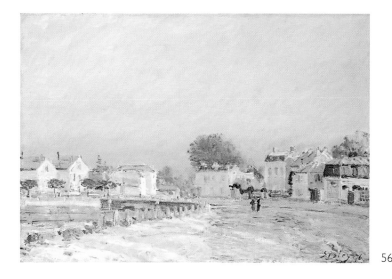

56

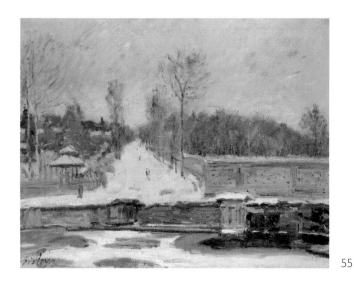

55

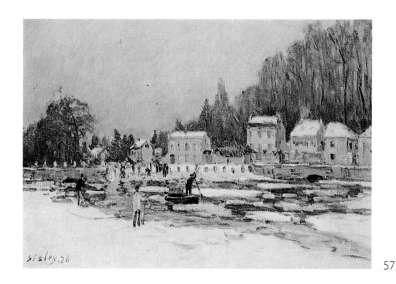

57

56 *The Watering Place at Marly in Hoarfrost.* 1876.
 37.8 x 54.9 cm. Virginia Museum of Fine Arts, Richmond.

57 *Breaking of the Ice, Watering Place, Marly.* 1878.
 38 x 55 cm. Private Collection.

58 *Fête Day at Marly-le-Roi* (formerly *The Fourteenth
 of July at Marly-le-Roi*). 1875.
 54 x 73 cm. Cecil Higgins Art Gallery, Bedford.

 Detail following pages
 Fête Day at Marly-le-Roi (formerly *The Fourteenth
 of July at Marly-le-Roi*). 1875.

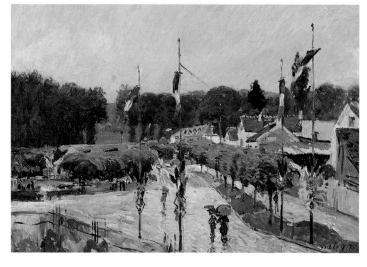

58

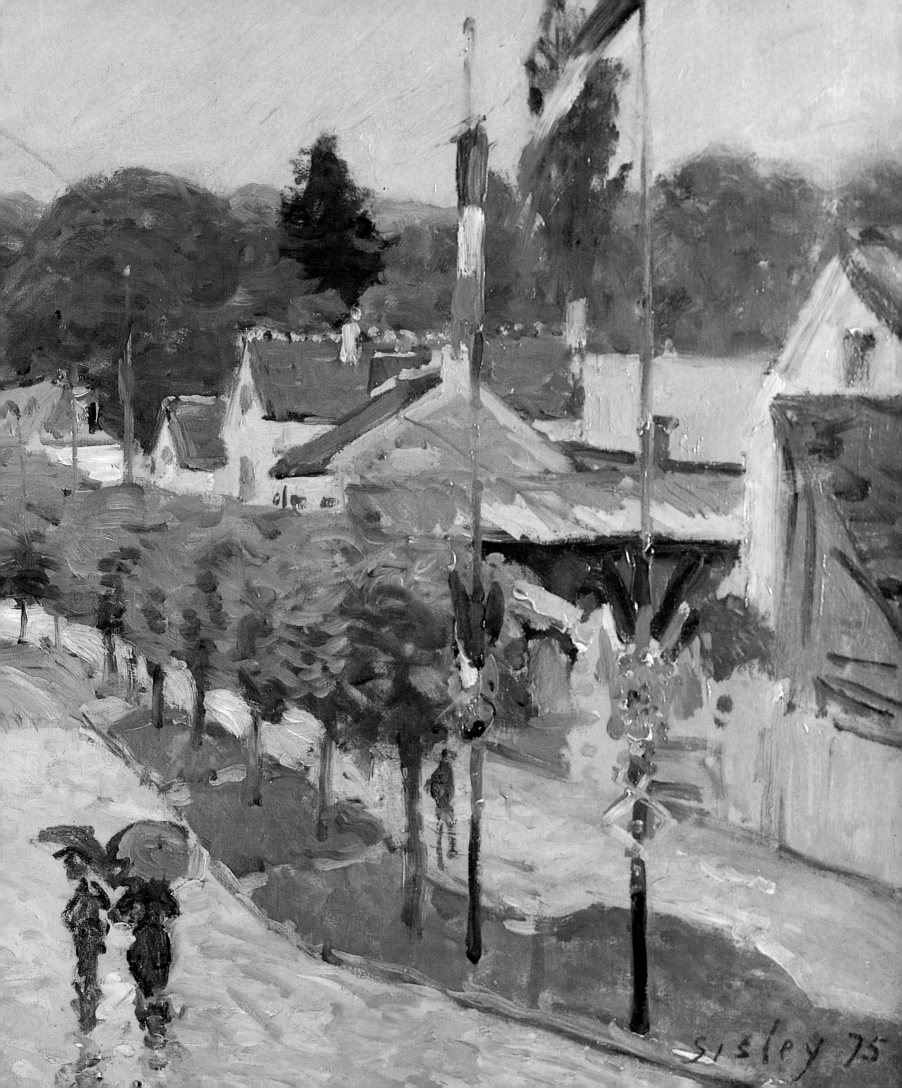

59 *View of Marly-le-Roi – Sunshine*
 (formerly View of St-Cloud). 1876.
 54.2 x 73.2 cm. Art Gallery of Ontario, Toronto.

60 *View of Marly-le-Roi from House at Coeur-Volant.* 1876.
 65 x 92 cm. Metropolitan Museum of Art, New York.

though still close to the watering-place, into the hamlet of Cœur-Volant between Marly and Louveciennes. In *View of Marly-le-Roi from House at Cœur-Volant* (D208; Plate 60) he shows the secluded property of a well-known singer, Robert Le Lubez, which afforded a view of Marly in the distance; the painting is one of those combinations of close foreground and far horizon that provoked Sisley to some of his most subtle depictions of changing air and light.[3]

Throughout this period Sisley steadfastly avoids the commonly acknowledged picturesque sights extolled in period guidebooks. He does not paint the pretty church, for example, or the neighbouring florid mansion (complete with orangery) of the playwright Victorien Sardou. He goes, instead, into the forge at Marly (48 Grande-Rue) to produce one of his most unusual paintings (D183; Plate 64), rare enough in being an interior, but a deep shadowy-blue interior lit from the dusty window and by the vermilion fire of the forge itself. Again, when he looks towards La Grenouillère, the scene of Renoir's and Monet's important paintings of 1869, it is closed for the winter, an insignificant structure at the edge of the Ile-de-Croissy, no better or worse than the prosaic wash-house in the foreground.

When he takes a fête day for his subject, it is raining, and he paints, from the window of his house, the limp Republican flags in front of the site of the demolished château (D170; Plate 58). It is inconceivable that Sisley would have made any

political point in his paintings; they are almost arrogantly aloof from any such message – political, social or auto-biographical (in any narrative sense) – and remain, in the old-fashioned use of the word, 'pure' paintings. That they touch on general aspects of contemporary life is undoubtedly true, but Sisley seems to have been equally content to paint the most rural, untouched aspects of nature, as he was to depict a sporting weekend at Molesey, a metal footbridge clouded in train smoke or boats in a strike on the Loing Canal. Even so, in *Fête Day at Marly*, the implications of the scene could hardly have been lost on him (English though he was), as he contemplated the ghostly swathe between the distant trees and remembered the extravagance of 'les Marlys' nearly two hundred years before.

The watering-place itself, screened by the row of young lime trees to the left in *Fête Day*, provided Sisley with the subject of nearly twenty paintings during his years at Marly – in brilliant sunshine, on a breezy summer day, or in deep winter. Throughout the 1870s he made pairs or small series of paintings of the same motif, usually in different weather conditions, sometimes viewed from a slightly new angle. Although he never took this procedure to the extremes espoused by Monet, Sisley was obviously interested in the changes to a subject brought about by seasonal variation and different times of day. His adjusted viewpoints enabled him to discover unsuspected felicities of composition; he

59

60

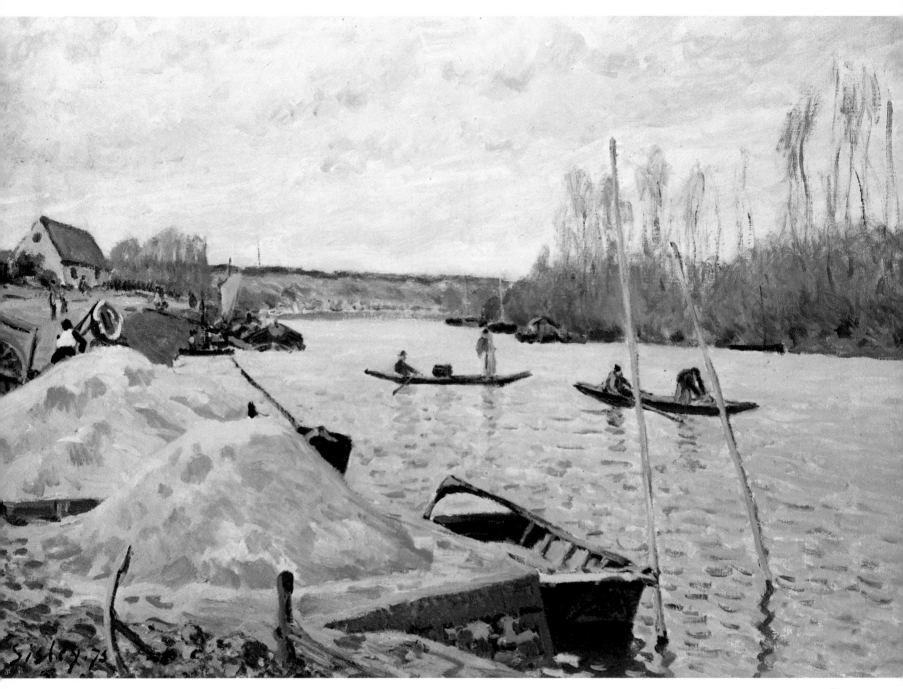

61 *Sand Heaps.* 1875.
 54 x 73 cm. Art Institute of Chicago.

62 *Sand on the Quayside, Port-Marly.* 1875.
 46 x 65 cm. Private Collection.

63 **Port-Marly in about 1905.**

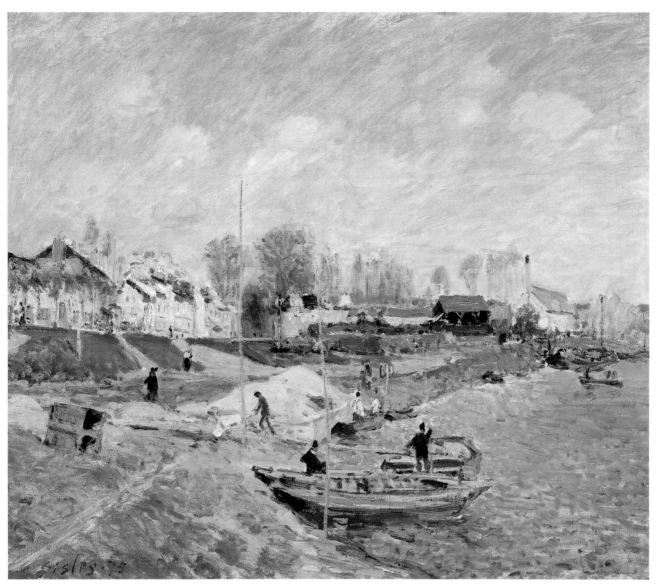

62

63

64

94

64 *Forge at Marly-le-Roi.* 1875.
55 x 73.5 cm. Musée d'Orsay, Paris.

65 *The Rising Path.* 1875.
65 x 50 cm. Private Collection.

pressed his design to different ends, adding or removing accents as the scheme demanded. It was only after his move to Moret in 1880 that Sisley began to make more consistent series of paintings in which the differences of light and weather are fully explored. In earlier years the differences are more strikingly seasonal, as in the two Louveciennes views of the chemin de l'Etarché (D95 and D146; Plates 68 and 67); another pair is of Madame du Barry's house in spring and under winter snow (D102 and D145; Plates 2 and 3). The latter picture is among the first of Sisley's long series of snow paintings from the 1870s.

It might be said of the Impressionists – Monet, Pissarro, Sisley – that they added the motif of the landscape under snow to the tradition of European painting. Of course, it had appeared before, particularly in Dutch seventeenth-century art (in Avercamp and Van der Neer, for example) and earlier in Bruegel, but its occurrence was fitful and examples are rare. In the earlier nineteenth century, the summer months were the province of the landscape painter; one finds, for example, Constable suffering from a cold in winter while working on high-summer compositions of Salisbury. The Barbizon painters began to include snow scenes among their repertory of seasonal effects, but of the Impressionists' immediate forebears, Courbet was the artist with the most consistent interest in the subject.

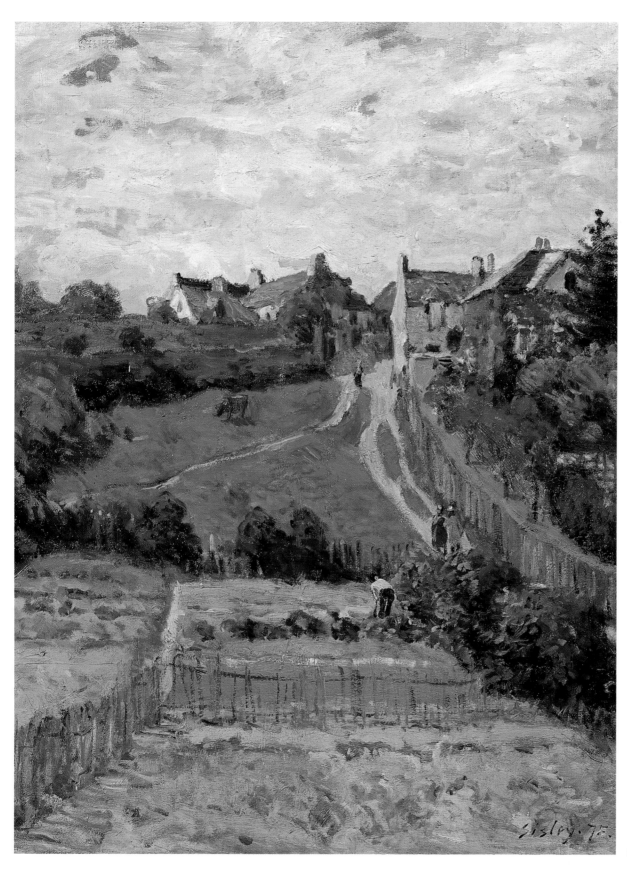

66 *Bougival*. 1876.
60 x 73 cm. Cincinnati Art Museum.

67 Following page
Snow at Louveciennes. 1874.
55.9 x 45.7 cm. The Phillips Collection, Washington.

68 Following page
Garden Path in Louveciennes (Chemin de l'Etarché). 1873.
64 x 46 cm. Private Collection.

The harsh winter of 1869–70 had drawn Monet and Pissarro out into the snow-covered route de Versailles in Louveciennes and two years later Monet made several views of Argenteuil under snow, including snow falling, a phenomenon unique to him among the Impressionists. Sisley's first depictions of Louveciennes under snow are of 1872; two seem to have been painted at the end of that year (D55 and D56) and purchased together by Durand-Ruel in February 1873.[4] Thereafter the artist seems to have taken advantage of several particularly snowy winters during the 1870s, culminating in the appalling freezing weather of 1879–80, when he painted by the Seine near Paris at the end of the year, and showed the subsequent floods at Moret in early 1880, after a terrible thaw.

Sisley painted snow in all its permutations – from the tentative first fall to the heavy, silencing blanket of deep winter, from the stale snow churned on a main road to melting slush in weak sunshine. Where Monet is the master of the *débâcle*, of the gliding ice-floe and desolated landscape, Sisley shows villages and gardens wrapped in inviolable silence, branches laden, skies thick with a further fall. His perfect sense of tone in the 1870s is nowhere better seen than in some of these grey-blues and wintry pinks, against sharp blue, pure white and malachite green (D193; Plate 69). The silhouetting of tree trunks, lone figures and receding fences give to such scenes their oriental delicacy. Once again Sisley

may have been inspired by Hokusai, among whose great prints of 1819–20 are several snow-bound landscapes such as the 'Village under Snow' from the *Hokusai Gwashiki*. But perhaps more to Sisley's taste were the prints of Hiroshige, with their infinitely subtle effects, rarely as dynamic as Hokusai's but to Sisley more engagingly lyrical and poised in mood. Not only are there parallels in atmosphere and feeling, but also obvious similarities of composition, as is made clear by a comparison between Hiroshige's *Evening Snow, Kambara* (*c*.1830–4; Plate 72) and Sisley's *Place du Chenil at Marly – Snow* (D196; Plate 70).

Even more refined are Sisley's several depictions of one of the weather's most fleeting moments: hoar-frost on a sparkling winter morning. Again, there are precedents (such as Turner's *Frosty Morning*) but adroit Impressionist handling allowed Sisley to capture this transitory state to perfection, as in the *Watering-Place at Marly – White Frost* (D244; Plate 56). Whether or not all these winter paintings were made outside in numbing cold is difficult to gauge. *Watering-Place at Marly* (D152; Plate 55) appears to have been swiftly painted in one go, with a few later additions, after the initial composition had dried.[5] For another view of the *Place de l'Abreuvoir* (D195) Sisley stayed firmly indoors, painting from an upper window in his house. After about 1881 snow scenes virtually disappear from his subject-matter, although there was a series of pastels of snow, often superb in quality (Plates 116,

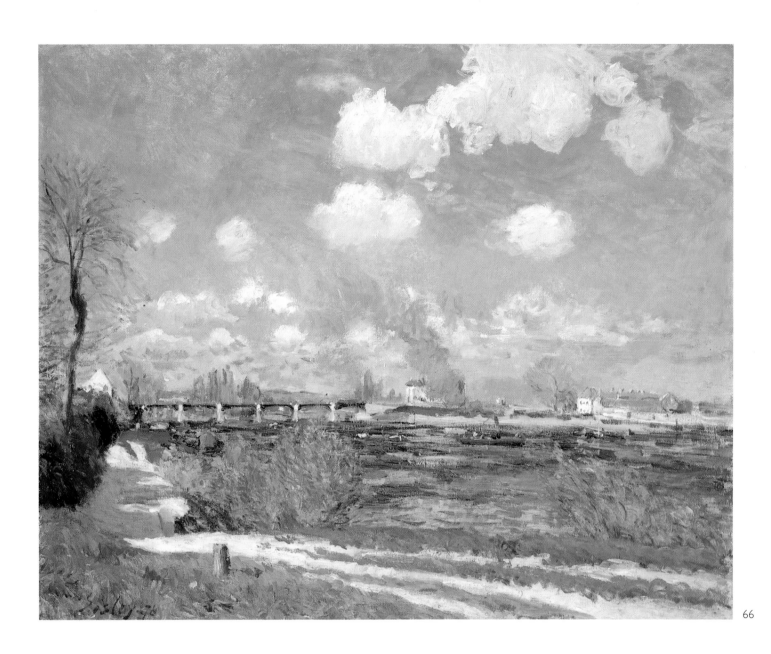

66

98

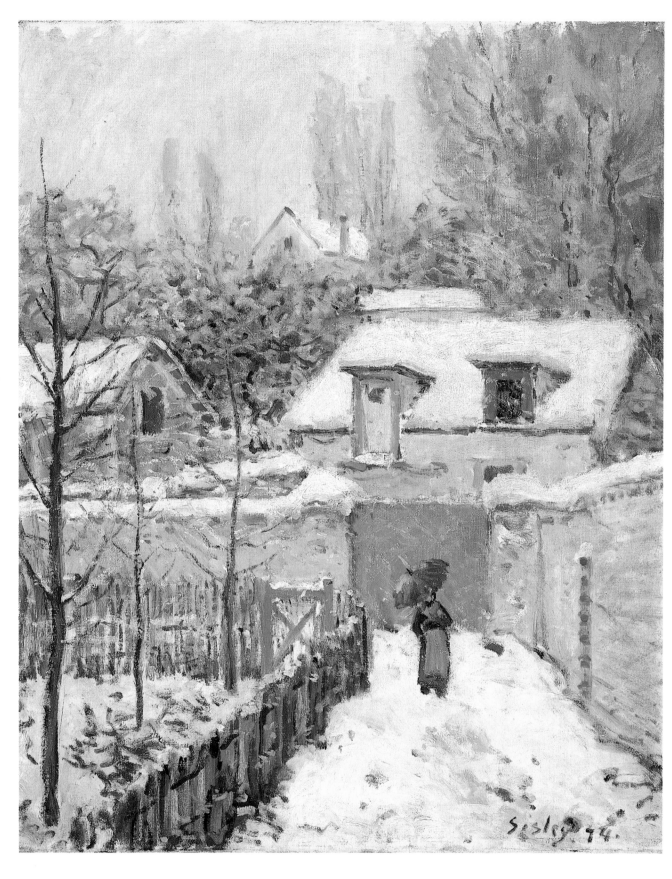

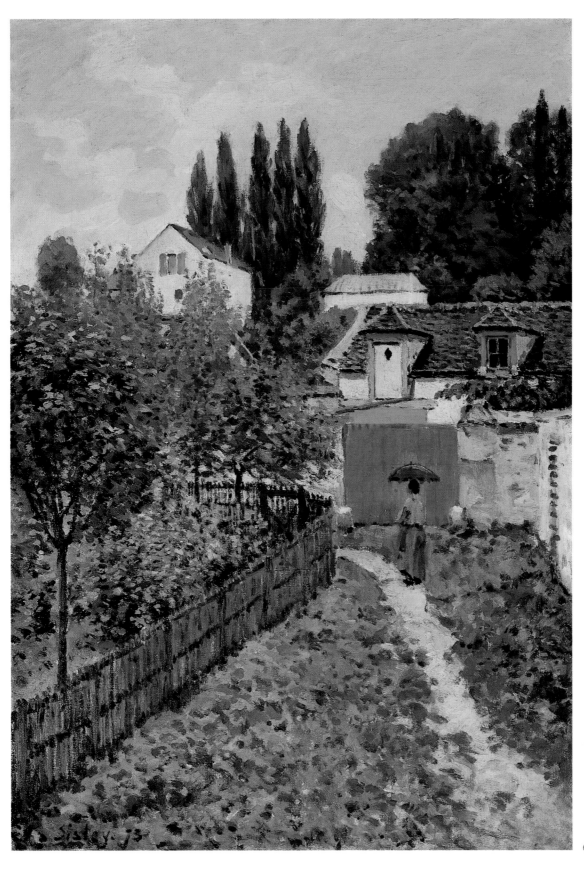

68

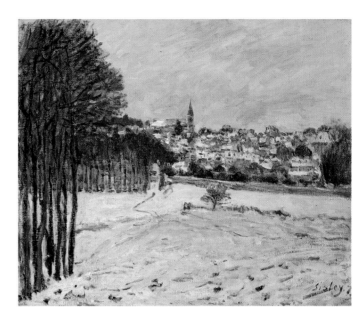

69

117 and 118) but, again, made from the protective vantage-point of a window in his house at Les Sablons.[6]

As a 'poet of the seasons', with an Englishman's passionate yet resigned interest in the weather, Sisley painted in all conditions. His investigative temperament seems to have known no bounds and, like Monet in this respect, though without his massive bravado, concern for his own comfort was of no account. There is hardly a seasonal moment from dawn to dusk that he did not attempt to capture. When, a little later, he began to paint in series, the sureness of his response to particular moments becomes even more marked. But at Marly he seems to have been so entranced by the variety of the landscape near at hand, that there was hardly time to concentrate over a long period on one motif to the exclusion of another. A painting such as the *Wood-Sawyers* (D230; Plate 73) is an example of a momentary sight, perfectly transfixed on a bright autumn morning in 1876. The scene is a few minutes' walk from his home down the avenue de l'Abreuvoir; it is still possible to locate almost the exact spot from which Sisley viewed the workmen sawing the great trees which he had painted only a few months before. He could easily have been arrested by the sight as he was walking to paint once more by the river at Port-Marly.

The avenue runs gently downhill between modest wayside houses at the foot of wooded slopes and gardens. It is soon joined by the busier route de Versailles and moves more precipitously towards the Seine and Port-Marly, with its shops and inns and carriage-traffic, businesslike, slightly forlorn, caught between the grander prosperity of St-Germain and the more obvious attractions of neighbouring Bougival. It was here that Sisley painted in late February 1876 his unsurpassed views of the quayside in floodwater, a series that remains among his most famous work.

Again, he was returning to an old subject, even to the same location, for he had painted floods here four years before (Plate 75). From the main road through Port-Marly,

100

70

69 **Snow at Marly-le-Roi. 1875.**
46.5 x 56 cm. Musée d'Orsay, Paris.

70 **Place du Chenil at Marly, under Snow. 1876.**
50 x 62 cm. Musée des Beaux-Arts, Rouen.

71 **Road under Snow, Louveciennes. c.1876.**
46 x 55 cm. Private Collection.

72 **Hiroshige. *Evening Snow, Kambara*. c.1830–4.**
Print from the set of *Fifty-three posting stations*
of the Tokaido. Victoria & Albert Museum, London

71

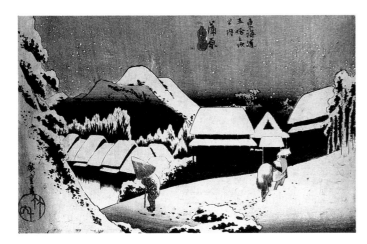

72

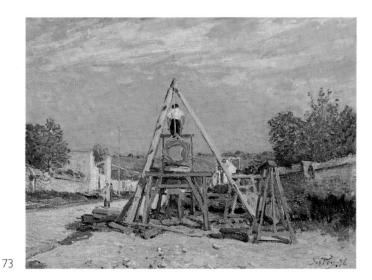

73

74

the short rue Jean-Jaurès, at right angles to the river, joins the quayside rue de Paris. Where it widens slightly to emerge near the river, on one side is an inn, À St-Nicolas in Sisley's paintings, on the other the Lion d'Or. In *Flood at Port-Marly* (D236; Plate 77) the wrought-iron curls of the hanging sign mark the Lion d'Or separated by the rue Jean-Jaurès from À St Nicolas. Remarkably, both establishments still exist (1991), the latter unchanged save that the ground floor has been altered and now accommodates one of the Le Brazza bars; the Lion d'Or continues as a restaurant.

Many other features of Sisley's group of paintings remain and provide an almost eerie moment of *temps retrouvé*, minutes from the ceaseless stream of traffic on the N 13. It was here, with his back to the Lion d'Or, that Sisley pitched his easel, the floodwater lapping at his feet. Little had altered in the four years since his last visit (shutters had been fixed to the ground-floor windows and a black and white sign appended to the first floor). Across the rue de Paris, rows of pollard trees stretch into the distance, parallel with the course of the river.[7]

The seven Port-Marly pictures (D235–41) show the flood at various moments of its progress – from its early stages, with the river swelling towards the trees (D235), up to its full limit, as depicted both in the large canvas in the Musée d'Orsay (D240; Plate 79) and in its more beautiful version of the same size in Rouen (D237; Plate 76). In these the water

almost touches the planks placed on barrels around the inn's perimeter; in the Rouen picture a woman stands precariously by the black door. In the smaller of the two Orsay paintings (D239; Plate 78) the heavy skies of the rest of the series have been replaced by swift-moving cumulus clouds against a background of light blue; the tall trees in the distance (on the Ile-de-la-Loge) show the approach of spring, making the red note of the inn-sign an even crisper accent.

Sisley suppresses the human implications of these flood paintings in favour of an almost Olympian detachment, in which any drama is distilled in the door's black rectangle and its steady reflection in the water. He was incapable of forcing his response, and it is this freedom from imposed feeling that gives such works their ability to move, surprise and enrich. In their fusion of sky, water, reflections, in their imperturbable equation of the human scene and the inevitabilities of nature, Sisley achieves a grandeur that he rarely attained again.

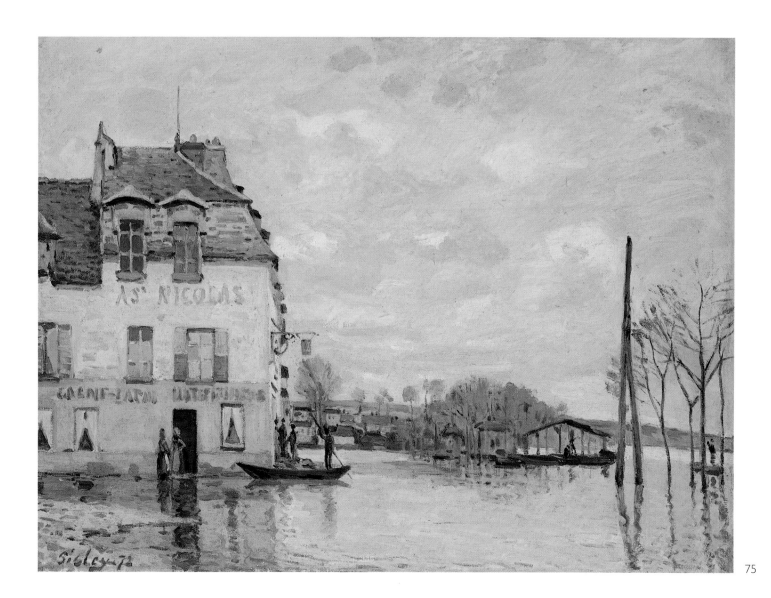

75

73 *Wood-Sawyers.* 1876.
 50 x 65 cm. Musée du Petit Palais, Paris.

74 **Port-Marly today.**

75 *Flood at Port-Marly.* 1872.
 46 x 61 cm. National Gallery of Art, Washington.

104

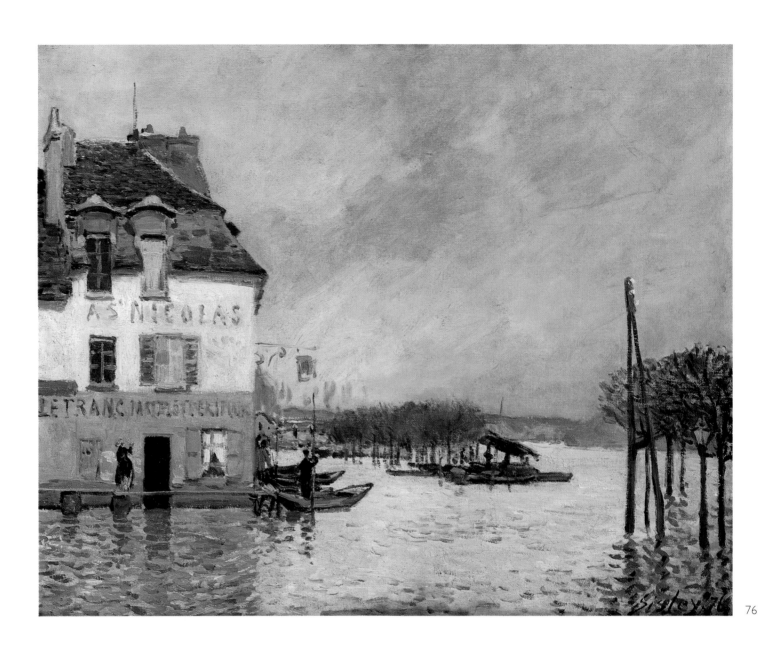

76

76 *Flood at Port-Marly.* 1876.
 50 x 61 cm. Musée des Beaux-Arts, Rouen.

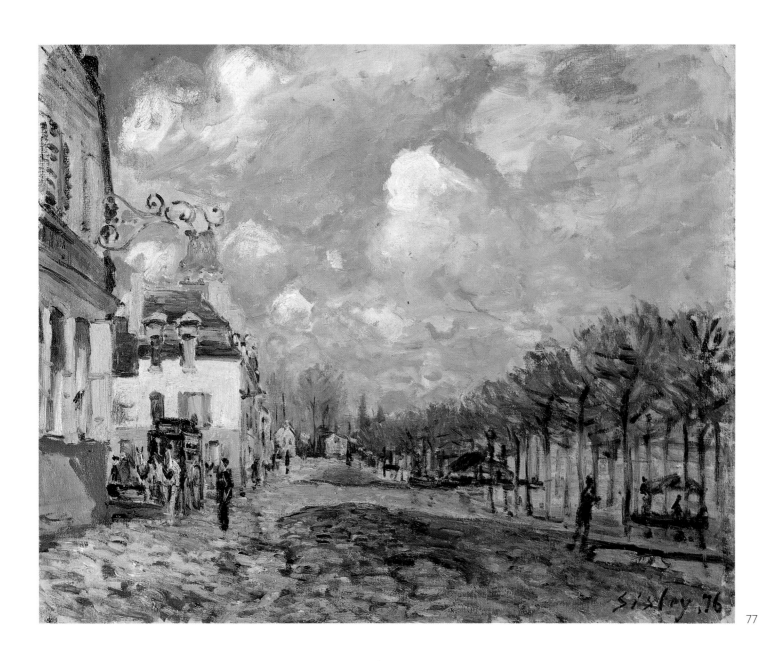

77

77 **Flood at Port-Marly. 1876.**
 50 x 61 cm. Thyssen-Bornemisza Collection, Lugano.

106

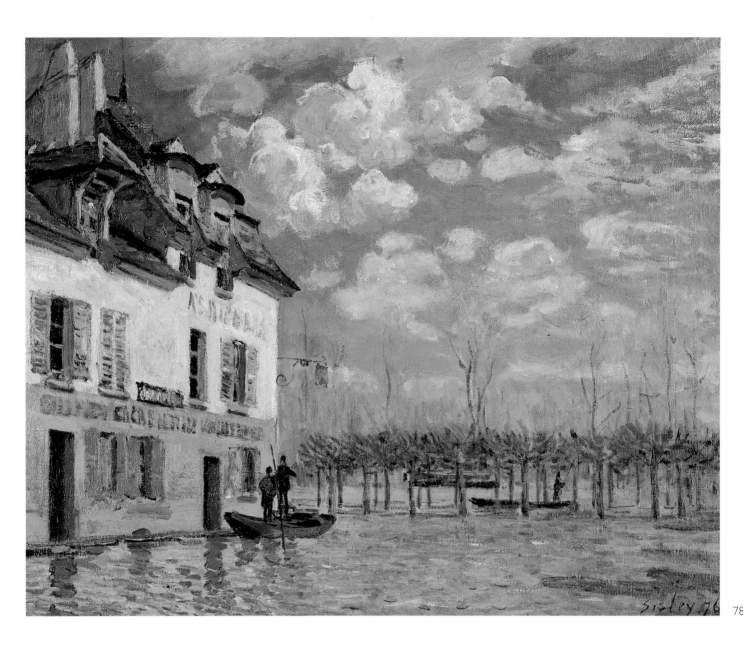

78

78 *Boat in the Flood at Port-Marly.* 1876.
 50.5 x 61 cm. Musée d'Orsay, Paris.

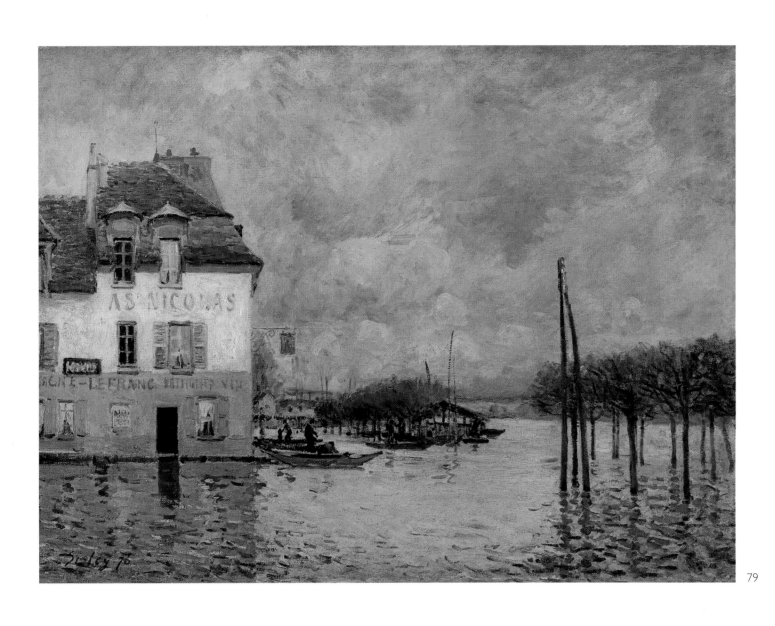

79

79 ***Flood at Port-Marly. 1876.***
 60 x 81 cm. Musée d'Orsay, Paris.

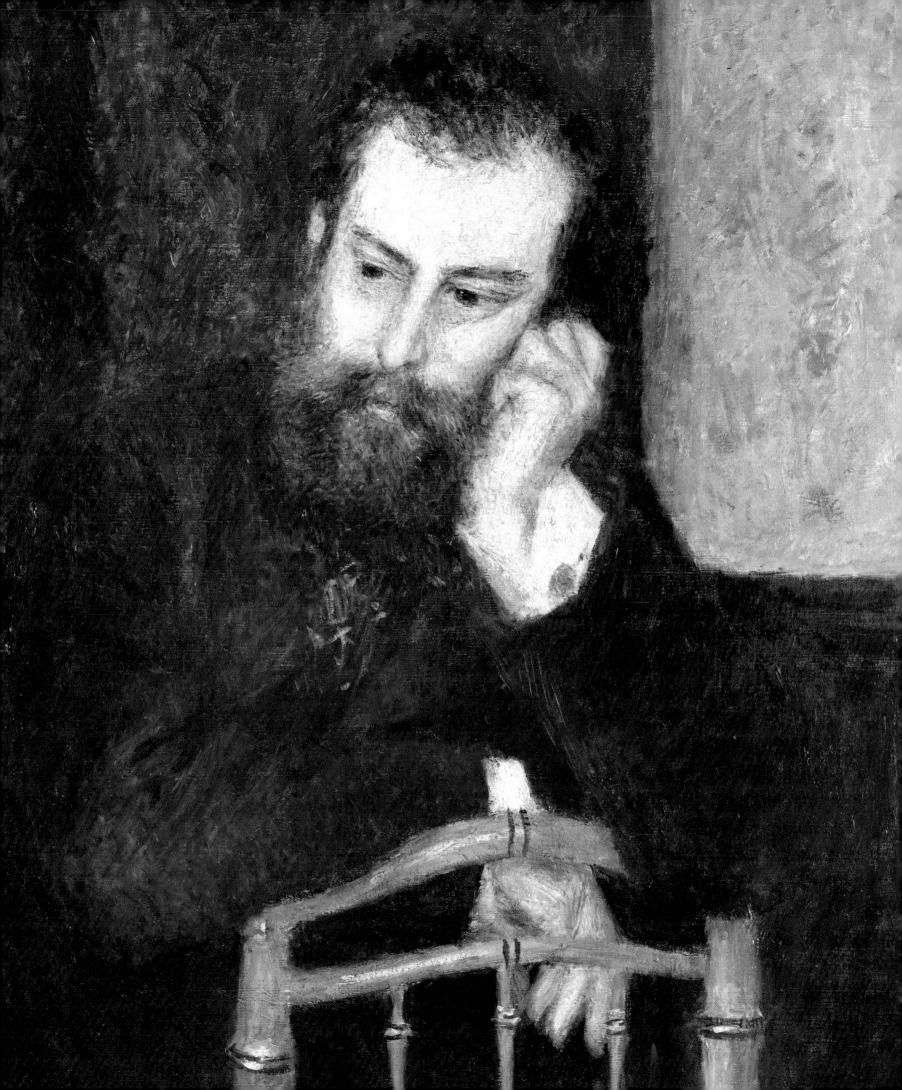

7 Patrons and Poverty

Until the 1874 Impressionist Exhibition few of Sisley's works had been shown publicly. His Salon contributions, though an important step towards his acceptance in the art world, had been too quiet to provoke any serious interest.[1] Since then there had been the paintings bought and sold by Durand-Ruel in his Paris and London galleries, and occasionally pictures on view with other dealers, as well as in one or two well-visited private collections. By the latter part of 1874, however, sales to Durand-Ruel, Sisley's chief resource, began to falter; Durand-Ruel was overstocked and underfunded. Renoir and Monet were also badly affected by lack of sales and the three Impressionists, in an unprecedented step, decided to hold a public auction of their works in March 1875; they were joined in the venture by Berthe Morisot.

Unlike her colleagues, Morisot, who had recently married Eugène Manet, the painter's brother, was comfortably off. Her participation was motivated by aesthetic camaraderie; having thrown in her lot with the 'intransigeants' in the First Impressionist Exhibition, she continued to align herself with them, supported by her enthusiastic and tireless husband. Differences of sex, temperament (a chronic self-depreciation), social milieu and income were put aside; she became one of the most staunch adherents of the movement, showing in seven of the eight Impressionist exhibitions. Joining her colleagues in the auction was a daring and independent move and it sealed friendly relations, in particular with Monet and Renoir. Although she mentions Sisley several times in her correspondence and held his work in great esteem, the extent of their friendship remains unknown.[2]

The sale was held at the Hôtel Drouot, the leading Paris auction house, on 24 March 1875. It almost caused a riot and, as Durand-Ruel later recalled, the police had to be called

> to stop disagreements degenerating into serious fights. The public were exasperated by the few supporters of the unfortunate exhibitors and tried to prevent the sale, uttering howls of rage at every bid.[3]

Sisley's twenty works, nearly all Louveciennes and Bougival subjects, fetched between 50 and 300 francs each, with an average price of just under 120 francs. Durand-Ruel, who was the adviser for the sale, bought twelve of Sisley's paintings. Although most were bargains, their purchase testified to Durand-Ruel's continuing support and, it should be said, his shrewd, speculative eye. There was little immediate return for him and several of the paintings were held as unmovable stock for many years.

For both Sisley and Renoir the auction was particularly disastrous; Monet fared a little better (with none of his works fetching less than 165 francs); a work by Berthe Morisot achieved the sale's top price at 480 francs.[4] Perhaps the only good to come out of the venture was that it attracted a few

80 **Previous page**
Auguste Renoir. *Portrait of Alfred Sisley* **(detail). 1874.**
65 x 54 cm. Art Institute of Chicago.

81 *Village Street, Louveciennes.* **1874.**
42 x 50 cm. City of Aberdeen Art Gallery and Museums.

82 *Foggy Morning, Voisins.* **1874.**
50.5 x 65 cm. Musée d'Orsay, Paris.

110

enlightened collectors, who proved invaluable to the artists in the following years. Yet, as Renoir suggested, some were motivated more by pity for the harsh treatment the artists received from the public than by any real appreciation of the quality of the work.

The notoriety of the sale (which received wide publicity), followed by the generally reviled Second Impressionist Exhibition of 1876, contributed to Sisley's degenerating financial position. There survive from the years 1877 to 1879, by which time Sisley was living in Sèvres, a few begging letters that indicate his often desperate situation. Years later, when Théodore Duret, one of the recipients of such pleas, published two of them, he commented: 'I have never experienced anything more pathetic, indeed tragic, than the anguish revealed in these two letters of Sisley.'5

The extent of Sisley's poverty is difficult to assess. Every account of his career emphasizes his appalling straits, and certainly the late 1870s when he lived in Sèvres (1877–80), and a further period in the mid-1880s appear to have been unremittingly hard. His begging letters, while they reveal his urgent need for money, give no indication of how he lived or how much he spent. What little evidence there is points to genteel rather than grinding poverty, with extended credit playing a significant part. There was no money for travel beyond his immediate neighbourhood; and there seems to have been no question of his buying his own home (he

rented houses to the end of his life). During his worst moments of discouragement, however, he was usually able to raise the sums required to settle with a creditor or to move the family goods from one address to another.

In such moments of crisis the support of a few patrons, collectors and dealers served Sisley well. Their names recur throughout the personal histories of Sisley, Monet, Renoir and Pissarro, ranging from well-to-do fellow painters such as Manet and Caillebotte to amateur dealers, cultivated industrialists and even a pastrycook who painted, wrote and collected when not attending to his brioches and vols-au-vent.

Inevitably, there was rivalry for the attentions of those who collected work by all the artists, as shown in Monet's recollection of a visit to Faure, an incident more amusing in retrospect than at the time. Of those names that recur in the provenances of Sisley's paintings, one of the most frequent is that of Eugène Murer (1846–1906); in 1887, according to an article on his collection, he owned twenty-eight works by Sisley, the largest number by any of the artists he helped (he had twenty-four paintings by Pissarro and twenty-one by his old schoolfriend, Armand Guillaumin). This curious man, whose real name was Hyacinthe-Eugène Meunier, was a pastrycook who, with his half-sister Marie, ran a shop and restaurant at 95 boulevard Voltaire in Paris (11th *arrondissement*). He was also a writer (his novel *Frémès*

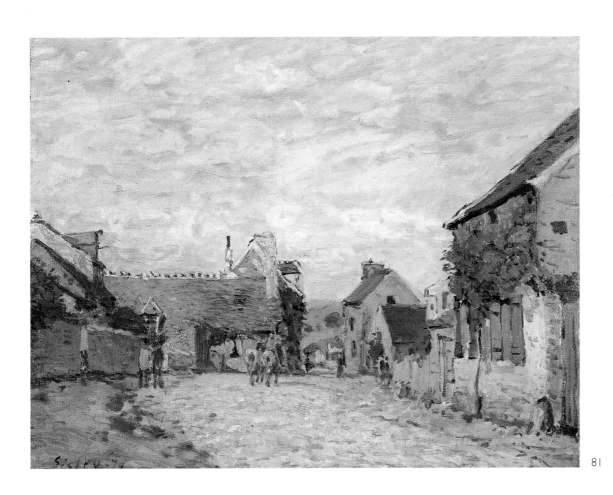

81

82

83 ***The Seine at Bougival.* 1872.**
50 x 65 cm. Yale University Art Gallery, New Haven.

84 ***Village on the Banks of the Seine***
***(Villeneuve-la-Garenne).* 1872.**
60 x 81 cm. Hermitage, St Petersburg.

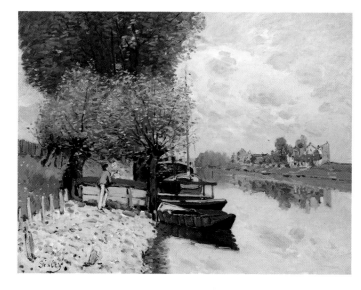

83

112

was published in 1876), a journalist, and later a painter. Above all, he was a collector, and his patronage led to weekly Wednesday dinners in his restaurant, where the regular guests were Renoir, Pissarro, Sisley, Monet, Guillaumin, Dr Gachet, and the writer and musician Cabaner. Cézanne came occasionally, as did Ernest Hoschedé.

Murer's great years of collecting were in the late 1870s, when the artists he admired and knew needed him most. Several writers subsequently accused Murer of having taken unfair advantage of the plight of his friends, thereby cleverly amassing, for a derisory outlay, a huge collection that included superb works. He could certainly be underhand, was unrelenting in his pursuit of an agreement, and not always punctilious in the return of paintings taken on consignment. Nevertheless, his enthusiasm was infectious, his help assured and regular, his hospitality unfailing.⁶

Murer held Sisley in particular admiration, esteeming his work above Monet's; he was 'the most subtle of the Impressionists; [with] the soul and the brush of a poet' who had 'the cast of mind of a Frenchman and the correctness of a gentleman'. Murer describes Sisley at the weekly dinners as 'brighter than a chaffinch'; his conversation, with 'his witty sallies and ripples of laughter', entertained the company until the dishes were cleared.⁷ Sometimes Eugénie accompanied Sisley on these evening outings from Sèvres, as did their neighbours there, Félix and Marie Bracquemond.

In 1880 Murer abandoned the boulevard Voltaire, left Paris (with a final farewell dinner), and in 1881 took over the Hôtel du Dauphin et d'Espagne, 'a first class house' in the place de la République in Rouen. He showed his collection there and entertained Pissarro and Sisley among others of his friends, before eventually selling his paintings and retiring to Auvers-sur-Oise, where he was a neighbour of Dr Gachet. Estranged, by then, from nearly all his early Impressionist friends and their colleagues, he painted derivative landscapes and jotted down some useful and generous memoirs.

It is difficult to be certain of the true identity of all the paintings by Sisley that Murer owned, though the titles are known from an 1887 article by Paul Alexis in the *Cri du Peuple*, and included an unusual Cats (a drawing), as well as a *Flood at Marly, Arch of a Bridge – Foreign Seascape* (so-called *The Bridge at St-Cloud*; D255) and a *View of St-Cloud* which is the sunlit view of Marly-le-Roi (D211; Plate 59). Murer's large number of works by Renoir included his portrait of Sisley (Plate 80).

Among the others to whom Sisley turned for help was the sharp-eyed, kindly, homeopathic doctor Georges de Bellio (1828-94), a well-to-do Romanian living in Paris. His preference was for early Impressionism and he assembled a great collection of works of the 1870s including Monet's notorious *Impression. Le Havre*. He owned Sisley's 1876 *Wood-Sawyers* (D230; Plate 73), which he lent to the Third

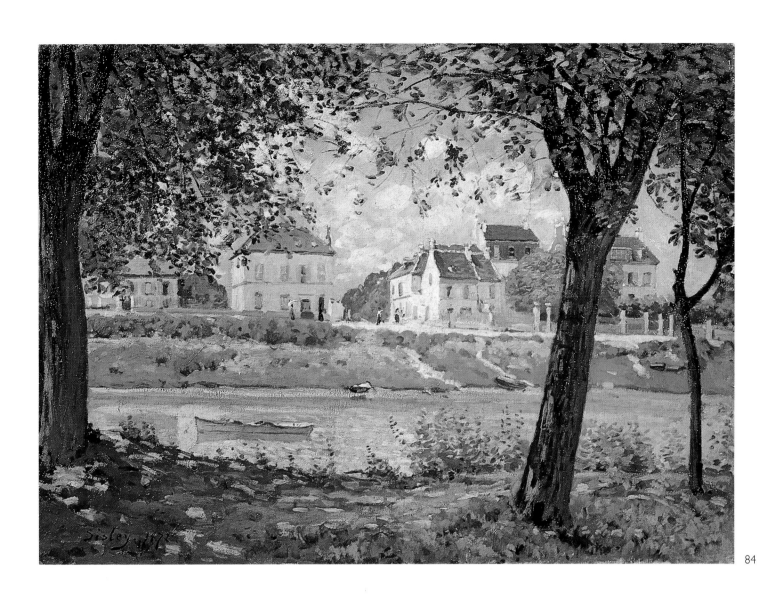

84

114

85

85 *Seine at daybreak*. 1878.
 37.5 x 45.5 cm. Gemeentemuseum, The Hague.

86

86 *Station at Sèvres c.1879.*
 15 x 22 cm. Private Collection.

Impressionist Exhibition; and the quintessential flowering orchard, *Spring near Paris – Apple Trees in Blossom* (Musée Marmottan, Paris).

Although his medical qualifications remain unclear, de Bellio was frequently consulted over the Impressionists' family illnesses. In April 1883, for example, at the same time as being one of the physicians attending Manet in his last excruciating weeks, he was also treating Eugénie Lescouezec; her symptoms are described in a letter from Sisley to him in which the artist asks for news of Pissarro and Renoir and describes the trials of being a landscape painter.

Other collectors and dealers who bought from Sisley or supported his work at auction included A. Dachéry who owned an excellent group of paintings of the period 1873–80 (including *Chemin de la Machine*, D102; Plate 2); the picture dealer Legrand, a former employee of Durand-Ruel, who was useful to Sisley in the late 1870s; the busy, self-effacing colour-merchant and dealer Alphonse Portier, who tirelessly searched for new clients on behalf of Pissarro and Sisley; and Jean Dollfus (1823–1911), one of the great nineteenth-century collectors who, from the mid-1870s onwards, added works by most of the Impressionists to his holdings of Géricault, Corot, old-master paintings, Far Eastern art and tapestries. In 1878 Dollfus bought three paintings by Sisley from the sale of the collection of Ernest Hoschedé.

In January 1874, a few months before the First Impressionist Exhibition, Hoschedé (1837–91), a rich textile merchant, business man and collector, had sold a number of paintings by the Impressionists (though, of course, the word was not yet in use) for unexpectedly high prices. Sisley's *Route de St-Germain*, near Bougival (D43), among three works by him on offer, fetched 575 francs, one of the highest recorded prices for his work in the 1870s. But Hoschedé's second sale (5 and 6 June 1878) was disastrous – as much for Hoschedé's creditors (his business affairs had rendered him bankrupt) as for the Impressionists. Sisley's thirteen paintings, nearly all Louveciennes and Marly subjects and of the finest quality, were sold for an average price of 112 francs. Even so, recognition was given to one of his Port-Marly flood pictures (D239; Plate 78), which achieved the sale's top price at 251 francs.[8] A souvenir of Hoschedé's patronage is Sisley's painting *The Garden of Monsieur Hoschedé* (D444; Pushkin Museum, Moscow), showing a corner of the estate at the Château de Rottenbourg, Montgèron, the Hoschedé country house near Paris.[9]

One patron who made a contribution to Sisley's life at a critical moment, and whose relationship with the painter is clarified by the existence of several letters, was the great publisher Georges Charpentier (1846–1905). Besides being a champion of the new naturalist school in literature, he was an early purchaser of Impressionist paintings, and was

especially devoted to Renoir. Charpentier was a generous publisher – his arrangement with Zola for the Rougon-Macquart novels must stand as one of the great publishing contracts – and his generosity failed neither Renoir nor Sisley. Hospitality in his splendid house in the rue de Grenelle was equally forthcoming: his wife Marguerite, young, attractive, smart, influential, held Friday evening salons which were attended by painters, musicians, writers and politicians. From time to time Sisley was a guest. Besides his own circle of friends such as Monet and Renoir, he could meet Zola, Edmond de Goncourt, Maupassant and Daudet, as well as politicians such as Clemenceau, Gambetta and Jules Ferry.

Marguerite Charpentier is seen at the height of her social success and matrimonial comfort in Renoir's *Madame Charpentier and her Children* (Metropolitan Museum of Art, New York), the painting that brought the artist wide acclaim at the Salon of 1879. It was this same Salon, however, that refused submissions by Cézanne and Sisley, dashing the latter's hopes which he had earlier expressed in a letter to Théodore Duret from Sèvres, 14 March 1879:

I am tired of languishing as I have for so long. The moment has come to take a decision. It is true that our exhibitions have served to make us known and that has been very useful, but I believe we should isolate ourselves no longer. We are still a long way from being able to

ignore the prestige of official exhibitions. So I have decided to submit some works to the Salon. If they are accepted, and I may be lucky this year, then I think I could make some money, and it is to prepare myself for this that I am appealing to all of my friends who take an interest in me.[10]

By the end of March 1879 Sisley's position had become intolerable; while waiting for the Salon verdict, he wrote to Charpentier that he was in urgent need of 600 francs and asked the publisher to lend him half of it: 'You are my only hope. I have been forced to leave Sèvres and am penniless. I don't know where to lay my head.'[11] It was the most disastrous situation he had so far experienced. Charpentier sent the sum, and Sisley and his family were able to move to a flat at 164 Grande-Rue in Sèvres, not far from their previous home, and a few minutes walk from the famous porcelain factory and the bridge carrying the road into Paris.

Sisley's two and a half years in Sèvres – his paintings of the Seine-side town show that he had left Marly for Sèvres by the early summer of 1877 – were marked by growing public recognition and, paradoxically, by a detectable slackening in the quality of his painting. For the first time his work begins to show a certain hasty repetition, a lowering of the creative temperature that in the previous four years had enabled him to produce an astonishing number of consistently great

87 *The Bridge at Sèvres. c.1877.*
38 x 46cm. Tate Gallery, London.

Detail previous page
The Bridge at Sèvres. c.1877.

88 *The Hill Path, Ville d'Avray. 1879.*
50 x 65 cm. Galerie H. Odermatt-Ph. Cazeau, Paris.

89 *Footbridge over the Railway at Sèvres. c.1879.*
38 x 55.7 cm. Private Collection.

Detail following pages
Snow at Louveciennes. 1878.
(see page 2)

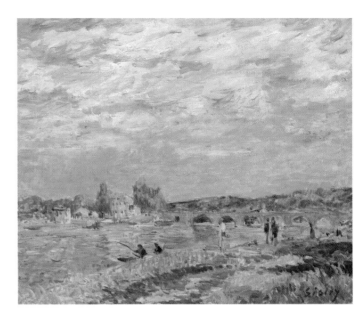

87

118

landscapes. But in his series of paintings of the bridge at Sèvres and of the adjoining bridge at St-Cloud, a new note appears. The emotional charge is often forced and, through an exceptionally rapid handling of paint, Sisley seems intent on easy effects.

The paintings were not unpopular with collectors, however, and there is no denying the appeal of many of these views of the Seine in summer – blue-skied, breezy, busy with riverside activity. The more obviously commercial aspects of the river, at a point nearer to Paris than the pleasure-giving reach at Bougival, expand Sisley's subject-matter and occasionally produce unusual compositions. Puffs of steam and smoke from trains, boats and factory chimneys echo the grander cloud formations in the sky. A train chugs over the many-arched viaduct on the skyline at Auteuil (D291), or passes high above the landscape near the stations of Sèvres and nearby Ville-d'Avray (ex-Daulte; Plate 89 and D329; Plate 88). Here are the villages and small towns once depicted by Corot, now in the process of being engulfed by Paris; fields on one side of the railway line, new villas on the other. River and railway run parallel at Bas-Meudon, just beyond Sèvres, where lamp-posts line a new road. Barges are unloaded at Billancourt on the right bank (where there was a landing-stage for the regular 'bateaux à vapeur' into and out of Paris); pleasure boats gather at the Point-du-Jour, with its flags flying, the new Palais du Trocadéro in the background.[12]

Sisley trespasses no further into the capital itself and was never again to paint so far from the sources of his true inspiration – pure landscape, small-town tranquillity, villages immersed in countryside.

These aspects of contemporary life, which run throughout the paintings of the Sèvres period, were hardly noticed by critics at the time. Few of the works were publicly exhibited, for between 1877 and 1881 Sisley showed only very occasionally in Paris.[13] At the Second Impressionist Exhibition (April 1876) Sisley's contribution was frequently overlooked or only briefly mentioned in the numerous reviews, although Zola had praised him and singled out the *Flood at Port-Marly*. The most sensitive appreciation of his work came later in the year, in a marvellous hymn of praise to Manet and the Impressionists by the poet Mallarmé. He immediately put his finger on one of Sisley's great qualities – his capacity to suggest the circulation of air in his landscapes through the most subtle spatial articulation:

Sisley seizes the passing moments of the day; watches a fugitive cloud and seems to paint it in its flight; on his canvass [sic] the live air moves and the leaves yet thrill and tremble. He loves best to paint them in spring, 'when the yonge leves on the lyte wode, waxen al with will', or when red and gold and russet-green the last few fall

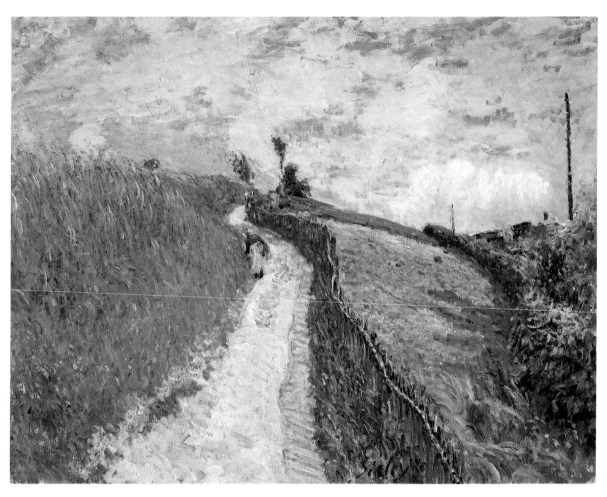

88

89

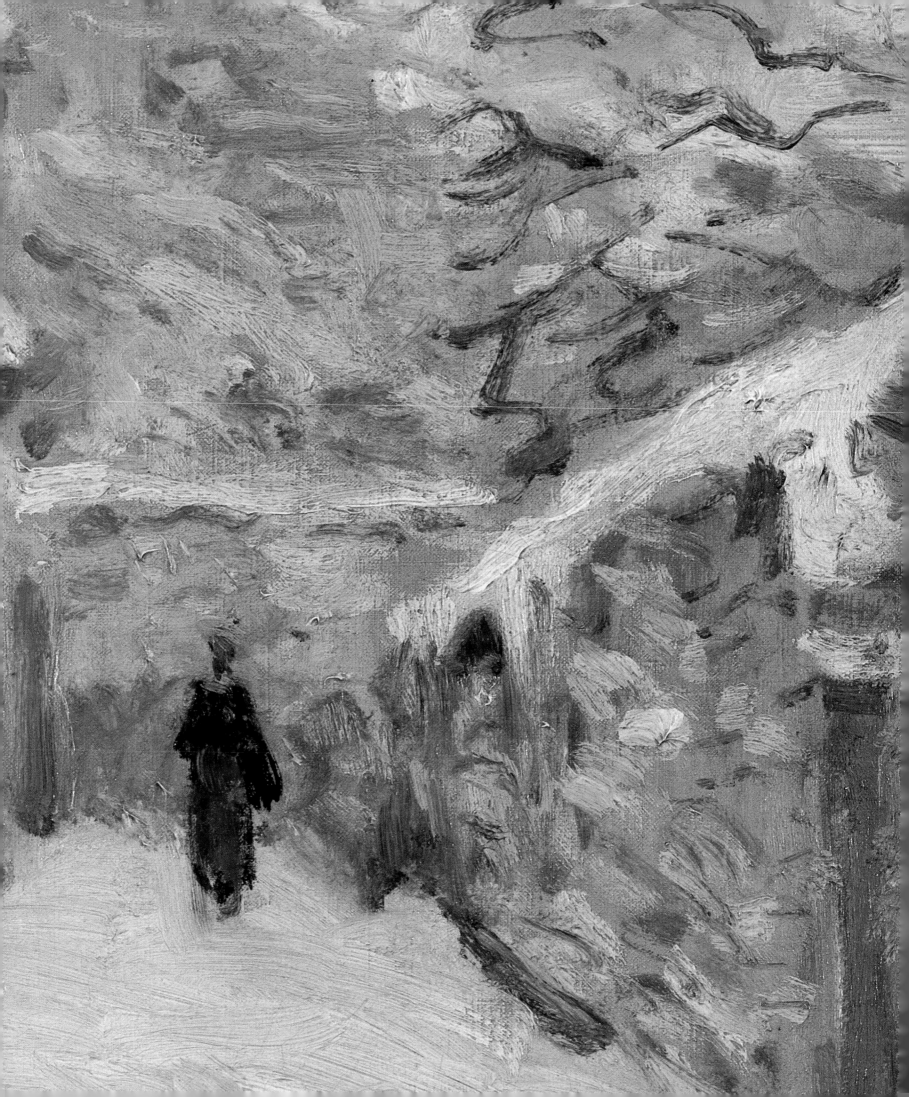

in autumn; for then space and light are one, and the breeze stirring the foliage prevents it from becoming an opaque mass, too heavy for such an impression of mobility and life.[14]

In April 1877, at the Third Impressionist Exhibition, Sisley was among the best represented of the eighteen artists who took part. As before, he seems to have played some role in the organization of the exhibition. Earlier in the year he had attended a 'working' dinner party held by Gustave Caillebotte at his house in Paris, where his fellow guests were Manet, Monet, Degas, Renoir and Pissarro. It was 'arguably the most important dinner party of painters held in the nineteenth century'.[15]

With seventeen works on show Sisley was well represented, but the majority of paintings are now hard to identify. The three Louveciennes/Marly works lent by Ernest Hoschedé, for example, are likely to have appeared in the second Hoschedé sale just a year later; although there are similarities between titles as given in the exhibition catalogue and the sale's *procès-verbal*, none exactly corresponds. Georges de Bellio lent three works including the *Wood-Sawyers* (Plate 73), a recent purchase. Its unusual composition and autumnal colours attracted the attention of several critics and Sisley made a line drawing from it,

which was reproduced in a short-lived journal *L'Impressionniste* (no. 4, 28 April 1877).

The majority of Sisley's works on show were of Louveciennes and Marly, in floods or under snow. *L'Auberge du Lion d'Or* (no. 223) is almost certainly the *Flood at Port-Marly* (D236; Plate 77), in which the hanging sign of the Lion d'Or figures prominently against the sky. It was this painting – perhaps the last of the series, showing the floodwaters receding and a coach and horses ready to make its way once more along the rue de Paris – that was singled out by Georges Rivière, co-editor of *L'Impressionniste* with Renoir's brother Edmond. In his second review of the exhibition he commends Sisley's taste, finesse and characteristic serenity:

> his large landscape, a road after rain, with water dripping from the tall trees, the wet cobbles, puddles of water reflecting the sky, is full of a charming poetry.[16]

Sisley's own person was represented in the exhibition by Renoir's portrait of him seated in Monet's studio at Argenteuil (Plate 80).[17] It is traditionally ascribed to 1874 and was probably painted shortly before Sisley went to London to work at Hampton Court. Rivière wrote of it: 'The series of portraits ends with that of one of the regular exhibitors,

Monsieur Sisley; this portrait has an extraordinary likeness and is a most valuable work.'[18] The portrait shows Sisley full-bearded, dark-eyed, pensive, his hair-line a little thinner in comparison with Renoir's portrait of him of a decade earlier; but here are the same impeccably white cuffs of the earlier portrait and recollected twenty-five years later by Julien Leclercq, when he wrote Sisley's obituary.

The year 1879 saw Sisley at perhaps the lowest point of his career so far. He had abstained, along with Monet, Renoir, Guillaumin and Cézanne, from the Fourth Impressionist Exhibition that year. The Salon jury, against his expectations, had refused his submissions. He was in constant need of money and, as he told Charpentier, he felt more isolated than ever.[19] At the same time he was perhaps growing tired of the landscape at Sèvres. For two years he had been infinitely resourceful (within his self-prescribed limits), searching the riverside for new motifs and returning to old ones at Bougival and Louveciennes. Towards the end of the year his situation seems to have impelled him to make a move and his thoughts turned to the Forest of Fontainebleau, an area he knew but where he had not painted since 1868.

It was, of course, much further from Paris than the Seine-side villages and suburbs that had constituted his whole world in the 1870s, where he had matured as an artist and where, in the final analysis, his greatest paintings had been made. Yet, like several of his colleagues either side of the turn of the decade, Sisley seems to have felt an urgent need for a change in his surroundings to allow for the emergence of new developments in his painting. Already in the years at Sèvres the surface handling of his work had become particularly complicated and he had begun to concentrate more exclusively on one motif, notably the series of the bridge at Sèvres. Now, looking about him in the small town of Moret-sur-Loing, he grasped the potential of the place. He moved there in 1880 and, until his death in 1899, it remained his home, becoming the centre of his life and the chief inspiration of his work. He wrote movingly of the place in his autobiographical letter to Adolphe Tavernier:

It is at Moret – in this thickly wooded countryside with its tall poplars, the waters of the river Loing here, so beautiful, so translucent, so changeable; at Moret my art has undoubtedly developed most . . . I will never really leave this little place that is so picturesque.

8 Seine et Marne

The rural remoteness that confronted Sisley and his family when they moved to the small town of Moret-sur-Loing must have presented an astonishing contrast to their former life on the busy outskirts of Paris. Although only seventy-five kilometres from the capital, Moret was definitely in the provinces, a still partly walled town, on the edge of the Forest of Fontainebleau, humming with local commerce, but hardly touched, it would seem, by the social and economic revolutions of the nineteenth century. To be sure, it had its railway, with a direct line to the Gare de Lyon in Paris; yet even this was some way from the town, as though reluctant to disturb the peace within; it skirted Moret with an almost grandiose gesture and halted a kilometre to its north. From the station it was a short walk into the village of Veneux-Nadon; and it was there, in a house by the railway line itself, that Sisley settled in 1880.

The year is one of the most scantily documented in Sisley's life – no letters, no official records, nothing in the correspondence or memoirs of his friends. It is known that at some point in the year Durand-Ruel once more resumed purchasing his work, and gave him a contract in which Sisley received regular income in exchange for the whole of his output.[1] For the moment, at least, the terrible anxieties of the previous years abated; Sisley could explore his new surroundings in comparative freedom from financial worry.

It would appear, from following the sequence of Sisley's work between late 1879 and spring 1880, that he had made a reconnaissance visit to the Moret area in the last months of 1879, presumably to look for a house to rent and to savour the district; he was there long enough to paint *Winter Sunshine at Veneux-Nadon* (D341), signed and dated 1879.[2] He was still in Sèvres in early 1880 and painted three views of the Seine at nearby Suresnes showing the same motif in distinctly wintry weather (D379–81); one of these is dated 1880.[3] It is probable that he then moved with his family to Veneux-Nadon.

The house he rented is still there, a sizeable L-shaped building facing the once straggling village street (rue de By).[4] On a practical level Sisley's new home offered all the busy amenities of Moret itself, not least its station, a few minutes' walk along the avenue de la Gare, a continuation of the rue de By. This was important: it offered, of course, easy access to trains to Paris and enabled the quick transport of canvases (cheaper than by road carriage) and the collection of artists' supplies. The station sold books and newspapers, there was a recommended buffet, it was convenient for visitors; and it remained a vital lifeline for Sisley over the following twenty years.

The artist resumed work almost immediately and painted the rue de By under snow, a bleak introduction to his newly found terrain (D401; Plate 93). Streaks of green and lemon

Sisley

90 **Previous page**
The Canal du Loing, looking towards St-Mammès,
in about 1900.

91 *Winter at Veneux-Nadon.* 1881.
54 x 73 cm. Private Collection.

92 *The Village of Veneux-Nadon.* 1881.
50 x 65 cm. Private Collection.

93 *Snowy Weather at Veneux-Nadon.* c.1880.
55 x 74 cm. Musée d'Orsay, Paris.

91

126

in the late afternoon sky foil the cold pink and ochre tones of the foreground with its trudging passer-by. Other later views (D445) were taken from an upper window of Sisley's house, as he followed his usual sheltering strategy in inclement weather. He assumes the watchful position he took up in Voisins in the snow, or Marly in the rain and, perched like a bird on a branch, on guard, missing nothing, takes advantage of the unfolding scene below. The snow-bound houses of the street stretch away alongside the railway line towards Moret, a woman draws water from the well of Sisley's garden, blue smoke curls into a leaden sky. Sisley's raised viewpoint in some of these works again demonstrates an affinity with Japanese snow scenes, particularly in the darker accents of passing villagers, in the tracery of bare trees, in the way space is here deepened, there suppressed by the snow's unexpected play with perspective, its disguise of familiar forms.

The view Sisley saw from his upper window is now virtually unrecognizable though the topography remains, as do the railed wall on the street and vestiges of the covered well. Originally the house must have had its own garden or *potager* at the rear; this was sliced away by the construction of the railway line in the early 1860s; now, almost sheer from the house, a steep embankment drops to the lines below. A few yards nearer to Moret a footbridge gives access to those houses of Veneux separated by the railway line from the rest

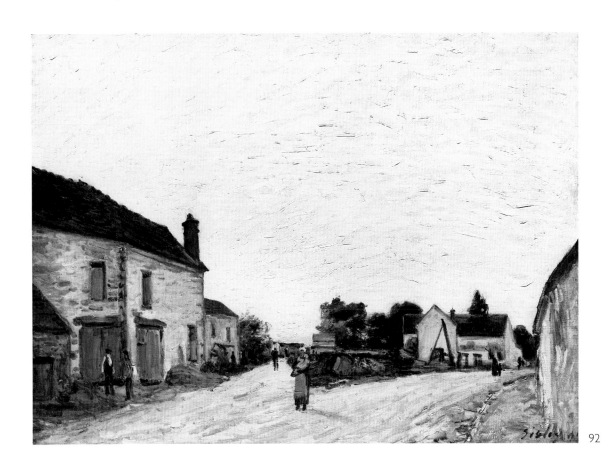

92

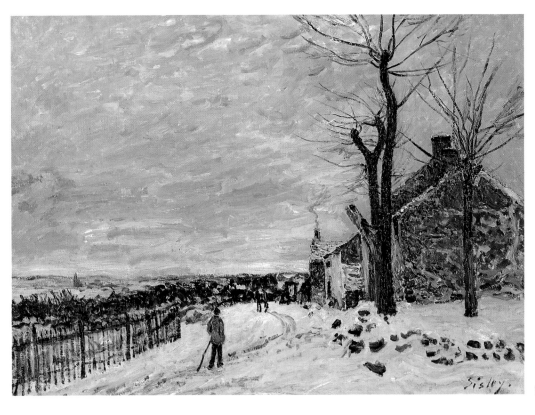

93

94 *Pierre Sisley, the Artist's Son.* 1880.
 Pencil, 23 x 31 cm. Walsall Museum and Art Gallery.

95 *The Family.* c.1880.
 Pencil, 23 x 31 cm. Private Collection, Sussex.

96 *Head of a Young Boy (Pierre Sisley).* c.1877.
 Pencil, 20.5 x 15.8 cm. Musée du Louvre, Paris.

94

128

of the village; beyond them is the wooded left bank of the Seine. The situation was ideal for the variety of the immediate landscape – farmland and forest, rail, river and canal, cottage gardens on the one hand, overgrown copses on the other, the whole area teeming with chance viewpoints and constantly changing light.

By the spring of 1880 Sisley had begun to investigate all the locations that became increasingly familiar as the year progressed. He began with views of Moret itself seen from a hillside to the north, taking in a wide area of the site of future explorations. He then proceeded with more intimate, close-up views of the edge of the Forest of Fontainebleau and its adjoining fields; the paths and clearings along the left bank of the Seine near his house; the little port and village of St-Mammès, settled in the fork of land where the Loing runs into the Seine. (See map) There is almost a sense of visual greed on Sisley's part as he turns this way and that, tasting the numerous possibilities on offer and testing his carefully acquired self-knowledge against the opportunities of new light, space, configurations of land and sky, and a whole new range of *effets* and feelings.

Only later did he sort out his discoveries methodically, in order to focus on those motifs that drew from him his most personal responses. He then began to work in a more concentrated way; by returning to the same spot, with slight changes in his viewpoint, he could take the measure of a

place in canvas after canvas. The method of working in series, first realized in Sèvres, became the programme for the rest of his life. He was nearer in this to the practice of Cézanne in the district around Aix than he was to Monet whose huge appetite finds little echo in Sisley's more circumscribed world.

Only an intimate knowledge of the complex topography of the Moret area can help identify Sisley's motifs. A good number of paintings have been mistitled and are thus sometimes placed out of their chronological sequence. This has partly obscured the recognition of several quite extensive series of works. Such groups, which become more apparent in the work of the last decade of Sisley's life, include views of the town from across the river, a turning on the Loing, the bridge at Moret, a boat-yard just beyond the town and, best known of all, the church at Moret. In the 1880s he often worked in series of two, three and four paintings, returning to the same motif weeks or months later. Critical neglect of Sisley's painting after 1880 has prevented a full recognition of his programmatic method of working. But to regroup his work thematically, rather than strictly chronologically, is of special value. It counters the belief that the artist meandered to no purpose through the last twenty years of his life.

Sisley himself was invariably accurate as to place, season and even time of day in the titles for his pictures. When they have been found to be wrong, it is usually a mistake on the

95

96

129

part of subsequent owners. A characteristic mistitling is the *Bridge at Villeneuve* (1881; D424, Philadelphia Museum of Art); it is, in fact, a view of St-Mammès from across the Seine, its church tower above the quayside trees, familiar from innumerable other paintings.

The entwined waterways of the area – the Loing, the Seine, the modest Orvanne, the Canal du Loing, their locks, weirs, confluences and bridges – admittedly make for confusions. Identification is not always easy nor, in many cases, is it especially necessary; but it frequently helps to understand the kind of motif Sisley has painted, his physical circumstances and the selectivity of his vision. What is to his left and right, beyond the canvas-edge? What is he *not* facing? What has he omitted? Sisley never felt the least compunction against editing from his paintings features that were in front of him as he worked – the strong accent of a single chimney, for example, in a Bougival view, a lamp-post from a street in Argenteuil. Similarly, in works showing the stretch of the Loing between Moret and St-Mammès, he occasionally omits the splendid white stone viaduct crossing high above the river. Houses along the quai du Loing at St-Mammès, familiar from countless paintings, sometimes disappear, and are replaced by trees or reshuffled along the bank. Again, in Sisley's time the road-bridge from St-Mammès across the Seine was constructed of four closely spaced arches near the river-bank, and continued by two pairs of piers, wide apart.

Sisley sometimes leaves out this second section of the bridge, allowing an uninterrupted vista along the opposite hillside (e.g. D506; Art Gallery of Ontario, Toronto); at other times it is an integral part of the structure of the painting (e.g. D516; Art Museum, Saint Louis). Obsessed by capturing the often fugitive essence of the scene before him, the artist could afford to ignore 'the tyranny of nature', in Degas' phrase, tailoring the composition to his original concept.

One of the areas that Sisley first discovered and to which he returned over the following three years was the Seine-side path from Veneux-Nadon to By. Crossing the railway footbridge, he could reach the river in ten or fifteen minutes, through the gardens and orchards of Veneux. The bank of the Seine is closely wooded here. Downstream, along the river's edge, a path leads to By and Thoméry, villages high up on the rocky cliff above. Broad and gleaming, the river makes a tremendous loop on its way north. 'The Seine is superb,' wrote one enthusiast, 'broad unmoving expanses of water stretch out between high wooded slopes, the branches coming right down to the river.'[5] Following the river upstream, the path continues close to the water's edge and the cliffs gradually subside into marsh and pasture. Quite suddenly the Seine is joined by the Loing; across the confluence St-Mammès occupies the right angle formed by the banks of both rivers, its quayside houses and boat-sheds, the subject of numerous paintings.[6]

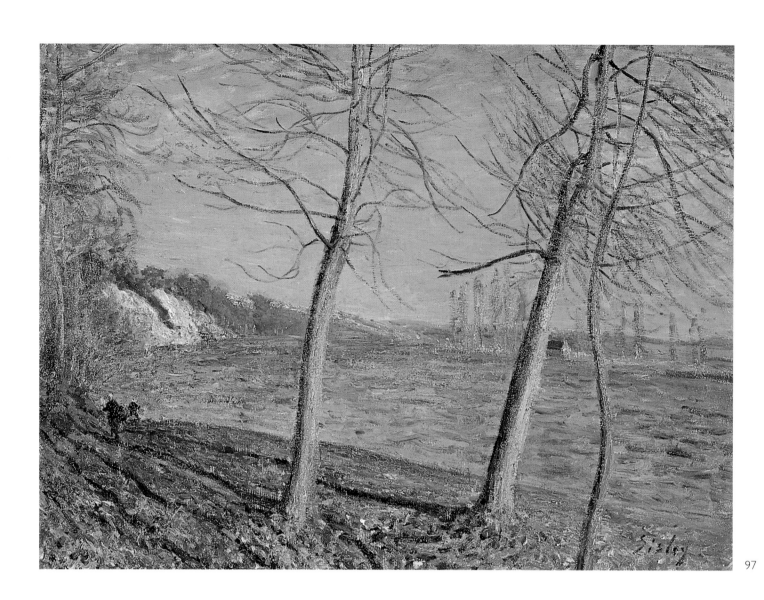

97

130

97 *Riverbank at Veneux.* 1881.
 60 x 81 cm. Johannesburg Art Gallery.

98 *Matrat's Boatyard, Moret-sur-Loing. c.*1883.
 38 x 55 cm. Musée départementale de l'Oise, Beauvais.

99 *View of Saint-Mammès. c.*1880–1.
 54 x 73.7 cm. Carnegie Museum of Art, Pittsburgh.

Detail following pages
*View of Saint-Mammès. c.*1880–1.

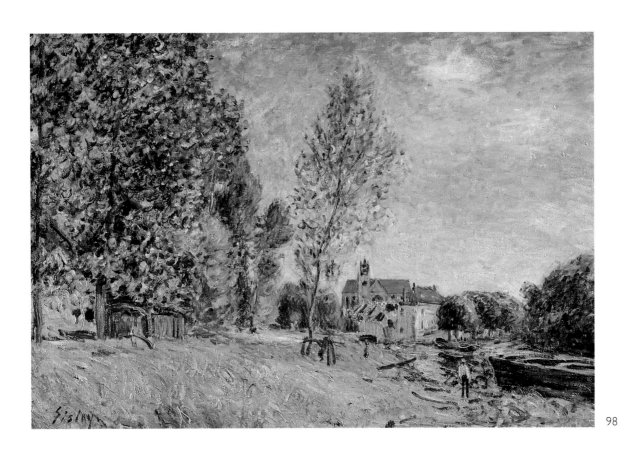

98

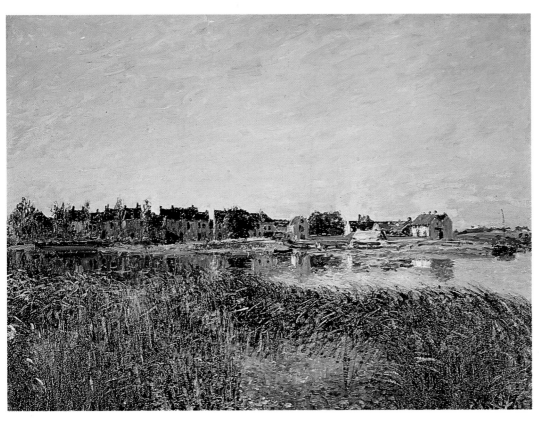

99

Sisley's delight in his new surroundings is seen at its freshest in two closely related pictures, *Small Meadows in Spring – By* (D391; Plate 101) and *On the Banks of the Seine – By* (D392; Clark Institute, Williamstown, Mass.). Traditionally dated to 1880, they could well belong to the following year when *Orchard in Spring – By* (D427; Plate 100) was painted. All have a vitality of handling and an exuberance of subject and colour that strike a new note in Sisley's work. The orchard painting contains his most startling figure, a girl raising her arms to the branches of two trees; it is surely the same girl (her hat and clothes correspond) pictured in the Tate Gallery painting (Plate 101) – almost certainly Jeanne Sisley, then aged 12. The setting of the Tate painting is still recognizable, the village of By on its heights, out of Sisley's viewpoint, to the left. For the *Orchard in Spring – By*, he faced the other way and moved up the bank of fruit trees nearer to the village. This particular riverside spot drew Sisley again and again. Close at hand was the disused embarkation-point of an old ferry from By across the Seine to the village of Champagne (vestiges of the landing-stage remain); two paintings record the view across (D398, Tate Gallery; and D406, Cone Collection, Baltimore), and a third also shows washerwomen at the water's edge (D466; Natonal Gallery, Ottawa).

Shortly after Sisley had painted these works, the village of Champagne was almost completely transformed by the building of one of the great industrial settlements of the Seine below Paris. It became the site of the Schneider factory (making electrical goods), with all its workers' houses and amenities. Its up-to-the-minute technology, bracing architecture and non-polluting presence made it one of the marvels of late nineteenth-century industrialization. But Sisley never painted there again. Increasingly, he was the recorder of a rural Ile-de-France, answering both personal predilections and a demand among collectors for 'attractive landscapes', as Durand-Ruel put it to Pissarro. There were no suburbs in Moret (though new villas flourished along the road to the station); villages such as Veneux were little changed during Sisley's residence; and the rivers and canal, though busy with commercial activity, remained within the confines of a traditional way of life.

Sisley appears to have had little or no interest in detailed depictions of agricultural life. These would have involved a close study of the human figure, something which Sisley had ruled out from his earliest days. However, he does give, through an unwavering attention to the landscape, a picture of the kind of activities that occupied most of the people among whom he chose to work. There were the flour and tanning mills at Moret, the construction and repair of boats around St-Mammès, market-gardening, forestry and poultry-keeping. One of the district's principal means of livelihood was the growing of vines, not in the usual vineyards, but trained on the sides of specially constructed walls. It was there that the fine white dessert grape known as the *chasselas*

was grown. During the 1880s and 1890s the area each year dispatched over 800 tonnes of these grapes to the markets of Les Halles. The trellises on which the vines grew can be seen fixed to some of the walls and courtyards in the village, though most of the walls themselves are now in ruins, or divide exceptionally elongated gardens for newer houses. In Sisley's time visitors exclaimed at the spectacular sight they presented, painted a brilliant white and stretching down the hillside from the heights of Thoméry. Several of Sisley's paintings show these walls (e.g. D441–3) sometimes in violet-blue shadow, interspersed with nut and fruit trees, high above the river (D442; Plate 102).

Sisley worked in all seasons and weathers along this beautiful and still unspoilt bank of the Seine. Its topography gave him new configurations of space in which far horizons combined with plunging views below; the horizontals of skyline, riverbank and receding path are overlaid by emphatic verticals and diagonals to produce densely structured surfaces. This becomes particularly evident in his landscapes painted in winter or early spring, before summer foliage obscured these far-reaching lines of vision. It is then, too, that Sisley's skies assume a greater variety and grandeur. With more subtlety than before, he determines the exact relation of the sky to the silhouette of the land. He knows how to differentiate its planes, order its clouds, diminish or enlarge its scope to produce a harmony inseparable from the land-scape below. Stormy and dramatic skies are uncommon in

his work: there are few equivalents to the turbulent sunsets of Daubigny or Monet, with their molten vermilions and oranges; nor are there the extreme evanescence of sunrise or the crepuscular effects of dusk. Even so, Sisley's range is impressive, from absolutely limpid summer blues gaining in density towards the zenith, to skies as vehement as any in Van Gogh or Vlaminck, in which thick, square-ended brush-strokes are rapidly imposed on areas of uniform colour. He can paint such skies as were never seen before, just as Renoir produces an earth of unimaginable fertility, or Monet both, in a world of water.

At its most typical, however, Sisley's repertory of effects in these riverside paintings constantly invokes the landscapes of Corot. Yet, even here, Corot's images are never as desolate as are some of Sisley's; where Corot's melancholy is meant to enchant, Sisley's is harsher, more unsettling. His work has none of that leisurely glissade of memory in which Corot wraps even his most particular observations. At this period Sisley defines a vein of undomesticated solitude that before had been largely absent from his painting. He is solemn and solitary, as he shows us the interlacing of bare trees against the immense diffidence of the sky. The chord contains his familiar notes of distilled structure and varied brush-work but is deepened by a sense of disconsolate withdrawal. Over the years this became a continuous accompaniment even to his most untroubled transcriptions of high summer.

136

100

100 *Orchard in Spring – By. 1881.*
 54 x 72 cm. Museum Boymans-van Beuningen, Rotterdam.

101

101 *Small Meadows in Spring – By. c.1881.*
54 x 73 cm. Tate Gallery, London.

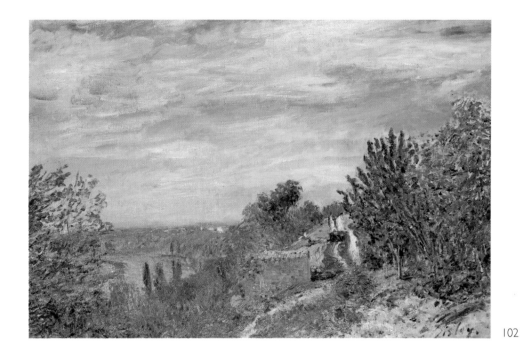

102

138 102 *Footpath in the Gardens at By. c.1881.*
 50 x 73 cm. Private Collection.

 Detail
 Footpath in the Gardens at By. c.1881.

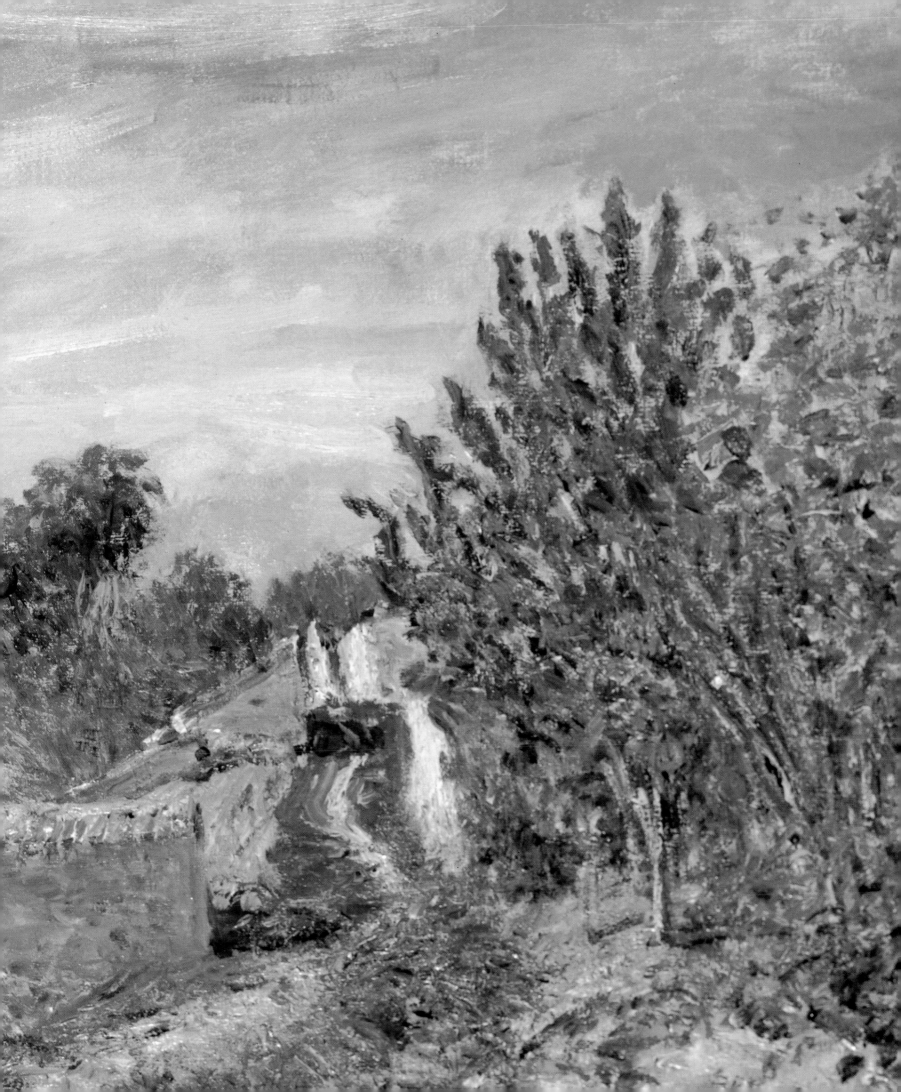

9 A Changed Man

After eighteen months of intensive work in his new surroundings Sisley decided on a change of scene, and in early summer 1881 he went once more to England. In the first days of June he was in the Isle of Wight and eager to begin painting. As a letter to Durand-Ruel of 6 June suggests, he had found an ideal place to paint – the famous Alum Bay – but was prevented from doing so by the failure of his materials to arrive from Paris:

> I am at Ryde on the Isle of Wight. I've been for several walks on the island, and as soon as my canvases arrive I shall set to work. The Isle of Wight is very much as I imagined it – a large park. Its reputation seems justified. The coast where I propose to work is at the very end of the island, it is a superb place called 'Alum Bay', and is the goal of many excursions. Ryde, where I am lodging, is like any fashionable English seaside town. That is to say, it has little to offer in the way of the picturesque. The most popular walk is the pier, which is very long and which I have frequently paced during the last two days, going to meet the boat from Southampton with the hope of seeing my canvases. I wrote this evening to Bertrand and Cie, 10 rue Lafayette, to ask about them. Would you, on your part, be kind enough to call there and hurry them on a little .[1]

Alas, this pacing of the famous pier at Ryde was apparently fruitless: the canvases he needed failed to arrive. It seems likely that Sisley was on too restricted a budget to buy any locally (for there was certainly an artists' supplies shop in Ryde at that time); he returned to Moret empty-handed, and nothing more is heard of this abortive journey.

Worse, however, was to follow. Durand-Ruel's renewed purchasing power in 1880 had been effected by backing from a prominent banker, Jules Feder, a director of the Union Générale. In the first weeks of 1882 the Union Générale collapsed and Durand-Ruel found himself in the galling situation of having to reimburse Feder to help him pay his debts.[2] There followed an extremely precarious few years for the artists whom Durand-Ruel had supported, particularly for Sisley and Pissarro. Even before the collapse of the Union Générale, Sisley's letters to Durand-Ruel beg for small advances and indicate his continual financial struggle.

In September 1882 he asks for 600 francs to cover the costs of moving from Veneux-Nadon into the town of Moret itself; at the end of October he handed over pictures to the value of 2,700 francs and, on 21 December, a further group of works at 1,500 francs. Durand-Ruel continued to send modest sums of two hundred or three hundred francs; the ledgers of the firm show that he was still buying paintings, some of them very soon after their completion. The well-known *Provencher's Mill at Moret* (D503; Plate 105), for

103 **Previous page**
Alfred Sisley. c.1892–4.
Photograph by Clement Maurice, Paris.
Archives Durand-Ruel, Paris.

104 *Provencher's Mill at Moret.* 1883.
Crayon, 12 x 19 cm. Musée du Louvre, Paris.

105 *Provencher's Mill at Moret.* 1883.
54 x 73 cm. Museum Boymans-van Beuningen,
Rotterdam.

104

142

example, is known to have been painted on a glum autumn day in 1883; it was bought by Durand-Ruel on Christmas Eve that year. 'Don't forget that I am on my beam ends and the end of the month is coming. I am relying on you.'[3]

The move to Moret in 1882 lasted for only about a year. Many of the paintings from these twelve months depict Sisley's immediate surroundings.[4] One shows Eugénie seated, with a parasol shading a book in her lap, in a walled garden close to the church in Moret (D485). Yet, so quintessential an Impressionist subject – extremely rare, however, in Sisley's work – was painted at a time of mounting debt and indifferent health: 'I have decided to leave Moret at the earliest possible opportunity, as it's not very good for my heart . . . However, I'm not going very far: to Les Sablons, a quarter of an hour away, but with better air.'[5] One commentator has suggested that it was only Sisley's 'friendly relations with the sheriff of the district' that saved him 'from the clutches of certain impatient creditors'. This may simply be hearsay, for to move from Moret to the village of Les Sablons put little distance between himself and so awkward a situation.[6]

Les Sablons, nowadays merged with Veneux-Nadon to form the community of Veneux-Les-Sablons, was a straggling village with a busy main street of traffic moving from Moret to Fontainebleau. Mostly, it consisted of farmhouses, cottages and barns, among orchards and gardens radiating from a

small church.[7] Although the house Sisley rented was only a short walk from the one he had occupied in Veneux-Nadon, its position enabled him to explore different subjects; he worked more frequently in the fields bordering the Forest of Fontainebleau to the west of the village and along the edge of the forest itself. Seasonal changes are explicitly studied, and the paintings reveal in a more tangible way an increasing solitariness. In the previous decade, in Marly and Louveciennes, there is a continual sense of humming life beyond the edge of the canvas; at Veneux-Nadon, he had achieved an almost romantic, audacious solitude, perched high above the banks of the Seine. But in many paintings made at Les Sablons, the note is one of withdrawn simplicity, meditative and undramatic. This is country life, neither bucolic nor picturesque, almost featureless, in which the only 'events' are a turn in the road or a fallen tree, a local woman on a path or a man standing in a field – the only reason for his presence being the patch of blue provided by his smock against the sunlit earth.

There is little in Sisley's work during this period to remind us of the nearby forest's social role as the leisurely playground that he had painted twenty years before; on the other hand, there is no sense of a highly organized agrarian community such as Pissarro depicted in his contemporary paintings of Pontoise. The countryside is neither a setting for unremitting toil nor yet a place for visitors coming there for refreshment

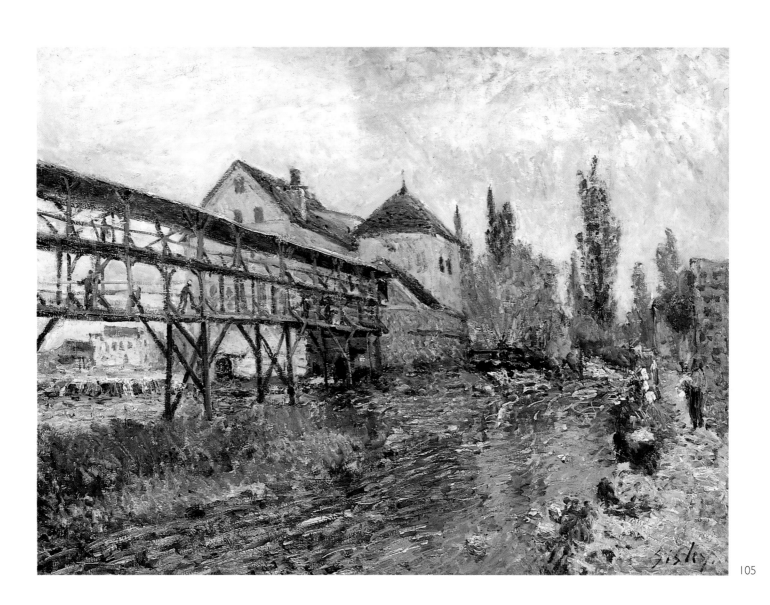

105

106 ***The Canal du Loing at Moret.* 1892.**
73 x 93 cm. Musée d'Orsay, Paris.

107 ***Study of Barges on the Seine.* c.1885.**
Coloured crayon, 20 x 25.5 cm.
Private Collection.

144

and holiday (as represented in Renoir or Morisot's work at this time). Sisley presents the quiet monotony of seasonal activities, freed from harsh labour. It is a countryside often beautiful in the varied aspects of its cycle, but also humdrum, a little worn at the edges; here are no 'angels going to market', as Degas remarked of Pissarro's peasant women. Although Sisley is inevitably selective, his is not the discrimination of a poetic idealist. Each view is chosen for its aesthetic realities, and its success or failure depends on how deeply it has entered Sisley's transforming imagination.

Sisley did not confine himself to such country landscapes; he travelled extensively in the district, several miles separating his favourite locations. He seemed unable for long to resist painting works in which there was water to offer its reflections, and river-banks to provide constantly changing activities. He was indefatigable in his exploration of the Loing, wide and shallow as it passed under the old bridge at Moret, deepening and curving as, joined first by the Canal du Loing and, almost immediately afterwards, by the energetic stream of the Orvanne, it flowed towards St-Mammès and out into the Seine. Each adjoining area satisfied the variety of needs within Sisley's visual temperament.

Paintings of the Canal du Loing, with tow-paths on either side, gave expression to his love of clustered lines of perspective running to a low horizon; towering poplars along its banks give those marked vertical divisions that make for

strong surface pattern, offsetting the diagonals that take us gently into the distance. One of his most celebrated works, *The Canal du Loing at Moret* (D816; Plate 106), painted early in the next decade, has all the elements carried out with Sisley's inimitable economy of colour – ochres, blues, soft violets, very pale greens in the spring sky above the far hillside. The house across the canal, the passing barge, and the figures on the path give all the necessary darker accents. A ragged bush in the foreground slows down what might have been too swift a curving away of the nearside path and bank; at the extreme right the composition is slightly opened by a violet shadow on the slope down to the Orvanne, whose course follows the canal. It is rare among Sisley's later paintings to find a work so simply achieved yet so subtle in all its intervals, like one sustained passage of melody drifting out of earshot.

More complicated motifs were discovered at the point where the canal, passing through the lock by the road out of Moret towards St-Mammès, flows into the Loing. Superb rows of poplars bordered the spit of land formed by the meeting of these two stretches of water. Standing back, amid the trees, was a substantial inn called the Robinson, dispensing refreshments for weekend visitors; there too were an ancient stone grange and a boat-yard (known as Matrat's boat-yard).[8] From here the old town of Moret, capped by its church tower and fronted by the mills clustered along its

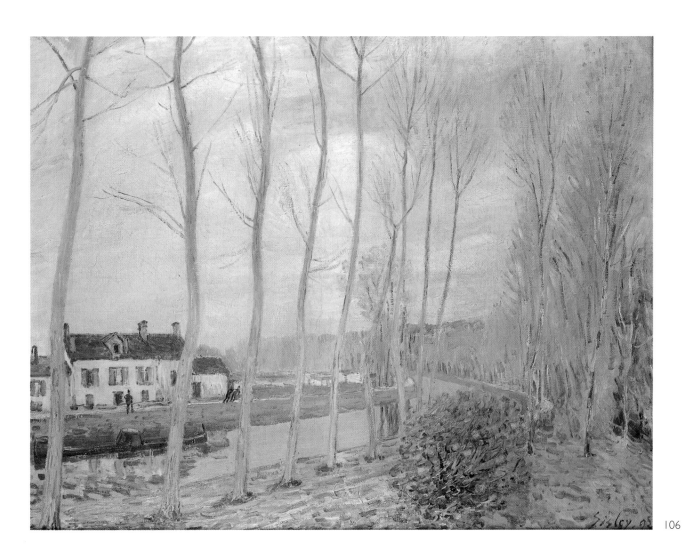

106

107

108

108 *Boats.* c.1885.
55 x 38 cm. Private Collection.

Detail
Boats. c.1885.

109 *The Loing at St-Mammès.* 1885.
54 x 73 cm. Philadelphia Museum of Art.

146

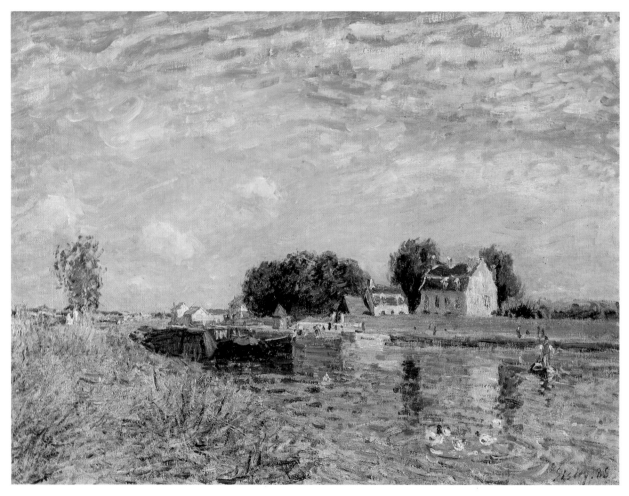

109

794 - **Saint-Mammès** - Le Barrage

F. Thion, éditeur, Moret-sur-Loing - Cliché Coffin

110

110 **The Weir at St-Mammès.**

111 *The Lock at St-Mammès. c.1885.*
Crayon, 12.9 x 21 cm.
Museum Boymans-van Beuningen, Rotterdam.

bridge, provided Sisley with the type of panoramic image that links him to the landscapists of seventeenth-century Holland.

But the motif Sisley returned to more often than any other in the 1880s was the Loing as it enters the last part of its journey to the Seine. It flows grandly under the two massive white arches of the viaduct; the houses of St-Mammès are strung along the right bank; the flat pastures of Veneux-Nadon stretch away from the left. It was from this bank that Sisley painted nearly fifty views looking up and down the river and across to the houses and trees in front of him (D609; Plate 109).

The most intense concentrations of such views belong to 1884 and 1885. Several include the lock (on the St-Mammès side) through which the innumerable types of river craft passed – the picturesque *berrichon*, the flat-bottomed *margota* used for haulage and the predominant *péniche*, a large multi-purpose barge. A weir was raised and lowered by the lock-keeper, its mechanism housed in two small cone-roofed buildings on either bank. These appear in several paintings, acting as spatial markers between river and sky. The most prominent building on the St-Mammès side was, and still is (for little here has changed), the custom-house, set back from the towing path behind the long wall, its mansard roof reflected in the water (D606; Plate 108). The red-tiled roofs of the other houses (see Plate 110), nearly all occupied by people working on the river, appear in most of Sisley's

111

paintings here. In some canvases he portrays the scene as almost deserted, a forlorn, forgotten expanse of river, shimmering under a hot afternoon sky (D625; Plate 120). In others passing barges break up the reflections; one can almost hear the sound of water slapping against the lock and the resounding shouts and greetings of bargees echoing along the bank.

Although Sisley was fascinated by all these riverside activities, a fascination noticed by his friends, the centre of his interest was never anecdotal or obviously descriptive. His chief concerns remained the diffusion of light and the circulation of air. He captures every shift between sharp sunlight and vibrant shadow, as the river widens and, almost with a feeling of relief, signalled by a cool quickening of the air, becomes one with the Seine.

St-Mammès itself stands on the right angle formed by this great confluence, its busier side fronting the Seine. Here were chandlers, supply shops, inns and cafés; boat-yards for construction and repair (D579; Plate 113); fuelling stages and stops for chugging steamers. Here the women of the village washed clothes and children played along the shingle. Sisley frequently positioned himself downstream, looking towards the bridge and prosaic church; the range of receding diagonals – houses, trees, road, river – was enlivened by figures at work on the boats or strolling along by the water's edge. Such figures were often added later, after the main subject of each painting was near completion. Having little significance beyond their inevitable presence, they were included as animating dashes of colour, or dark points against the light, a spatial punctuation that rarely failed him.

One further group of works took Sisley beyond the bridge to the quieter, more steeply banked stretch of the Seine, the quai de la Croix-Blanche (D509). The house of that name (number 19), double-fronted and with twin turrets, adds a note of unexpected grandeur to the modest, close-packed dwellings on either side of it. Further along, at 41 rue Vieux-Relais (the same street under a different name), is the site of an unusual painting – the courtyard of an ancient house (D544; Plate 112), with the Seine glimpsed through its arched gateway beyond the street outside. A drawing of the painting is inscribed by Sisley 'tresseuses de jonc' ('rush-plaiters') and 'à Caillebotte 500F'; it was one of nine works by Sisley left to the French state by Gustave Caillebotte on his death in 1894.[9]

Paintings such as this or the *Courtyard at Les Sablons* (D543; Plate 114) are rare in Sisley's work; they exchange the monotony of foliage and water for a direct glimpse of domestic, village life. Such is Sisley's success in dealing with their complex structural detail, so inviting are these views of the yards, streets and alleys of his surroundings, that it is curious he did not attempt such scenes more often. There

150

112 *Courtyard of Farm at St-Mammès.* 1884.
 73.5 x 93 cm. Musée d'Orsay, Paris.

113 *Boatyard at St-Mammès.* 1885.
 54.9 x 73.3 cm. Columbus Museum of Art, Ohio.

114 *Courtyard at Les Sablons.* 1885.
 54 x 73 cm. City of Aberdeen Art Gallery and Museums.

113

114

152

were one or two more of this kind painted in Moret itself (Plate 124) and, of rather different character, the series of the town's church. Perhaps a growing aloofness on Sisley's part made him reluctant to paint in the streets of the places where he lived, with all the social incidents and interruptions such an activity entails. It should be remembered that Sisley's style of painting and the subjects he undertook would have been greeted with incomprehension by the majority of his neighbours. His work appeared 'fuzzy', imprecise, hardly 'finished' and often garish in colour; it lacked conventional sentiment or anecdotal interest. Even among a more sophisticated public who had come to accept pure landscapes as a respectable branch of painting, how unambitious Sisley's work must have appeared with its almost total lack of effusive guidebook charm.[10]

From the mid-1880s onwards, however, criticism was voiced not only by a disaffected public but from within Sisley's own circle. Some of it was certainly justified. In 1887 Pissarro was disparaging over his friend's recent paintings: 'As for Sisley, he has not changed, he is adroit, delicate enough, but absolutely false,' he wrote to his son Lucien. He repeated his view in a letter the following day: 'I just can't enjoy his work, it is commonplace, forced, disordered; Sisley has a good eye, and his work will charm all those whose artistic sense is not very refined.'[11] Critics too were unhappy with the direction Sisley's work had taken; Astruc deplored

his 'lack of progress'; others ignored his work altogether; increasingly Sisley felt that a conspiracy was afoot.

Although he had received several favourable reviews at the time of the Seventh Impressionist Exhibition of 1882, his solo show at Durand-Ruel's in June the following year went virtually unnoticed. In the years 1884–8 he only contributed to group exhibitions, and he refused to show in the last Impressionist Exhibition of 1886. His relations with Durand-Ruel began to sour, and he started to rely instead on the newly attentive Georges Petit. Petit's resplendent *galeries* in the rue de Sèze saw an annual Exposition Internationale, which attracted several of the original Impressionists – Monet, Morisot, Renoir, Pissarro – as well as Sisley. By the early 1890s, after several infidelities with other dealers (and private sales he had engineered himself), Sisley appears to have broken his contract with Durand-Ruel. In 1897 he wrote to Octave Maus, secretary of the Belgian exhibiting society, *Les XX*, that he showed only with Georges Petit.[12] Nevertheless, Durand-Ruel's commitment to Sisley continued in the 1890s; relying on older, unsold stock and works bought at auction, he showed Sisley's work in exhibitions in Europe and the United States.

In spite of this growing international profile, modest though it was, Sisley remained as penurious as ever. At the end of 1885, after one of his most prolific years of painting, he wrote despairingly to Durand-Ruel (17 November):

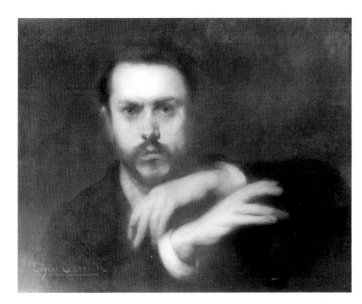

115

on the 21st I shall once more be without a sou. But I must give something to my butcher and my grocer; to one I haven't paid anything at all for six months, to the other nothing for a year. I also need money for my own needs as winter approaches. There are some essential items that I must have. I hope to be able to count on some quiet in order to work.

I am *in a terrible state*. Tomorrow or after I shall send you three canvases. They are all I have that are finished.[13]

Earlier that year Sisley had even thought of painting fans, to make some quick and easy sales. There were also schemes to attract new collectors, and he was on friendly terms with well-placed critics such as Gustave Geffroy, Arsène Alexandre and the young Adolphe Tavernier. All three became staunch apologists in the 1890s. Another plan, from the late 1880s and presumably hatched with Durand-Ruel's co-operation, was for a series of pastels; they required less time to execute, less expensive materials and were thought to be easier to sell (which proved to be the case).

As a medium, pastel was new in Sisley's work, but he took to it with mastery. Most of his contemporaries who consistently used pastel, such as Degas, Morisot and Cassatt, generally reserved it for figures and portrait heads; Pissarro drew pastel landscapes, from time to time as did Guillaumin, with bold fresh results. Monet's most substantial series, apart

from some works of the late 1860s, was made in London in 1901.

Sisley's pastels are entirely of landscapes and the finest group is undoubtedly the series carried out in early 1888 (Plates 116, 117, 118 and 119).[14] They are winter and spring views from an upper window of his house at Les Sablons, with deep snow or scintillating sunshine on cold, clear days. Most include the sidings and goods-yard of Moret's railway station viewed through several tall bare tree trunks just beyond Sisley's garden wall and gate. Clouds of pink steam dissolve into the sky; tiny figures make their way through the snow. Sisley's raised viewpoint and linear delicacy again elicit his rapport with Japanese art – in the downward plunge of the foreground, the diffusions of focus in mid-ground, the expanding horizon, all spatially organized between the crisp staccato verticals of the tree trunks. Incidents near the edge of the paper acknowledge the almost arbitrary nature of Sisley's chosen section of landscape. The shifts in his angle of vision are slight but the window from which he worked afforded a panoramic view – from the neighbouring houses of Les Sablons on his left, to the railway lines disappearing to his right, in the direction of Moret. Seen in their topographical order, the pastels, of which there are at least eight, give a visual sweep of nearly 180 degrees, unfolding like a fan with the added effect of seasonal changes and transitions of mood.[15]

153

154

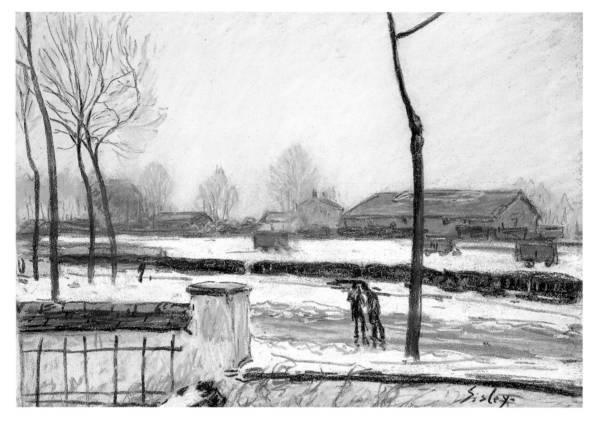

116

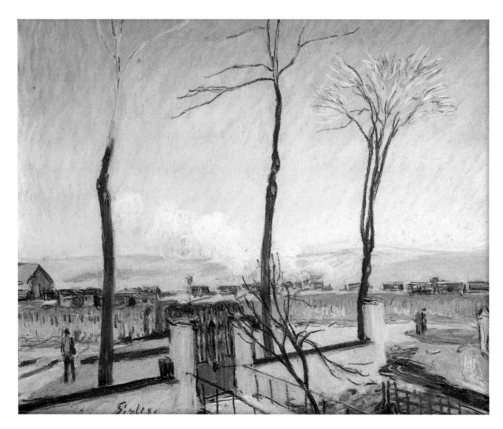

117

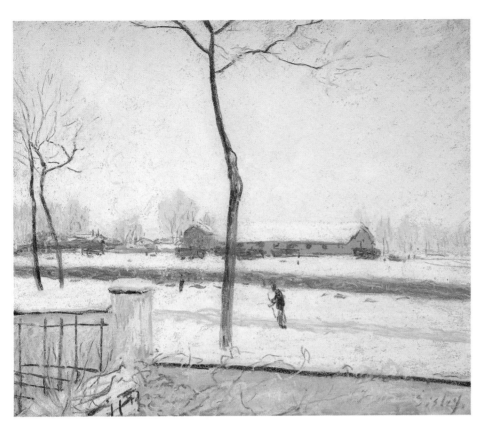

118

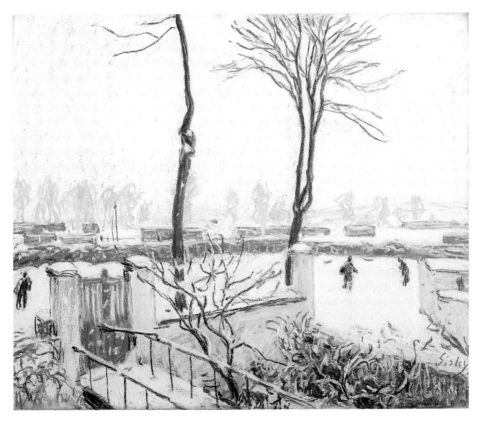

119

116 **Previous page**
Winter Landscape, Moret. 1888.
Pastel, 38 x 55.4 cm.
Von Der Heydt-Museum, Wuppertal.

117 **Previous page**
Winter Sun, Moret. 1888.
Pastel, 46.4 x 55.9 cm. Christie's, London.

118 **Previous page**
Snow Scene, Moret Station. 1888.
Pastel, 18 x 21.5 cm.
National Gallery of Scotland, Edinburgh.

119 **Previous page**
Approach to the Railway Station, Moret. 1888.
Pastel, 38.4 x 46 cm. Cincinnati Art Museum.

120 *Banks of the Loing at St-Mammès.* 1888.
38 x 54 cm. National Gallery of Ireland, Dublin.

From the late 1880s onwards Sisley was increasingly preoccupied with working in series, sometimes of the same strongly defined motif seen from slightly different vantage-points, sometimes by simply adjusting his sight lines from a fixed point, as in the long series of paintings of Moret and its bridge, or the pastels of the station. He would surely have concurred with Cézanne who, in a letter to his son, extolled the infinite possibilities of working in this way:

> Here on the bank of the river the motifs multiply, the same subject seen from a different angle offers subject for study of the most powerful interest and so varied that I think I could occupy myself for months without changing place, by turning now more to the right, now more to the left.[16]

For Sisley, every nuance of change in time of day, light, weather and season could be explored without the confrontation of unfamiliar subject-matter. Unfortunately, whatever initially excited him in his chosen motif is not always apparent and a good many paintings seem blandly repetitious. He loses his consummate sense of tone in an attempt to provide a thin brilliance of surface. He can become too literal and thus forgoes that sense of detached withdrawal that characterizes much of his best work. A lyrical economy of means is replaced by plodding realism.

A comparison of *Bridge at Hampton Court* (Plate 37), for example, with one of the riverside views of St-Mammès or of the countryside around Les Sablons, reveals Sisley's slackening of vision. The earlier work is painted with generous strokes of colour, relaxed in their calligraphic rhythms; the brush-strokes of the broadly painted sky are clearly visible; the river is more densely textured with full dabs of pigment over which Sisley has placed longer, thinner strokes of pale blue. Here is that variety of surface he felt was essential to a work of art; it is as much a direct result of the immediate necessity of feeling, as of conscious surface considerations. In later paintings the facture becomes more complex. Paint is less succulently applied and substantial formal elements lose their pictorial weight in a dry and matted impasto; commas, dashes, spots and loops make up a rough, agitated surface in too great a contrast to the often calmly painted skies. Foliage of trees and indeterminate foreground 'shrub' become furry and congealed, their rhythmic coherence within the composition lost in febrile scumbling. In such ways Sisley frequently creates a false impression of excitement in works that are superficially attractive but which fail to disclose any personal discoveries. Even so, he usually retains a sense of order and contemplation; he is never rhetorical, and when he fails, it is through understatement rather than empty elaboration. These less good works, mainly from the later 1880s,

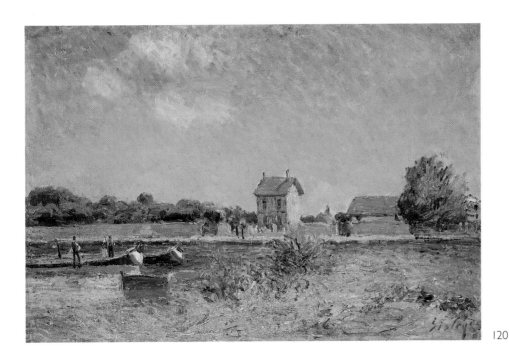

120

certainly have qualities to recommend them or passages of the old beauty, but they are undeniably of a lesser order than his great achievements of the 1870s.

Obviously there were moments of discouragement, and there is a notable falling off after 1885 in the number of works Sisley produced. He seemed less inclined to go out in all weathers. In earlier years he had been intrepid – braving frost, flood, wind and scorching sun. The practical difficulties of pinning down some particularly elusive impression are described in a letter he wrote to Georges de Bellio in 1883:

> The weather has been marvellous here. I have started work again. Unfortunately, because the spring is dry, the fruit trees flower one after the other and are over very soon, and I am hard at it! Life isn't a bed of roses for a landscape painter. This morning the wind was so strong that I was forced to stop. The weather became overcast and raged for a while. But every cloud has a silver lining, as they say, since it has given me the chance to have a short talk with you.[17]

From the mid-1880s onwards Sisley's health was unpredictable and several of his letters allude to influenza, rheumatism and fatigue. At one point he is said to have suffered a partial paralysis of the face.[18] Ill-health and poor spirits probably account for the dearth of works in 1887 –

only five are ascribed to that year in the *catalogue raisonné*. The journeys to Paris began to tire him; he saw less and less of his old colleagues. Pissarro, for example, wrote in 1891 that he had not seen Sisley for at least two years, and in 1899, at the time of Sisley's death, Renoir admitted he had not encountered his old friend since they had attended Manet's funeral together in 1883.[19]

Sisley himself attributed this withdrawal from his old friends and their congenial gatherings in Paris to his uncertain health, even to the strain on his pocket that such visits entailed. This may, in part, have been true but the real reason ran deeper. In many respects he was a changed man, unpredictable in temper and given to periods of hermetic solitude, alternating between extreme affability and black moods of suspicion and distrust. He could no longer be counted on for his jokes and ringing laughter. When he moved with his family to his final home in Moret itself, a high wall surrounded his house and garden.

10 Moret and *La Vieille Eglise*

'A very paltry little town' was how Tobias Smollett described Moret-sur-Loing in one of his letters from France in 1763, though he adds he found good accommodation there. In the following century visitors were kinder and writers of guidebooks and 'travel impressions' enthused over its commanding position on the Loing, its ramparts and gateway, its huge ruined *donjon* and the beauties of its Gothic church. It was not a large place – just over 2,000 inhabitants – but it was the chief town of the district, its once royal past proclaimed by the remains of its encircling walls and towers and some fine Renaissance façades. From the bridge over the Loing the main road enters the town through the Porte de Bourgogne; the narrow principal street (la rue Grande) runs swiftly to a similar tall gateway at the other end, the Porte de Samois; the road continues out of Moret to the station and Veneux-Les-Sablons. The streets between these two great gates are modestly built and close packed; near the church some larger houses dignify the Place Royale, including the part-timbered Maison du Bon Saint-Jacques where, from the seventeenth century until twenty years ago, the nuns of Moret made a delicious *sucre d'orge*. The corner of this building appears at the far right of one of Sisley's paintings of the church (D835; Plates 134 and 128).

The fame of Moret rested not so much on what was found inside the town but on the view it presented from across the Loing (see Plate 121). Old flour and tanning mills clustered along the bridge; the river, scattered with tiny islands, seemed more like a moat protecting the houses and terraced gardens that, on either side the sturdy Porte de Bourgogne, in turn defended the pinnacled tower of the church. Add to this the tree-lined walks along the river, the continuous sound of water from the weir and the great wheels of the mills, the houseboats and fishermen, and there was, as every guide-book exclaimed, 'a captivating picture', a sight 'worthy of the brush'.[1]

These supremely picturesque aspects of Moret left Sisley unabashed. Gathered in one spot were the motifs that had mesmerized him since he began to paint. Here were water, sky, reflections, a busy riverside; the multi-arched bridge was for the artist the last in a long line of such structures going back through Sèvres and St-Cloud and Hampton Court to Argenteuil and Villeneuve-la-Garenne. Here was that conjunction of man-made and natural, the interleaving of foliage and house fronts between sky and water, that marked Sisley's first Impressionist canvases on the Canal St-Martin.

With the exception of two groups of paintings – of the town's church and of the Welsh coast – all the best works from the last decade of Sisley's life are concentrated round this beguiling reach of the Loing. Sometimes he depicts it in heightened colour and with an almost hard clarity of detail; at other times the landscape seems like an apparition, the distant church tower rising insubstantially above the

121 **Previous page**
The church and bridge at Moret-sur-Loing, in 1895.

122 *Alley of Poplars, Moret-sur-Loing – Cloudy Morning.* **1888.**
60 x 73 cm. Private Collection, New York.

123 *The Bridge of Moret and Mills under Snow.* **1890.**
60 x 81 cm. Private Collection.

river, as though seen through misted glass. It was through such paintings that Sisley seems to have recognized not so much a change in his work, but a definite maturing of his vision. In 1892 he wrote to Tavernier that he felt he had made great strides in the previous three years but was even then wishing to enlarge the field of his study – 'd'agrandir mon champ d'études'.

Those three years were spent in Moret itself with everything close at hand. The date of his move from Les Sablons is unsure but it was probably between 1888 and late 1889.[2] Sisley is usually recorded as having lived in two successive houses in Moret, occupying first a property in the rue de l'Église, one of the town's shopping streets, and staying there until late 1894, when he moved to his final home at 19 rue Montmartre between the church and the donjon. But the census of 1891 for the *commune* of Moret shows that he was already in residence in the rue Montmartre (along with Eugénie and Jeanne; Pierre is unlisted and had presumably moved by then to Paris).[3] The artist may well have started his Moret life in the rue de l'Église (his letters are simply inscribed 'Moret-sur-Loing'), but this new date for his occupation of the charming house and garden in the rue Montmartre suggests a settled contentment. The eight-year period (at least) that he lived there was the longest time he had stayed in one house. Built at the corner of two quiet streets, its position was perfect. A small walled garden in front and no immediately adjoining neighbours offered a seclusion that Sisley obviously valued. At the back the upper windows looked over the lilac trees of a further patch of garden (twice painted by Sisley, D807 and D808) and towards the roof-tops of the town.[4]

Sisley's studio was in the attic with two skylights at the front, and this and the first floor were reached by a narrow staircase.[5] The rooms were full of Sisley's unsold paintings, according to one visitor; another recorded that the studio contained 'a few memoranda, mere diagrams often, the jottings of a halt on the way to fix the whereabouts of a subject for another time'.[6] As almost nothing is known of Sisley's painting practice, speculation is fruitless, but it would seem likely that the 1890s saw an increasing use of his studio for the completion of works begun out of doors. A number of later works have a definitely 'finished', slightly artificial look, redolent of painting away from the motif itself.

Of Moret inside its walls, there are few paintings, though some rapid pencil drawings exist – a study, for example, of the rue de la Tannerie, the subject of a pair of paintings (D809 and D810). The first, of 1892, shows the narrow street below Sisley's house in strong sunshine; the other, taken from an identical viewpoint, was made in soft, overcast weather. Also from 1892 there is a small autumn view of the curving rue des Fosses, which formed the old walled boundary of Moret.[7]

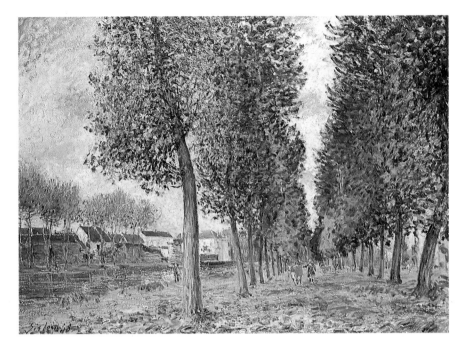

122

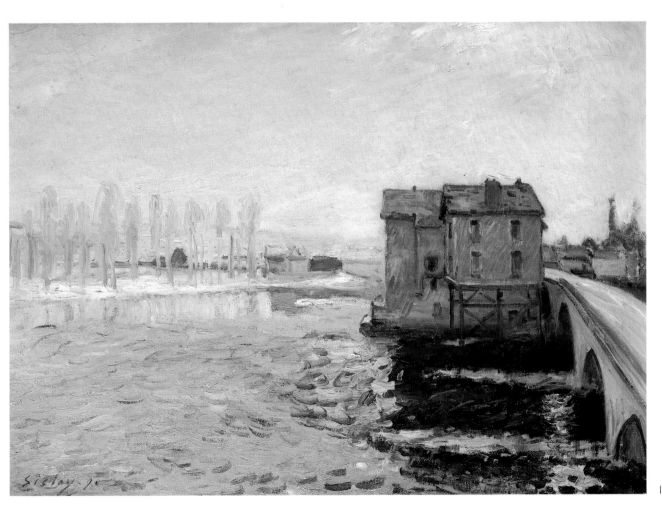

123

124

125

These views culminated in Sisley's substantial series of paintings of the church at Moret, the most extensive exploration of one motif in his work. All show the Église de Notre-Dame, always viewed from the south-west, and painted over a period of about a year – perhaps from summer 1893 to summer 1894. Although most of the group was published in François Daulte's catalogue (D818–22 of 1893 and D834–40 of 1894), and was studied in an earlier exploratory article by Oscar Reuterswaerd in 1952 (see Bibliography), the series is one of the best-kept secrets of late Impressionism.

The details of the series are complex, for it was never consecutively numbered, was not shown in its entirety, and the titles of individual works have not been systematically employed. Even the extent of the series is unknown, and Sisley makes no reference to it in his letters to his friends during 1893–4, the period of its execution. One or two were exhibited in his lifetime – at the Société Nationale des Beaux-Arts (1894) and in the 1897 retrospective at the Galerie Georges Petit. Others appear to have been purchased soon after completion, above all by Sisley's two devoted patrons, Georges Viau (?1855–1939), a dentist, and François Depeaux (1853–1920), a Rouen industrialist.

Fourteen works are definitely identifiable and there are probably two or three more. All save one (D834; Birmingham City Art Galleries) include the façade of the building; seven are vertical canvases (little varying from 81 by 65 centimetres,

the largest being 100 by 81 centimetres; Plate 130) and six are deep horizontal canvases (the largest, again, being 81 by 100 centimetres; Plate 134). A loosely drawn pastel study (Plate 127) established the main lines of the church as seen in the vertical canvases. Its status, however, is uncertain and it is hard to tell whether it was preliminary to the whole series or a brief realignment made while the works were in progress.

Such problems multiply as the group is studied, but three questions in particular must be considered. First, what were Sisley's motives behind the conception of this extraordinary concentration on the church? Secondly, was he influenced in his choice of subject and programme by Monet's series of Rouen Cathedral begun in February 1892. Lastly, did he intend to exhibit the paintings as a group?

The church, of course, was not new to his work. Sisley had painted it on numerous occasions, the distinctive, benign summation of the roof-tops of Moret seen from across the Loing. Its tower appears on the horizon of several paintings made in the nearby countryside in the manner of Ruisdael's *View Of Haarlem*. Sisley himself had mentioned it in a letter to Monet a decade before as one of the attractions of the town.[8] Now that he was settled only a short walk away from the church he began to realize the visual possibilities of its massive bulk above the surrounding cobbled streets. As Proust wrote of his beloved church at Combray, its presence, even when hidden from sight, was entirely dominant and

163

126

124 *Rue de la Tannerie at Moret.* 1892.
 55 x 46 cm. Private Collection.

125 *The Artist's House and Garden, 19 rue Montmartre, Moret.*
 Pencil. Size and whereabouts unknown.
 Reproduced from *The Studio*, December 1899.

126 *View in Moret (Rue des Fosses).* 1892.
 38 x 46 cm. National Museum of Wales, Cardiff.

127 ***The Church at Moret** c.1893.*
Pastel, 30.1 x 23.3 cm. Museum of Fine Arts, Budapest.

128 **The Church at Moret in about 1895.**

129 ***The Church at Moret in Sunshine.** 1893.*
65 x 81 cm. Musée des Beaux-Arts, Rouen.

127

164

every view among the houses of the town seemed to be composed with reference to it.

None of this long familiarity, of course, explains Sisley's absorption, month after month, in a single view of the building. After years of stalking it from all angles there is almost a feeling of relief as he makes his final confrontation. He takes the most obvious view of the church, the one that appeared most often on contemporary postcards (Plate 128) and is still its most photographed aspect. Curiously, it is scarcely picturesque, with most of the tower obscured and the fine sculpture on the façade being virtually invisible. However, by choosing this view, awkward in its blunt factuality, Sisley has avoided some of the inevitable associations of what was, after all, a famous building in a much-visited town. Characteristically, he has not separated the church from its setting (as Monet mostly did in Rouen). To the right, a pump and covered market provide foreground animation and a sense of scale; to the left, the rue de l'Église slips into the distance, with the wooded heights above the Loing just beyond. Even in this unusual composition Sisley keeps faith with those tenets of spatial organization that had marked his work from the beginning.

Sisley's view of the church is taken from the corner house of the rue de Grez (continued by the rue de l'Église) and the rue du Puits du Four. Photographs taken from the stepped doorway of the house give almost exactly Sisley's

view but he may have worked from a window above. Obviously, if he painted extensively *in situ*, he would have had to have been comfortable, with room for a sizeable canvas and easel. This suggests that he adopted a position inside the house, as was often his practice. It also suggests that Sisley worked on the series in his studio and that he may have used photographs of the church as *aides-mémoire*. The drawing of the silhouette and the details of the architecture in each of the paintings are astonishingly similar, as though a tracing had been used.

Once he had established, as it were, the skeleton of the painting, then the real work began. He chose a variety of times and weather – from a wet morning in December (ex-Daulte; Plate 135) to the late afternoon sunshine of waning summer (D820; Plate 129) and a dismal afternoon in winter (D836; Plate 131). Incidental detail is kept to a minimum – passers-by change from picture to picture, a cart appears near the pump, a flight of birds whirls into the sky. Yet the church holds its ground, simple and ornate, bulky and delicate, as it receives the infinitely varied inflections of the light. Now its roof is tangerine against the most intense blue sky (D840; Plate 130), now a muddy grey, dulled by rain (Plate 133). A palpable facture of short strokes, dense or thin, maintains alternations of movement and weight over the whole surface. Sisley's subtle chromaticism is given full play, from the complex intervals of colour on the flying

128

129

buttresses to the diminutive street with its hazy weft of red and violet shadows (Plate 130).

Each work is pervaded by that continual note of withdrawal from the world; Sisley refuses to be distracted, never says more than he need, suggests no social or religious implications. By remaining prosaically steady-eyed, he achieves a visual poetry that is more akin to the doting tranquillity of earlier Dutch and English masters than to Monet's prophetic dissolutions of Rouen Cathedral.

All discussions of the paintings of the church at Moret raise the question of Monet's influence on Sisley's conception. There is too little evidence to form any conclusion. Even if one agrees with some commentators that Sisley simply stole the idea from his friend's Rouen series, the resulting comparison is unjust to Sisley's aims as well as to his achievement. He had, after all, worked in pairs or small groups of paintings since the early 1870s. His familiarity with the work of Turner and Constable and of Rousseau at Barbizon was an inescapable precedent. The idea for this extended series of paintings of the church might well have evolved quite naturally from the long sequence of paintings of Moret seen across the bridge and from the group of the bridge itself (D656, 657, 660; Plates 137 and 138). He is sure to have known Monet's grain-stacks series, fifteen of which were shown by Durand-Ruel in May 1891, although it is unlikely that he had seen any of Monet's Rouen Cathedral

group by the summer of 1893 when he started his own church series. Monet had begun painting the cathedral in February 1892, but did not exhibit his work until 1895. That Sisley had heard about the paintings is apparent from a visit he paid to Rouen in early February 1893 to see his friend and collector François Depeaux. They were joined by the painter Albert Lebourg, a great admirer of Sisley's work; Lebourg took Sisley through the streets of Rouen to the rue du Grand-Pont to show him the angle of vision Monet had adopted for the first of his cathedral series. The account of this visit does not make clear whether or not Monet was actually back in Rouen at the time, but he began his second campaign there in mid-February.[9] By then the extent of Monet's project was well known among his friends, and Sisley could hardly have escaped hearing about it, not only from Depeaux and Lebourg, but also from critics such as Geffroy, a friend of both artists. But to hear of the paintings is a different matter from seeing them. However, the possibility must be entertained that some element of competition with his old friend pointed Sisley in the direction of his own local 'cathedral'.[10]

Nevertheless, the comparison with Monet was made almost from the start. In mid-September 1893, when Sisley's series was under way, Berthe Morisot, her daughter Julie, and Mallarmé, driving from nearby Valvins to Moret, met Sisley, who must have shown them his new work. Mallarmé, it

166

130

130 **The Church at Moret. 1894.**
100 x 81 cm. Musée du Petit Palais, Paris.

131

131 **Detail**
The Church of Notre-Dame at Moret after Rain. 1894.
73 x 60 cm. Detroit Institute of Arts.

168

132

132 **The Church at Moret in Morning Sun. 1893.**
 80 x 65 cm. Kunstmuseum, Winterthur.

133

133 ***The Church at Moret, Rainy Morning.* 1893.**
81 x 65 cm. Langmatt Foundation
Sidney and Jenny Brown, Baden, Switzerland.

134 ***The Church at Moret, Evening. 1894.***
81 x 100 cm. Private Collection.

135 ***The Church at Moret, Rainy Morning. 1893.***
**65.9 x 81.3 cm. Hunterian Art Gallery,
University of Glasgow.**

136 ***The Church at Moret – Icy Weather. 1893.***
65 x 81 cm. Private Collection.

134

170

seems, at once concluded that the series was derived from Monet's.[11] Since then the paintings have continued to exist in the shadow of the Rouen Cathedral series, inevitably denigrated in the face of Monet's overwhelming achievement. In some measure this typified the public perception of the two artists themselves, and may explain Sisley's readiness to agree, for example, with Tavernier's censuring of Monet's work in an article; he wrote to the critic: 'You have attacked Monet on one of his most vulnerable aspects: his exhibitionist side.'[12]

On the other hand, Monet was strenuous in his support of Sisley and showed a continuing interest in his affairs. He was pleased, for example, when the Société Nationale des Beaux-Arts elected Sisley to membership in 1890, enabling him to show his work each year at the annual exhibitions held in the Champs-de-Mars, Paris: 'There is better news of Sisley', he wrote to Gustave Caillebotte,' he exhibited at the Champs-de-Mars where he had six canvases very well displayed, which must have done him some good.'[13] But it must have been irksome for Sisley to see Monet's tremendous rise to fame in the 1890s. Even the unusually temperate Pissarro bracketed himself with Sisley as being 'treated worse than the others'; '. . . like Sisley, I remain in the rear of the Impressionist line.'[14] But whereas Pissarro lived just long enough to see his fortunes change for the better, Sisley did not. His last years have frequently been seen as one gradual decline without a glimmer of hope, his work falling off in quality as well as quantity.

Misanthropic, bitter, resigned to obscurity, easily pleased by a word of encouragement but swift to take offence, the victim of a conspiracy in the art world of Paris, envious of the success of his old colleagues: thus has the portrait of Sisley in his last years been drawn. Others saw a man who, if certainly resigned, never gave way to bitterness: 'He only rejoiced in the favour which had fallen upon some of his group, saying with a smile, "They are beginning to give us our due: my turn will come after that of my friends."'[15]

The critic Arsène Alexandre was the first to indicate the changes that had occurred in Sisley's character. He contrasts the carefree Sisley of before 1870, full of gaiety and high spirits as he worked alongside his friends in the Forest of Fontainebleau, with a man who became suspicious and unsociable. He would bite the hand that tried to feed him, and could turn abruptly and ungratefully on those whose solicitude he had welcomed a moment before. Alexandre, writing in 1899, says that it was ten years earlier that Sisley had suffered most from these black periods of anxiety, irritability and discontent. He is probably referring to the late 1880s, the period of Sisley's adult life about which the least is known. But it would seem likely that the roots of this change in his conduct went back much further. Perhaps

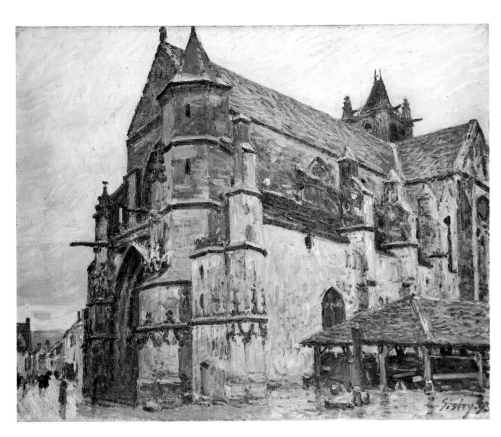

135

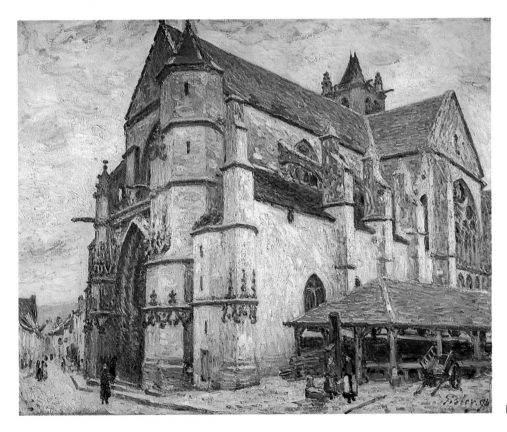

136

137 *Moret-sur-Loing – Rain.* 1888.
 54 x 73 cm. Private Collection.

138 *Street in Moret (Porte de Bourgogne from*
 across the Bridge). c. 1888.
 60 x 73.2 cm. Art Institute of Chicago.

 Detail
 Street in Moret (Porte de Bourgogne from
 across the Bridge). c. 1888.

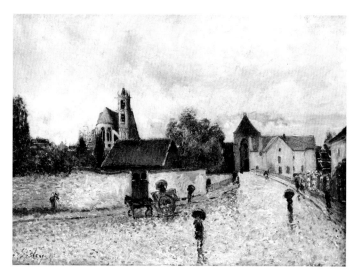

137

172

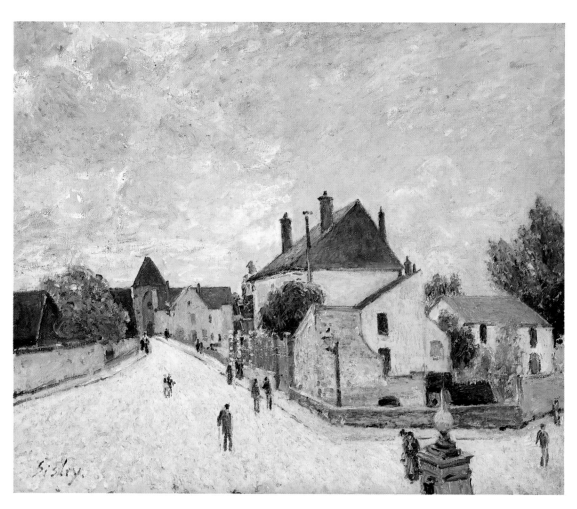

138

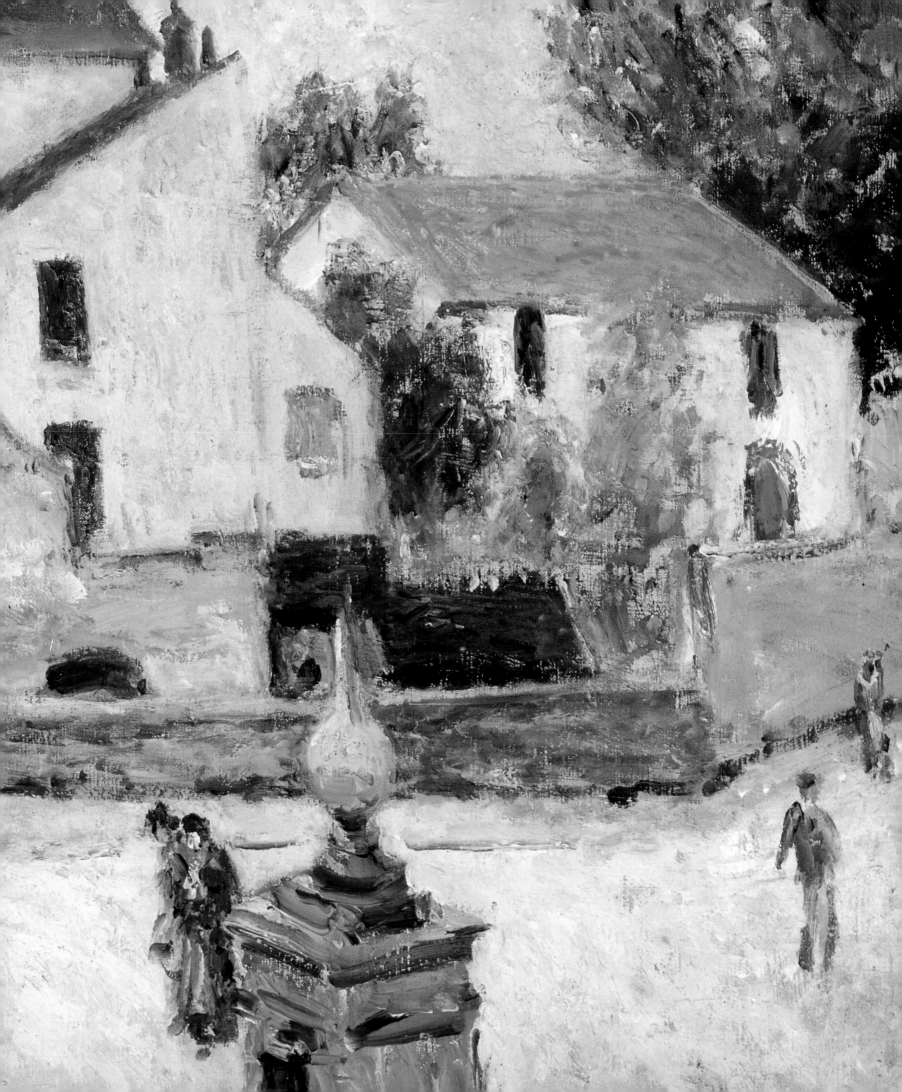

139 ***Barges on the Canal du Loing, Spring. 1896.***
 54 x 65 cm. Ordrupgaard Collection, Copenhagen.

140 ***The Bourgogne Lock at Moret – Icy Weather. c.1882.***
 54 x 73 cm. National Gallery, Prague.

174 there was some hereditary strain of mental imbalance in the Sisleys – Sisley *père*, it should be remembered, was described as having died 'mad', and the glimpses we have of Alfred's son, Pierre, after his father's death are hardly reassuring (see Appendix A). Alexandre advances a theory that Sisley was a deeply divided man, not only in his general behaviour, running as it did from one extreme to another, but also in the role of artist, when he was totally separated from his daily character. Before his easel, from which flowed works that showed no sign of his troubled spirit, he held to some inner strength and serenity derived from music:

He told me, one day when we were chatting about art, that when he was young he had gone to Pasdeloup's 'Popular Concerts', and one of the things that had moved him most, and produced a sensation of unforgettable ecstasy was the trio of the scherzo in Beethoven's Septet

'This phrase was so lively, so catchy and stirring,' he told me, 'that it seemed as if, ever since the first time I heard it, it was part of myself, it answered so exactly to every-thing at the very depths of my being. I sang it continually. I hummed it as I worked. It has never left me . . . '

And that is undoubtedly the explanation! Life had been only too full of difficulties, some imaginary and others, alas! only too real; at work, a sort of secret scherzo had saved his painting from the worries of his domestic life. (See Appendix D.)

It is an ingenious theory and valuable as first-hand evidence, for Alexandre knew Sisley in his later years, but it has a romantic ring to it, and might be more plausible were there any corroborative evidence.

Nevertheless, Alexandre's more general observations on Sisley's fluctuating state of mind and erratic behaviour are confirmed elsewhere. His old friend Murer, for example, wrote that he was misanthropic in his later years and was vulnerable enough to show a certain bitterness towards Monet's increasing public acclaim.[17] Another insight is provided by the journal kept by Julie Manet. Two days after Sisley's death Renoir talked to Julie of his old friend: 'Monsieur Renoir has been saddened by the death of Sisley, who had been the companion of his youth and for whom he retained great affection, although he had not seen him since the death of my uncle Edouard [Manet].'[18] Julie records how Renoir returned to the theme a few weeks later:

Later we talked of Sisley and the way in which he had lived so withdrawn at Moret in these last years, thinking

139

140

that everyone wanted to rob him. When he met Monsieur Renoir, with whom he had once lived, he crossed the road to avoid speaking to him. He made himself very unhappy. Monsieur Renoir reminded me that when I went to Valvins with Maman we met him one day when we were visiting Moret. Maman persuaded him to come and see her at Valvins, he accepted, then, after he had said good bye, he ran after her and said: 'Well, no, I shan't be coming to see you.'[19]

But if Sisley cut himself off from the friends of his youth, he cultivated new ones, especially those who might be helpful to him. Some of these only saw Sisley's affable and cultivated side, the man whose conversation was enchanting, who was well-read, knowledgeable of the life around him in Moret, and completely absorbed in the beauty of the nearby countryside and the Forest of Fontainebleau. This was the figure recollected by Gustave Geffroy, one of Sisley's most eloquent and devoted champions in the 1890s and the author of the first book on the painter.

Sisley was always punctilious in thanking anyone who mentioned his work favourably in the press – not, it must be said, a frequent event.[20] His friendship with the critic Adolphe Tavernier (1853-1945) seems to have evolved in this way. Tavernier's long and appreciative article on Sisley in 1893 in *L'Art français*, marking the artist's exhibition at

Boussod et Valadon, sealed their good relations. The younger man obviously encouraged Sisley, wrote about him on further occasions, was given paintings (and purchased others), and spoke at Sisley's funeral.

Early on in their friendship Sisley had sent Tavernier a copy of a letter he had just written. It was a fierce rejoinder to Octave Mirbeau's dismissal of his recent work at the 1892 Salon of the Société Nationale, as being a feeble echo of his former achievements. Mirbeau's criticism had appeared in the *Figaro* where he entertained a large readership with his volatile, forthright views on art, and aired his great admiration for Monet, Pissarro and Rodin among others; thus his 'chronique désobligeante' was launched from within the citadel and struck Sisley as further confirmation of a conspiracy against him.[21] The complaint from Mirbeau came at a time when Sisley felt he had made great strides in his painting. On 1 June he wrote to Tavernier:

My dear friend,
To keep you in touch – here is a letter that I am asking M. F. Magnard to insert in the Figaro.
'Monsieur Mirbeau,
An article on the Salon that appeared in the Figaro of the 25th of last May, in which you consecrated a few rather unfriendly lines to me has been brought to my notice. I have never replied to a criticism made in good faith.

I always, on the contrary, try to profit by it. But there the intention to do injury is so evident that you must allow me to defend myself. You have made yourself the champion of a coterie which would be happy to see me in the dust. It will not have this pleasure, and you will gain nothing by your unjust and perfidious criticism.' There! Do you think I was right to reply?[22]

Sisley's suspicion of this malevolent coterie may have been a further reason for his abandoning attendances at the monthly Impressionist dinners and at the 'Pris de Rhum' dinners organized by George Charpentier. To the latter, Sisley had given more practical reasons: that his health forbade his attendance, that it was inconvenient and expensive to spend the night in Paris and that he lived 'trop Loing'.[23] In the mid-1890s his visits to Paris became less frequent. He told Tavernier that he had only been there twice in the first six months of 1895 and then it was to see his dentist, who was, of course, Georges Viau: 'Qu'il est donc adroit! et quel homme charmant.'[24]

On the other hand, it should not be imagined that Sisley was entirely isolated in Moret or that his contacts with the world were severely limited. In 1894 he spent the summer as a guest, first of Murer in Rouen and then, near by, at the country home of François Depeaux. Depeaux's enthusiasm for Sisley's work eventually led to his owning nearly fifty of his paintings. Four of these came to him from this Normandy visit – in exchange, presumably, for 'board and lodging'.[25] In this way Depeaux greatly eased Sisley's material circumstances during his final years.

In Moret itself Sisley was by no means alone in depicting the town and its surroundings. In the years during which he lived there its popularity with painters (and with writers and musicians too) made it one of the most colonized districts, on a par with Dieppe or with Pont-Aven in Brittany. Views of the old bridge and church, of the Loing and the Seine at St-Mammès regularly appeared at the Salon and the Société Nationale des Beaux-Arts. Nearby Grez-sur-Loing, a few kilometres upstream, provided another centre, particularly for British and American artists. It was from there in 1893 that the young American student, Ernest Lawson, came to Moret to pay homage to Sisley.

Its most famous resident from the late 1890s onwards, however, was the composer Frederick Delius. The affinities between his orchestral music, such as the 'tone poems' *Summer Night on the River* or *A Song before Sunrise*, and Sisley's paintings of the Loing are inescapable in their descriptive mood. The long, winding, melodic line of Delius, with its elegiac sonorities and sudden moments of intensity, forms a perfect counterpart to some of Sisley's last works. In particular, the series which Sisley appears to have left unfinished, of a wide turning in the Loing, just beyond Moret,

141 *Moret-sur-Loing*. 1891.
65 x 92 cm. Galerie H. Odermatt-Ph. Cazeau, Paris.

Detail previous page
Moret-sur-Loing. 1891.

142 **Moret-sur-Loing.**

180

is astonishingly evocative of Delius's spacious, trance-like orchestral colour. As well as works by Monet and Gauguin, Delius owned one of Sisley's paintings; but there is no record of a meeting between these two 'English' neighbours, equally devoted to this corner of the Ile-de-France.

Among Sisley's visitors at Moret, perhaps the most unexpected was the young Francis Picabia (1879–1953) whose early Sisleyesque landscapes, brilliant pastiches, give little indication of his spectacular contribution to the twentieth-century avant-garde. Perhaps the precocious Picabia was one of the 'several painters' who visited Sisley in the autumn of 1897, mentioned in a letter to Tavernier.[26] At the same time he had met 'Miss Hallowell, an American who has great influence in her country', and of whom Sisley doubtless entertained hopes of transatlantic deals.[27]

Another American who eventually settled in Moret was a fellow exhibitor with Sisley in the exhibitions of the Société Nationale des Beaux-Arts. She was Miss Kathleen Honora Greatorex who, having initially specialized in oriental landscapes, obviously transferred her affections, as did many of her compatriots, to Impressionism, and showed landscapes of Giverny and of Moret (such as *Bateau-Lavoir at Moret*, in the 1892 exhibition). She does not figure in any study of Sisley nor in his letters, but there is a touching account of her as an elderly expatriate recorded by Claude Sisley in his article on his family:

In 1926, while staying in Paris, my wife and I went to Moret where Alfred had lived . . .
We heard that there was an old lady living in the village who had known him well, called Miss Greatorex, whom we visited. She proved to be a good-looking but very fragile old lady – possibly over 80 years of age . . . She was amazed to see me. 'I always understood that Alfred had no relation in the world.' From what she said it was clear that she had been the only friend that Alfred had had in the village. He had always been very poor, and although she did not say so in so many words, it was evident that she had helped him with money and hospitality. She told us that he had married his wife after the two children had been born, and that they had been legitimised.[28]

It is not known whether Miss Greatorex knew, during Sisley's own lifetime, the details contained in that last sentence. Given Sisley's secretiveness about his personal life, she may well have been kept in the dark about his real reasons for disappearing to England in June 1897.

181

141

12. MORET-SUR-LOING — Vue d'ensemble en Aval du Pont

142

11 A Midsummer Marriage

Sisley's personal history in the last two years of his life was, at first, overshadowed by the critical and commercial failure of a large retrospective in February 1897. Following this, there was a midsummer interlude of three months in England and Wales during which he produced one of the most captivating groups of work of his later years. In the last months of 1897 and early in the following year, there were definite signs of an improvement in his reputation, if little in his material circumstances. But any comfort or elation this may have given him was obliterated by Eugénie's final illness from cancer and, at the same time, the discovery that he himself had contracted the disease.

Two days before Christmas 1896 Sisley told Tavernier that he had just concluded an arrangement with Georges Petit whereby he would be given the gallery's 'grande salle' for a retrospective in February.[1] Petit was full of enthusiasm for the success of the show; Sisley approached several collectors of his work to ask them to lend their best examples. He wrote to Charpentier and Viau, to the dealer Eugène Blot, to his admirer, the fashionable jeweller Henri Vever; he saw François Depeaux and Edmond Decap. A catalogue was prepared with a preface by Léon Roger-Milès, a critic and collector with a special enthusiasm for contemporary landscape painting.

The exhibition opened on 1 February and ran for a month; 146 paintings and six pastels were shown, and though the bulk of the exhibition was devoted to the work of the 1880s and 1890s, there were good early paintings going back to the *Parc de Courances* of 1868 (D10), the Argenteuil *Fishermen Mending their Nets* (D27; Plate 161) and J.-B.Faure's three Hampton Court paintings (D118, 121, 122). It seemed the perfect opportunity to assess Sisley's contribution to Impressionism and, as Petit must surely have thought, to acquire his work. Alas, the exhibition was a dismal fiasco. There were no sales (though admittedly many of the best works were already in private collections) and only a handful of reviews.[2]

Sisley's hopes for the exhibition had been bolstered by the recent successes of his fellow painters. Several retrospective and one-artist shows in the years preceding Sisley's had consolidated the reputations of his friends and colleagues. If Impressionism was still derided in many quarters, the public had had no lack of opportunity to see both old and new work by its leading practitioners. Retrospectives for Renoir and Pissarro in 1892 had been critical and financial successes, particularly for Renoir; the acclaim given to Monet's Rouen Cathedral paintings in 1895 had been outstanding; and Berthe Morisot's exhibition in 1892 at Boussod et Valadon had surprised her by its number of sales and enthusiastic press. At the same time, numerous group shows and exhibitions elsewhere in Europe and in the United States, if still arousing puzzled disdain, already showed the

143 **Previous page**
Alfred Sisley. *c.*1897.
Photograph. Sirot-Angel Collection, Paris.

144 ***The Cardiff Shipping Lane*. 1897.**
54 x 65 cm. Musée des Beaux-Arts, Reims.

184 widespread influence of Impressionism on young painters from Chicago to Munich.[3]

The 1890s can be seen as the first period of assessment for the Impressionist movement instigated thirty years before and of which Sisley was already an acknowledged participant. Yet his importance could hardly be gauged from the more recent paintings he had shown in the 1890s. There was little in these essentially conservative works, notwithstanding their often brilliant colours and surprising variety of brush-work, to excite the emerging generation of artists. At the same time, it was still far too early for his work of the 1870s to have achieved the irreproachable status that it gained in the decade after his death. This most 'discreet and gentle' of the Impressionists, as Van Gogh called Sisley, attracted only imitators and pale followers.[4] As a representative figure of Impressionist landscape painting, but one who had not dramatically pushed forward from the original precepts of the movement, his consistency was his undoing. The work of Monet and Renoir appeared far more seductive to those painters of the 1890s who were forging styles that were to lead to the exhilarating innovations of the early twentieth century.[5]

Sisley's extensive stay in Wales in mid-1897 has long been the subject of curiosity – why would this, by now, ailing artist leave his family to spend three months alone on the Welsh coast? The usual explanation is that his patron, François Depeaux, visiting Cardiff on business, had recommended Wales to Sisley and offered to pay his expenses. Sisley himself may well have felt a need for the challenge of new subjects, in line with his desire to broaden the scope of his work, and some weeks by the sea would benefit his health. However, the circumstances of his visit were different; he had a specific purpose and neither was he alone; Eugénie accompanied him.

They crossed to Southampton at the beginning of July 1897:

We were at Falmouth after we left Southampton – Falmouth is a pretty little town in Cornwall, on the edge of a delightful bay; we stayed several days, but since I did not find what I was looking for, we left for Cardiff, a coal-mining town![6]

They quickly removed themselves from the smoke and docks of Cardiff, and on 9 July settled in Penarth, a small resort just south-west of the city. Here they found cheap and comfortable lodgings with a Mrs Thomas at 4 Clive Place, a modest semi-detached house near the centre of the town. From there it was a short downhill walk to the sea front. 'The town has everything an English seaside resort entails: an Esplanade, a Beech [sic] and a Pier where you can walk on the sea.'[7] He must surely have remembered his

144

145 *The Bristol Channel, Evening.* 1897.
Coloured crayon, 18.8 x 25.3 cm. Musée du
Petit Palais, Paris.

146 *Bristol Channel from Penarth, Evening.* 1897.
54 x 65 cm. Allen Memorial Art Gallery,
Oberlin College, Oberlin.

147 *English Coast (Penarth).* 1897.
53 x 64.5 cm. Niedersächsisches
Landesmuseum, Hannover.

186

145

anxious pacing, years before, of the pier at Ryde, while
waiting in vain for his canvases to arrive. On this occasion he
seems to have come well provided with French materials.

After a few days he began work, choosing a breezy spot
on the highest cliff outside the town. To his left Penarth Pier
was just visible, with Cardiff Bay beyond (D866 and ex-
Daulte; Plates 144 and 147). Straight ahead was the Bristol
Channel, dividing the Welsh and Devon coasts. This, he
wrote, was 'superb', with its busy shipping lane of vessels,
sailing in and out of the great port.[8] Turning to his left, he
painted the undulating edge of the cliffs, a favourite summer
walk, with the shore far below; in the distance lay the head-
land of Lavernock Point and, in the haze on the horizon, the
island of Flat Holme.[9]

To his 'dear friend' Tavernier, Sisley gave his impressions
of his surroundings: they were mixed and he found good and
bad, side by side. He liked his lodgings but found the people
he met 'not very friendly – nor the English'; there were two
kinds of food: bad and less bad; as for the beds, they appalled
him: 'a mattress in 2 *sections* stretched upon a kind of coat of
mail' – they had to be seen to be believed.[10]

In this same letter to Tavernier, Sisley tells him that he
had made the acquaintance of the French Consul in Cardiff,
a 'charming man' by the name of Adolphe de Trobriand 'who
has been very helpful to me', although he does not disclose
the nature of his business with the Consul.

146

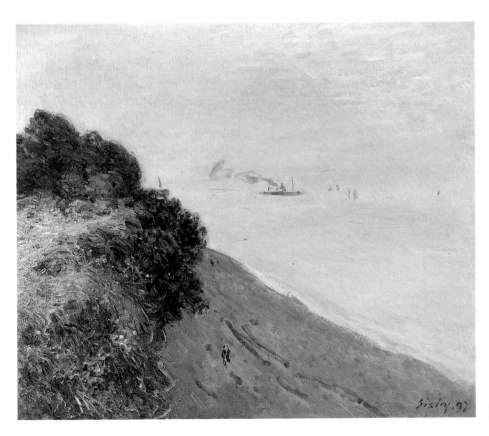

147

148

The surprising point was that on 3 August Trobriand had witnessed Eugénie's declaration that Alfred Sisley was the recognized father of her children Pierre and Jeanne. Two days later, on 5 August, Sisley and Eugénie Lescouezec were married in Cardiff Register Office.[11] This desire to legitimize their union, after more than thirty years of living together, almost certainly lay behind their plan to visit Wales. Neither was in robust health and old age was approaching – Sisley was 57 and Eugénie was 62. As an Englishman, it was easier for Sisley to marry under English law; to do so in Cardiff avoided the complications (and possible publicity) of marriage in France. Eugénie, as a French citizen, had signed the declaration of recognition in order to establish the rights of inheritance of the couple's two children. There is even the possibility that the marriage was prompted by Jeanne, for her father mentions that he had come to know Trobriand 'through my daughter'. Perhaps Jeanne, who still lived with her parents in Moret, was with them in Wales.

Whatever the exact circumstances behind the marriage, it ended the long 'irregular liaison' which had forced Sisley's break with almost his entire family. Eugénie was now Madame Sisley, as she had been in name all along to their friends and neighbours. Such late marriages were by no means unusual among Sisley's friends, for Pissarro, Monet and Renoir all married after their children had been born.[12] But the Sisleys left it later than any of the others and

Eugénie was to live as Madame Sisley for scarcely more than a year.

Ten days after they had been married at Cardiff, the Sisleys moved further along the coast, to Langland Bay, a few miles from Swansea on the Gower Peninsula. They stayed at the Osborne Hotel, perched on the very edge of the cliff and presiding over Lady's Cove (now called Rotherslade Bay), an inlet at one end of the larger sweep of Langland Bay. The Osborne and the nearby Rotherslade Hotel were recommended in the guidebooks as suitable accommodation from which to explore the dramatic coastline with its grotesque limestone rocks, its magnificent views across to Devon, twenty miles away, its exotic flora and excellent bathing.[13]

Probably it was François Depeaux who suggested to Sisley that he stay at Langland Bay; certainly he visited it while Sisley was there, for a pencil drawing (Plate 148) survives of what appears to be the lounge of the hotel, inscribed by the artist: 'to Monsieur Depeaux, a memento of his visit to Osborne Hotel, Langland Bay. His obedient A. Sisley.'

On 18 August Sisley wrote to Tavernier:

I have been here for 5 days. The countryside is totally different from Penarth, hillier and on a larger scale. The sea is superb and the subjects are interesting, but . . . you have to fight hard against the wind, which reigns supreme here. I had not experienced this nuisance before, but I'm

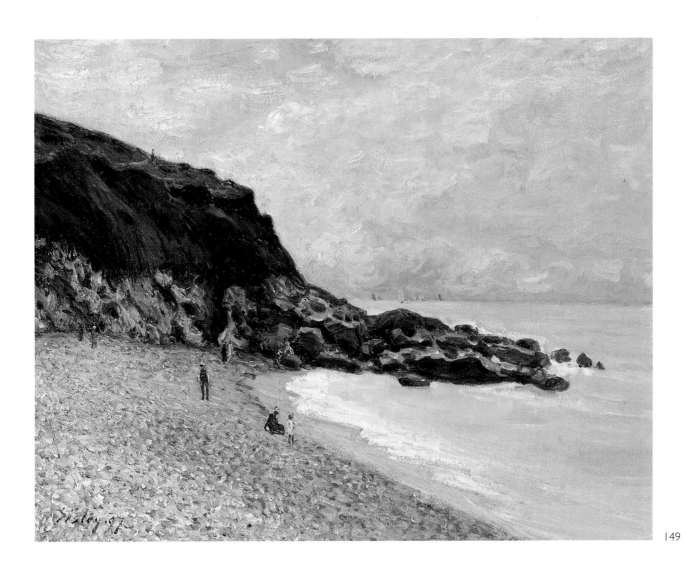

149

148 *Lounge of the Osborne Hotel, Langland Bay.* 1897.
Pencil, 15.6 x 25.4 cm. Private Collection.

149 *Lady's Cove before the Storm.* 1897.
65 x 81 cm. Fuji Art Museum, Tokyo.

150 **Following page**
Langland Bay, Storr's Rock – Morning. 1897.
65 x 81 cm. Kunstmuseum, Bern.

151 **Following page**
The Wave, Lady's Cove, Langland Bay. 1897.
65 x 81 cm. Private Collection.

Detail following page
The Wave, Lady's Cove, Langland Bay. 1897.

190

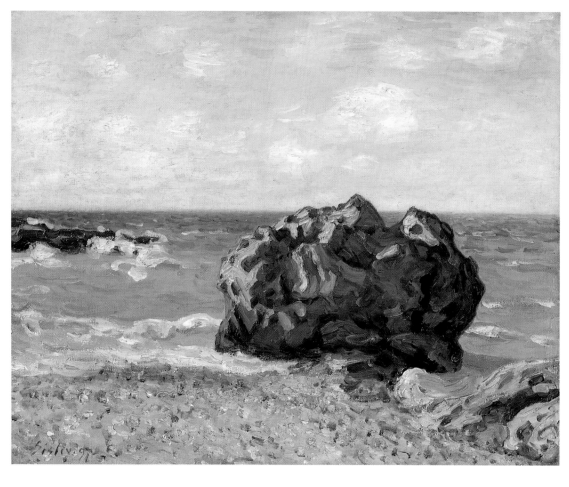

150

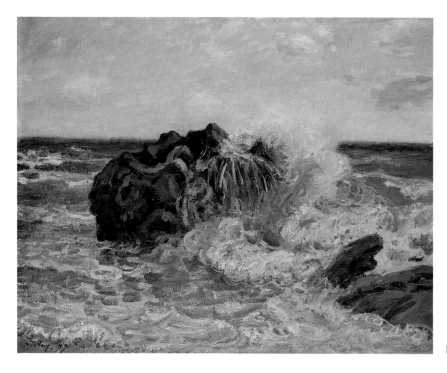

151

152 *Bathing Machines on the Beach, Langland Bay.* **1897.**
Crayon, 15 x 25 cm. Musée du Petit Palais, Paris.

153 *Lady's Cove, Langland Bay.* **1897.**
Pastel, 28.5 x 36.5 cm. Tzwern-Aisinbet Fine Arts,
Brussels.

154 *Lady's Cove, Langland Bay – Morning.* **1897.**
65 x 81.2 cm. Private Collection.

152

192

getting used to coping with it and I have already discovered the knack.[14]

He did not have to venture far from the hotel to find what he wanted. A little way down the beach the enormous Storr's Rock provided a startling motif, either splashed by the tide or high and dry in the evening sun (D877–81; Plates 150 and 151). He painted the beach itself, with its strip of sand below the shingle dotted with strollers and bathers (D871 and 872; Plate149); up on the cliff above them, people make their way along the coastal path (Plate 146). He worked in oil and in pastel, and made several drawings, including one of the bathing-machines on the beach, with Snaple Point in the background (Plate 152). He was pleased with what he had accomplished and, a fortnight after his return to Moret in the first days of October, he told Tavernier he had worked well and brought back twelve paintings, all of the sea at Penarth and Langland: 'so come and see them'.[15]

This body of work, exploring effects of light and the vagaries of the sea, inevitably invites comparison once again with Monet.[16] At the Seventh Impressionist Exhibition Monet had shown several views of the sea at Fécamp, the horizon line pushed to the top of the canvas, allowing maximum contrast between densely coloured cliffs and shimmering sea below. Sisley must have remembered such works (he showed in the same exhibition) and their echoes abound in the

Penarth paintings. It should be recalled, however, that he had used similar, if less immediately radical, strategies of composition himself in his views of the Seine seen from the hillsides of By and Thoméry and in the group of views of Moret from above the Loing (D351–4). His viewpoint in the coastal paintings is as vertiginous as Monet's, but he remains so enamoured of discreet tonal changes and a measure of descriptive nicety that his images appear less flat and undoubtedly less obviously sensational.

The five paintings of Storr's Rock (D877–81) virtually constitute Sisley's farewell to painting.[17] Each takes a different time of day, from morning high tide to evening low tide, and shows the rock from different angles. Its eastern side is a cleft and jagged mass as the waves buffet from the south; its northern aspect, more bulbous and looming, is seen in late September sun, a molten and empurpled silhouette. Inevitably, Sisley's paintings assume symbolic associations of endurance, in spite of his refusal to romanticize. At the same time, they suggest the whole direction of his endeavour, his search for an equilibrium between stability and transience, between material permanence and the constant flow of light, weather and the seasons. The rock remains hard and tenacious beneath its chameleon changes of outline and colour; breaking against it, the sea sprays into the air, an exemplary image, confessional in its intensity, for the close of Sisley's life.

153

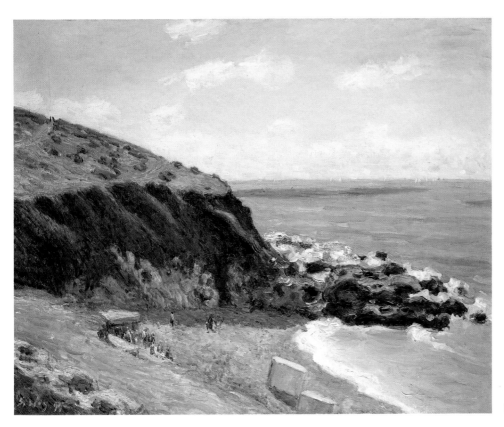

154

12 'Mon Malheureux Ami'

Little is heard of Sisley once he had returned to his 'beloved' Moret. He went on to complete several views of the Welsh coast and continued to make additions to a series of paintings begun in 1896, seasonal variations of a view on the Loing – trees banked against the sky, a tow-path in the foreground; the river slowly turns on its final stretch between Moret and the Seine. The mood is pervasively elegiac, the ingredients familiar, but the effect is even more distanced by the aloof introspection of Sisley's viewpoint. The elements of his world seem held in suspension.

In the following year painting itself was abandoned. Although there are notes and letters to friends, and four of his paintings were attracting admiration at the Champs-de-Mars Salon in May, all Sisley's attention was now turned towards Eugénie. She was dying from cancer of the tongue. 'Sisley was the soul of devotion, looking after her tirelessly, watching over her as she lay in her chair trying to rest.'[1] The inexorable disease had no cure and on 8 October 1898 she died. Later that day Pierre Sisley went to the Hôtel de Ville to register her death, and two days afterwards she was buried in the cemetery on the edge of Moret.[2]

A month later, Sisley wrote that he himself had been in the hands of doctors for five months. Fears for his own health had surfaced during Eugénie's terrible decline. It was found that he was suffering from cancer of the throat. As various treatments made him impatient for results, he began to lose heart: 'No change; no improvement.'[3] He gave up a horrible 'Colonel' de Brocq (even though he was a collector of Sisley's work) and tried another doctor, recommended by American friends. Yet his state remained precarious, and there were even moments of relief:

> I have recovered better than I would have believed possible from my last haemorrhage. My strength has returned a little, although I am still ridiculously thin. I have a localized treatment with sodium arsenate: rinses, washes and powders of Pond's Extract, leg- and back-massage with eau de cologne. I should never have thought that anything so simple could be so effective. You see, my dear friend, that I am holding my own for as long as I can.[4]

Athough he was not going to succumb easily and further courses were tried, he must have known, as all too painfully revealed by Eugénie's death, that his disease was incurable. Earlier, in a letter to Dr Viau, his medical adviser now that Georges de Bellio was dead, he had remembered Eugénie: 'When I was discouraged, my good and brave freind always used to tell me: We must struggle to the last; that is what I am doing.'[5] In all Sisley's letters this is the only indication of his relations with Eugénie, the more eloquent now that she was no longer there.

196

Three weeks later, on New Year's Eve, Sisley sent off a despairing note to Dr Viau:

I can no longer deny, my dear friend, that I am at the end of my strength. I can hardly get into my chair when my bed is being made.
I can no longer move my head because of swollen glands in the neck, oesophagus, throat and near the ears. I don't think this can last much longer. Nevertheless, if you have a doctor in whom you trust and who will not cost me more that 100 to 200 francs, I will see him. Tell me the time he is coming and the day, and I will send a carriage to the station.
I shake your hand most affectionately but also sadly.
Your obedient friend
A. Sisley.
These swellings mean that I can only breathe with difficulty and every attempt to cough up mucus in the throat is useless.[6]

The next day, 1 January 1899, he repented sending his letter, showing that sensitivity to others which his old friends remembered.

Dear Friend,
Don't take any notice of the letter I sent you yesterday,

I was in the 'blue devils', a moment of weakness that has passed. I understand the egoism of animals better than ever: to write that to you on New Year's Eve. Forgive me, it was only another token of affection.
I send my very best and most sincere wishes to you all.
In eternal friendship
A. Sisley.[7]

Dr Viau called in a specialist, Dr Marie, and a new set of treatments was prescribed. Yet, in spite of the 'excellent' new doctor's grogs and iodine which brought temporary relief in daytime, Sisley wrote that 'the nights are always bad.' Gradually Sisley's determination gave way in the face of interminable pain. On 13 January 1899, with two weeks to live, he wrote his last lines to Viau: 'Farewell, my very dear friend, and believe that I love you.'

News of Sisley's serious illness reached beyond the high walls of the house in the rue Montmartre. Dealers in Paris, according to one observer, had begun to take an unusual interest in his work, now that it was known that he would paint no more. With characteristic generosity Pissarro wrote about his beleaguered friend to his son Lucien: 'He is a great and beautiful artist, in my opinion he is a master equal to the greatest. I have seen works of his of rare amplitude and beauty, among others an *Inundation*, which is a masterpiece.'[8]

On about the same day as Pissarro wrote this tribute, Monet travelled down to Moret at the dying man's request. Sisley wished to say farewell and to entrust the well-being of his two children to his friend.[9] In bed, wearing his habitual and now inauspicious black skull-cap, Sisley could hardly speak.[10]

A week later Pierre, accompanied by a devoted neighbour, Pierre-Auguste Dubras, went once more to the Hôtel de Ville and informed the mayor that:

Alfred Sisley, painter, aged fifty-nine years, born in Paris and of English nationality, son of the deceased William Sisley and Félicité Sell, widower of Marie Louise Adelaïde Eugénie Lescouezec, died today 29th January at one o'clock in the morning in his own home.[11]

On 1 February, a cold rainy day ('Temps Pluvieux – le Matin', Sisley might have called it), Jeanne and Pierre were joined at their father's grave by his friends – Monet and his wife, Renoir, Lebourg, Tavernier, Jean-Claude Cazin (who spoke on behalf of the Société Nationale des Beaux-Arts), as well as by dignitaries and neighbours from the town. Later, a gravestone, commemorating both Alfred and Eugénie Sisley, was put in place, a gnarled and mossy rock brought from the nearby Forest of Fontainebleau, where Sisley's life as a painter had begun. It had been there, in the company of Monet and

Renoir, who now mourned him, that Sisley had discovered the persistent equation that was fundamental to his art – the realization of what was before his eyes in all its sensuous materiality, informed by a resonant longing for imagined landscapes. The black door of the flooded inn, the solitary figure in the snow, the sun on the trees besides the Loing, all such images stand at the heart of Sisley's inviolable discretion.

On their father's death Jeanne and Pierre were left without resources. The situation was more serious for Jeanne, now an amateur painter and engraver, unmarried and living alone in Moret, than it was for Pierre who earned his own living in Paris as a 'décorateur'. There was no property and just under a thousand francs' worth of household goods.[12] Their real inheritance was the mass of unsold paintings in their father's studio. Here they were doubly fortunate. First, the value of the work was mounting and they could now expect prices never achieved in Sisley's lifetime; and second, they had Monet as their protector and benefactor. When their impoverished state was revealed Monet immediately made plans for a benefit auction to be held at the Galerie Georges Petit on 1 May 1899.

The sale was to be in two parts: works by Sisley himself (twenty-seven paintings and six pastels) and works given 'in aid of the children of my unfortunate friend, Sisley', as Monet wrote to one of the donors, Georges d'Espagnat.[13]

198

156

156 *Cows by the Seine at Saint-Mammès. c.1895.*
Pastel, 34 x 48 cm. Private Collection.

157

157 *By the River Loing. c. 1896.*
Pastel. Musée des Beaux-Arts, Rouen.

158 **The Goose Girl c. 1895.**
Pastel, 28 x 38 cm. Christian Neffe, London.

159 **Geese. c. 1897.**
Pastel, 19 x 24.5 cm. Dennis Hotz Fine Art, London.

158

200

All Sisley's early friends in the Impressionist movement rallied to Monet's request – Pissarro, Renoir, Cézanne, Guillaumin, Degas; Julie Manet gave a painting by her mother Berthe Morisot, and a Caillebotte came from the artist's brother; many of Sisley's associates in the Société Nationale des Beaux-Arts gave works on paper; Fantin-Latour sent a painting, and young admirers of Sisley such as Edouard Vuillard and Maurice Denis responded to Monet's plan. A catalogue was prepared, with prefaces by Geffroy and Alexandre (see Appendix D). The sale was a success, being attended by prominent dealers such as Bernheim Jeune, Durand-Ruel, Vollard (who purchased the Cézanne) and Sisley's faithful friends and collectors, such as Viau, Tavernier and Depeaux. A Norwegian landscape by Monet fetched the highest price in the second part of the sale (6,000 francs) and he himself bought one of the Sisleys (4,500 francs); Georges Petit ensured success by paying 9,000 francs for Sisley's Cabins by the side of the Loing, Evening.[14] 'The Sisleys are doing well,' Julie Manet wrote in her diary. 'Monsieur Monet is promoting them, he is clearly taking this sale to heart and busies himself with it most devotedly.'[15] The grand total divided between the two children was over 145,000 francs, an astonishing achievement.

In the years following Sisley's death his work of the 1870s gained the status denied to it in his lifetime, and there was

a rush to acquire it, especially in the United States. England failed, unfortunately, to purchase anything from the grand display of paintings by Sisley included in Durand-Ruel's Impressionists' exhibition in London in 1905. The French state did little better; the Musée d'Orsay's unsurpassed collection is almost entirely made up of gifts and bequests. Most celebrated of these are the two paintings of the floods at Port-Marly (Plates 78 and 79). The finer of the two, *Flood at Port-Marly*, had been owned by Adolphe Tavernier who sold a number of works from his collection in 1900. It fetched the almost unheard of sum of 43,000 francs and was bought by the collector and financier Comte Isaac de Camondo to join the *Boat in the Flood*, which he already possessed. He bequeathed both paintings to the Louvre in 1908.

This turn of events must have surprised and dismayed some of the citizens of Moret (though more perspicacious neighbours, such as Miss Greatorex, were able to reap the benefit of their former charity). It was decided to honour the painter who had lived and worked in the town for nearly twenty years; a committee was formed (in 1905) and, naturally, it ran into trouble. A monument, including a specially commissioned bronze bust of Sisley, was to be erected in the town. Prominent local citizens were joined by Gustave Geffroy and other friends of the artist (including Francis Picabia and Monsieur Sauvé, a Moret newsvendor who turned painter under Sisley's influence). Jeanne Sisley,

159

although giving her approval to the scheme, was not on
the committee. Without telling its members she visited
Rodin and obtained his agreement, in principle, to carry
out the proposed bust. The committee demurred, however,
Rodin took umbrage and withdrew, and Jeanne Sisley had
to apologize, at the same time 'profoundly regretting' the
committee's failure to enlist Rodin's services.[16]

Six years passed, and eventually the academic sculptor
Eugène Thivier performed the task. It was not a particularly
appropriate monument – a semi-naked female nude pertly
coiling against a high stone plinth supporting a bronze
head and shoulders of Sisley in a stolid, conservative style.
Originally intended to stand just outside the town in the
Place du Pont, at the far side of the bridge, the monument was
finally positioned where it stands today, on the Champs-de-
Mars, an open space of grass and trees bordering the river. It
was here that Sisley had often been seen in the 1880s and
1890s, at his easel, wearing his customary beret, his Inverness
cape and the distinctive yellow clogs, worn by those who,
like himself, worked in all weathers by the Loing.[17]

Notes

Chapter 1

1 Cogniat, 1978, pp. 8–9; Daulte, 1972 (English language edn., 1988, p.14)

2 Claude Sisley's article (see Bibliography) was based on his own researches in England and France, his father's investigations, family evidence, etc. The photographs which illustrated his article in *The Burlington Magazine* came from a Sisley family album that has subsequently disappeared. Several new details have been added here, e.g. the marriage date of Sisley's parents.

3 William Sisley's profession is usually given as an importer of artificial flowers, mainly from South America, for the luxury market in France and England. The early article by Julien Leclercq (see Bibliography) is the first to describe William Sisley as a '*commissionnaire en fleurs artificielles*'; Théodore Duret states that he had '*sa clientèle dans l'Amérique du Sud*'. Though such information may have come from Sisley himself or his children, no evidence has emerged to confirm it; most other sources (the Sisley family papers, commercial directories, etc.) point to a broad array of *articles de luxe* as the staple of the Sisley business. The growing of real roses, as opposed to the selling of artificial ones, became the life's work of Jean Sisley, William's cousin, who after a successful business career in Paris moved to Lyon. His daughter Jeanne became a writer under the name of Jean Bach Sisley, author of a play *Jean-Jacques Rousseau à Lyon* and other forgotten works. Two letters written in 1924 to her English 'cousin' Claude Sisley are interesting documents in the family papers (private collection).

4 Claude Sisley, p. 252.

5 Records of the Cimetière Parisien du Nord-Montmartre, Paris, 18th *arrondissement* (943, 1866); the tomb can be seen today, renamed 'La Famille Leudet', after William and Felicia's son-in-law (husband of Aline-Frances Sisley).

6 Duret, p. 84.

7 See letters to T. Duret, 30 May 1888 (Braun, 1933, p. 6) and letter to A. Tavernier, 28 January 1898 (Huyghe, 1931, p.154).

8 Leclercq, p. 228; Murer in P. Gachet, 1956, p. 193; Prins in Prins, 1947, p. 59, and Prins, 1975.

9 Geffroy, 1923, p.3.

10 Unpublished letter, Sisley to A. Tavernier, 19 January 1892 (Fondation Custodia (F. Lugt coll.), Institut Néerlandais, Paris, 1973-A1).

Chapter 2

1 A. Billy, *Les Beaux Jours de Barbizon*, Paris, 1944, quoted in Monneret, 1987, I, p. 882.

2 Poulain, 1932, p. 18.

3 Quoted in Geffroy, 1923, pp. 9–10.

4 Daulte, 1959, p. 37.

5 I have been unable to see this interesting work, but, to judge from a reproduction, it seems likely that Sisley's head was added by Renoir (and is stylistically close to Renoir's portrait of Sisley, *c*.1864; Plate 6). The Gleyre studio painting is reproduced in W. Hauptman, 'The artist and the master', *FMR*, 15, October 1985, pp. 45–66.

6 The most recent account of Gleyre's teaching appears in H. Barbara Weinberg's *The Lure of Paris. Nineteenth-Century American Painters and Their French Teachers*, New York, 1991, pp. 50–66. The book contains an up-to-date bibliography. See also Albert Boime's pioneering study *The Academy and French Painting in the Nineteenth Century*, 1971; and the catalogue to *Charles Gleyre 1806–1874* (Grey Art Gallery, New York University, 1980) with text by W. Hauptman and N. S. Newhouse.

7 It is not in Daulte, 1959, but was reproduced by him in his 1957 article on Sisley, in *Connaissance des Arts*, p. 48. See also Lloyd, 1985. The signature seems to have been added by Sisley at a later date.

8 Lois Marie Fink's recent book *American Art at the Nineteenth-Century Paris Salons*, Washington, DC, 1990, and her own advice led me to these letters. They were given to the Archives of American Art by the Carnegie Museum, Pittsburgh, 1966.

9 Two versions (neither in Daulte, 1959) of *The Farm at Trou d'Enfer* are known: Fisher's painting, now in the Manchester City Art Galleries, and the one mentioned here. The Manchester painting was long entitled *A Normandy Farm* (see Lloyd, 1985, cat. no. 11). For Fisher at the Atelier Gleyre, see Vincent Lines, *Mark Fisher and Margaret Fisher Prout*, London, 1966, p. 19.

10 See J. Rewald, 'Lucien Pissarro: Letters from London, 1883–1891', *The Burlington Magazine*, 91, July 1949, pp. 188–92.

11 The portrait passed to Sisley's daughter Jeanne (along with two small heads by Renoir of herself and her brother Pierre); all three were sold from the exhibition *L'Atelier de Sisley*, Bernheim Jeune, Paris, 1907 (nos. 1–3).

12 *A Day in the Country*, exh. cat., no. 11

13 R. Fry, 'Sisley at the Independent Gallery', *Nation and Athenaeum*, 3 December 1927.

14 The letter was first quoted in A. Tavernier's article on Sisley in *L'Art français*, 18 March 1893; it was extensively used again by Tavernier in his preface to *L'Atelier de Sisley*, Bernheim Jeune, Paris, 1907, pp. 5–10, where Tavernier states that it was written at a friend's request in January 1892. (See Appendix C.)

15 Sisley more than likely met Corot through the architect turned painter Jules Le Cœur (1832–82) in *c*.1865, the year in which Le Cœur acquired a house at Marlotte in the Forest of Fontainebleau; see Cooper, 1959 (pt. II), p. 322 and n. 4.

Chapter 3

1 For Lise Tréhot, see Cooper, 1959 (pt. I). Sisley gave Madamoiselle Tréhot a small Corotesque landscape *Country Lane near Marlotte*, *c*.1865, rep. Rewald, 1961, p. 99.

2 See Anne Distel in *Renoir*, 1985, exh. cat., no. 9. Carpentier was an artists' supplies merchant, from *c*.1868 at 6 rue Halévy; Sisley was a client in the 1860s (see letter from Sisley to J. Woodwell, *c*.1865, Archives of American Art, Washington, DC).

3 As recorded by Distel in *Renoir*, 1985, exh. cat., no. 9.

4 Several early sources (and thus some recent ones too) give 1840 as the year of Sisley's birth, all probably derived from information given in T. Duret's pamphlet *Les Peintres Impressionnistes*, 1876.

5 See J. Renoir, 1962, p. 110.

6 Archives de Paris, Cadastre de 1862, D1P4, carton 449.

7 Illustrated in Daulte, 1972, p. 38; the later painting *In the Boat* is also in Daulte, 1972, p. 50.

8 Two closely related paintings by Monet of an evening meal in progress and of coffee after dinner (*c*.1868–9) were long known as *The Sisley Family at Dinner* (Bührle Foundation) and *Interior* (National Gallery, Washington, DC, Mellon Collection); these traditional identifications were finally demolished by John Rewald in 'Notes sur deux tableaux de Claude Monet', *Gazette des Beaux-Arts*, 1967, pp. 245–8.

9 Joseph R. Woodwell letters, Archives of American Art, Washington, DC.

10 The identity of the helpful Monsieur Wolff is elusive; he is mentioned in other letters to Woodwell and appears to have been a patron of this group of artists. It is just possible that he was the young Albert Wolff (1835–91),

later the powerful journalist and scourge of the Impressionists.

11 For his Salon address in 1868 Sisley gave Bazille's studio at 9 rue de la Paix, 17th *arrondissement*, renamed that year rue la Condamine.

12 As reported in J. Leclercq, p. 228.

13 J. B. Sisley to Claude Sisley, 51 avenue de Noailles, Lyon, 8 January 1924. The letter and an English translation (quoted here) are preserved in the family papers (private collection).

14 Researches of Claude Sisley; Mairie de Congy, Acte de Décès, 6 February 1879, C2E 184/8; Archives départementales de Seine et Marne.

15 All details here come from documents in the Archives départementales de la Marne; the censuses of 1872 and 1876 (respectively 122 M, 172, and 122 M, 193); W. Sisley's posthumous inventory (15 May 1879, 3.593 F) and subsequent Déclaration de Succession (4 August 1879, 3Q 324/32). At the time of his move to Congy in *c.*1871–2, W. Sisley's Paris address was his business headquarters at 1 passage Violet, 10th *arrondissement*, as recorded in documents from the early 1840s onwards. This roomy early nineteenth-century house, still standing at what is now 1 rue Gabriel-Laumain, also contained living quarters. Two of W. Sisley's grand-children, Maurice and Lucienne Leudet, were born there; and in 1863 Sisley 'fils' (almost certainly Henry) was domiciled there on the second floor (Archives de Paris, Cadastre de 1862, D1P4 1221).

16 Duret, p. 76.

17 An interesting and little-known profile of Monsieur Worth, focusing on the effects of the Franco-Prussian War on the Paris dressmaking business, to which the Sisleys were connected, is found in F. Adolphus, *Some Memories of Paris*, New York, 1895, pp. 178–200. A general discussion of the economic climate of this period is given in T. Kemp, *Economic Forces in French History*, London, 1971. Foreign imports show a sharp decline in the 1870 French trade figures.

18 For an account of Bougival and its famous floating bathing-place and restaurant, La Grenouillère, see *A Day in the Country*, exh. cat., pp. 79–87.

19 One of these works, an unusual still life (D8), is almost certainly misplaced and belongs perhaps to the later 1880s or early 1890s; but I have only seen it in a colour reproduction. One should add to these early works a unique interior with a seated woman (rep. Daulte, *Connaissance des Arts*, 1957); *Lane near a Small Town* (Bremen, Kunsthalle); a *Garde champêtre* on a woodland path (*c.*1868–9; rep. Daulte, 1972 (1988 edn., p. 18)); a small landscape given by Sisley to Lise Tréhot (*c.*1865; rep. Rewald, 1961, p. 99); and a minute sketch (3½ x 3 ins.) of a house among trees (1869; rep. Daulte, 1972 (1988 edn., p. 75)).

20 The correspondences between Impressionist sites and subjects of the 1870s and those of the Fauve painters (especially Vlaminck and Derain in Marly and Bougival) need further investigation. Braque's two 1906 paintings of the Canal St-Martin take Sisley's viewpoint in his *Barges on the Canal St-Martin* (D17); Vlaminck's *Bougival* (1905; Dallas Museum of Art) is the type of long-range but informal view pioneered by Pissarro and Sisley in Louveciennes; cf. Sisley's *Bougival* (1876; D209), which was painted from a nearly identical spot; *Marly* (1872; D43) shows the same buildings as Vlaminck's *Restaurant de la Machine at Bougival* (1905; Musée d'Orsay).

21 *The Seine at Argenteuil* (D13), undated but assigned by Daulte to spring 1870; however, even this may belong to early 1872 as part of a group of Argenteuil paintings (D25–30).

22 Her year of birth has always been given as 1870, but it was registered by her father as having taken place on 29 January 1869 at 27 cité des Fleurs, 17th *arrondissement* (Archives de Paris, 17th Arrondissement – Naissances, no. 229 in volume for 1 January to 9 April 1869).

23 See Archives de Paris, Cadastre de 1862 D1P4, carton 449; at 27 cité des Fleurs Lecouzec [*sic*] is registered as renting the first floor (kitchen, dining-room and two heated rooms) from 1867 to 1873.

24 See K. Flint, *Impressionists in England. The Critical Reception*, London, 1984. Alas, Sisley is not given an individual section in this book, unlike Morisot, Renoir, Pissarro and Monet.

25 Quoted by J. Patrice Marandel in *Bazille and Early Impressionism*, exh. cat., The Art Institute of Chicago, 1978, p. 180.

26 G. Geffroy, 'Alfred Sisley', in Sisley Sale, 1899, pp. 5–6.

27 Many of Sisley's first sales to Durand-Ruel are recorded, painting by painting, in Daulte, 1959, the first being 200

francs received for *The Bridge at Villeneuve-la-Garenne* (D38; Fogg Art Museum, Cambridge, Mass.) on 25 June 1872, shortly after the picture was completed. Sales continued regularly from 1872 through to 1874, with prices ranging between 200 and 350 francs, an exception being the 450 francs paid for *Resting by the Stream* (D42), a large work purchased on 16 September 1872. According to Shikes and Harper, 1980, p. 105, Sisley's receipts from Durand-Ruel in 1872 amounted to 5,350 francs, and in 1873 were 6,260 francs. These were supplemented by further sales made by Sisley to dealers such as Portier and le Père Martin and occasional private purchasers (e.g. Edouard Manet). As a comparison, the average annual income of a middle-class family in France in *c*.1870 was 5,000 francs; professional families earned about twice that amount (see *The New Painting*, 1986, exh. cat., p. 116 n. 76). The wage of the ordinary working man was about 130 francs per month. Thus Sisley at this time was relatively affluent; after *c*.1875 his position worsened considerably.

28 Anita Brookner, *The Burlington Magazine*, 99, July 1957, p. 248 (review of Sisley exhibition, Durand-Ruel, Paris, 1957).

Chapter 4

1 Archives départementales des Yvelines. See also Laÿ, 1989, pp. 53–4.

2 Sisley's painting is *Country Road, Springtime* (1873; D63); it is reproduced alongside Renoir's painting, with the same title, in Rewald, 1961, p.287.

3 Madame Vigée Lebrun, *Souvenirs*, 1835-7, chapter XXXII.

4 The house, which had fallen into ruin, was demolished in *c*.1960; no photograph of it appears to have survived, but from Sisley's paintings of it and of other houses in the immediate neighbourhood (several still recognizable today) its location is immediately apparent.

5 See Daulte, 1959, under cat. no. 149 and Daulte, 1972, p. 22; R. Brettell in *A Day in the Country*, exh. cat., no. 22, p. 102. A watercolour of Mitte's wineshop, *Impasse de Voisins*, by a local photographer and painter, Henri-Guillaume Bevan, is reproduced in Laÿ, 1989, p. 65, fig 55. Though perhaps tedious, this establishment of Sisley's exact address not only adds some flavour to his otherwise completely undocumented years in

Louveciennes but sharpens the focus of his selected subjects and repeated motifs as they unfold around his fixed point of habitation. The house at 2 rue de la Princesse was almost certainly the scene of one of Sisley's very few interiors, the celebrated *The Lesson* (Plate 19) which shows Jeanne and Pierre Sisley working at a dining-table. It is surely this painting that was exhibited as *Dans la maison de Voisins* (1873) in *L'Atelier de Sisley*, Bernheim Jeune, 1907 (no.14) together with Renoir's early portrait of Sisley (no. 1) and his heads of Jeanne and Pierre (nos. 2 and 3) – 'family' pictures sold by Jeanne Sisley along with twenty further works from her father's studio.

6 The eight Impressionist exhibitions have been most recently and fully scrutinized in the invaluable exhibition catalogue *The New Painting*, 1986. For a handy list of the works shown, etc., see Monneret, 1987, II, pp. 231–52.

7 Durand-Ruel in Venturi, I, p. 28.

8 Ibid.

Chapter 5

1 K. Clark, *Landscape into Art*, 1949 (Pelican edn., 1966, pp. 100–1).

2 See Daulte, 1959, no. 37. Durand-Ruel's profit was 160 francs on the 200 francs he had paid Sisley for the painting, 24 August 1872.

3 Jacques Salomon, 'Giverny, 14 juin 1926, déjeuner chez les Monets', *Arts,* 14 December 1951.

4 Claude Sisley, p. 252.

5 *View of the Thames and Charing Cross Bridge* (D113) is a curious, unsuccessful work which appears to concertina a view of Charing Cross Bridge with the skyline of St Paul's, as it might be seen from Blackfriars Bridge (and was so viewed by Daubigny in 1870–1 for his *St Paul's from the Surrey Side*, dated 1873; National Gallery, London).

6 The Molesey Regatta was instituted in 1867 and after an uncertain start became a calendar fixture by 1873 (the year before Sisley's visit), taking place in the second half of July, after the celebrated Henley Regatta. Its course has changed several times and thus it is difficult to know the line it followed in 1874 (contemporary descriptions are vague). It would appear to have run from the Middlesex side of the Thames opposite Tagg's Island to Garrick's Villa upstream. The 1873 regatta coincided with the

205

opening of Tagg's Island Hotel (the building on the right in D126), its first-floor verandas and sloping lawn especially designed for viewing the continuous stream of weekend boating. The hotel was demolished and rebuilt in 1912. The Castle Inn, where Sisley probably stayed, was demolished in 1930 to make way for a new bridge (1933) several yards downstream from the one shown in Sisley's paintings. The lock and weir depicted in Sisley's work have both have been rebuilt. For details here and in the text, I am indebted to Nicholas Reed who lectured on Sisley in London at St Michael and All Angels, Bedford Park, London, 22 September 1990. R. G. M. Baker's *Thameside Molesey*, Buckingham, 1989, includes useful photographs and much relevant material.

7 G. Geffroy in Sisley Sale, 1899, p. 11.

8 In other ways the Machine was the least loved element in the whole enterprise of the '*merveille de Marly*'; there were the attendant perils for the river traffic of the build-up of stones and sand; the appalling smell in hot summers of the polluted Seine churned up by the Machine's rotating wheels (while Sisley was in England, there was an '*arrêt de pompages*' because of excess river pollution); and there was the terrible noise made by its mechanism which could be heard throughout the area (Madame Vigée Lebrun wrote that its '*bruit lamentable*' drove her mad). The small windows at the back of Madame du Barry's house (seen in Sisley's paintings, Plates 2 and 3) were a protective measure against the incessant sound from the Machine down below. In 1967 the Machine was replaced by an electric pumping station.

9 It was from this same tower that Renoir, at the end of the Commune, mistakenly believed that he saw the Louvre being burnt to the ground (see J. Baudot, *Renoir, ses amis, ses modèles*, Paris, 1949).

10 Victorien Sardou's 1867 description, quoted in Laÿ, 1989, p. 46.

Chapter 6

1 The road had several names and is given as rue de l'Abreuvoir in Laÿ, 1989, p. 56. I have adopted its current (1991) name here. Sometimes Sisley's address is mistakenly given as 2 place de l'Abreuvoir – the houses that form a semi-circle round the watering-place itself and which appear in many of Sisley's paintings of

1875–7. Several of these houses remain today. The site of Sisley's own house has not been redeveloped.

2 Many of Sisley's paintings have been mistitled, usually after his death and often by private owners. Works from the Louveciennes/Marly period have often been confused, particularly those painted on the route de Versailles, the high road between the two distinct villages, and those on the avenue de l'Abreuvoir, the main road from Marly which confusingly becomes one with the route de Versailles on its way downhill to Port-Marly and the river. The Courtauld Institute's painting referred to here is certainly of the latter road, not Louveciennes; several of the houses still exist. Further examples include the *View of St-Cloud – Sunshine* (Plate 59), which shows Marly-le-Roi on its hillside from the Parc de Marly (as in *St-Cloud*, D212); it is almost the same viewpoint adopted in the Musée d'Orsay's *Snow at Marly-le-Roi* (Plate 69). The most notorious example of this confusion was the long-held title *Chemin à Sèvres* for the Musée d'Orsay's *Chemin de la Machine, Louveciennes* (Plate 2), now officially renamed. I have doubts about the beautiful *Street in Ville d'Avray* (Plate 27), which seems to show the rue de la Princesse from near Sisley's house, looking up to the Château de Voisins. Although given as 1876 in Daulte (204), it is clearly dated 1873. For Sisley's *The Fourteenth of July* and its problematic title, see Chapter 7, n.12.

3 The painting has been erroneously mistitled *View of Louveciennes* and *The Artist's House*. It is correctly identified as the home of Le Lubez in Laÿ, 1989, p. 144.

4 *Early Snow at Louveciennes* (Plate 32), which looks down the rue de Voisins, with the gates to the château at the turning on the left, was originally thought to have marked Sisley's move to the village and is assigned to the year 1870 in Daulte. A date of winter 1870–1 is argued for by Richard Brettell (*A Day in the Country*, no.19, p.98); the early form of Sisley's signature and the style of the work tally with this; but, if correct, it was painted on a visit to the village. Richard Thomson, placing it in late 1871, suggests the prominent red-tiled roof is evidence of post-war repairs (*Camille Pissarro*, South Bank Centre, 1990, p. 22). But the house in question had been altered and rerooved before the war (Cadastre de 1876, Voisins–Louveciennes, Archives départementales des Yvelines). Nevertheless, late 1871 or early 1872 would

appear to be correct. Unusually, a preliminary study exists for this painting (Plate 33), which might suggest that Sisley worked on the canvas partially or wholly indoors, from drawings. But too little is known of his practice to be more than tentative on this point. Whatever the date and detail of its conception, however, the work remains, as Brettell suggests, one of the masterpieces of this genre from the early 1870s.

5 An excellent technical analysis of this work can be found in the catalogue to *Impressionism in the Making*, National Gallery Publications, 1990, pp. 148–51. Of particular interest are Sisley's very restricted palette (five colours and black and white) and the substantial areas of the canvas's ground colour (a beige-tinted white) that Sisley has left untouched. The painting shows the côte du Cœur-Volant mounting from the semi-frozen watering-place, with the park on the right and the beginnings of the hamlet of Cœur-Volant on the left. D56, also a snow scene, has gained the incorrect title of *Côte du Cœur-Volant*.

6 For the effects on Sisley's health through painting out of doors in winter, see A. Alexandre at Appendix D.

7 The painting from this series in the Fitzwilliam Museum, Cambridge (D241), has traditionally been identified as a view of the quayside at Port-Marly, looking upstream along the rue de Paris towards the A St-Nicolas Inn. I would suggest with some confidence that though Sisley is indeed facing upstream (towards the hillside of Bougival), he has in fact simply turned round and moved nearer to the river itself (where there are now a promenade and municipal gardens); to his right are the blue shutters of the Lion d'Or, the first building shown at the right edge of the painting.

Chapter 7

1 See, however, Sisley's letter to Tavernier, Appendix B.

2 Morisot may have encouraged Sisley to visit the Isle of Wight in 1881; she had painted there in 1875 (a few months after the Impressonist sale at the Hôtel Drouot) and encountered the reactions of the English to seeing a woman painting *en plein air*, an intolerably conspicuous figure. For a meeting between Sisley and Morisot at Moret-sur-Loing, see page 165. Charles Daubigny also went to the Isle of Wight, albeit briefly, in 1871.

3 Venturi, 1939, II, p. 201.

4 A full listing of the sale's lots, purchasers and prices is given in Meret Bodelsen's article 'Early Impressionist Sales', *The Burlington Magazine*, 110, June 1968, pp. 331-49; it is repeated, with some corrections, in Monneret, II (1987 edn.), pp. 451-2. The purchaser of *Thames Barrier* (lot 62; 60 francs) is given as Sisley himself but it might conceivably have been an indulgent member of his family; works by all four participants were purchased by their respective family members and friends. The well-known and ubiquitous art critic Ernest Chesneau (1833–90) was the purchaser, for 100 francs, of Sisley's *Misty Morning* (Plate 82), a picture left to the Louvre by Antonin Personnaz in 1937.

5 T. Duret, 'Quelques lettres de Manet et de Sisley', *La Revue Blanche*, 15 March 1899, p. 435. Three letters to Duret are included in Duret's article rather than twelve as listed in Daulte, 1959. Another short letter (from 7 avenue de Bellevue, Sèvres, late 1877) is in the collection of the Pierpont Morgan Library, New York, and is an impetuous demand for Duret's friendship.

6 There are several accounts of Murer, but the primary source is Gachet, 1956; see also Marianna Reiley Burt: 'Découverte: Le Patissier Murer: Un Ami des Impressionnistes', *L'œil*, 245, December 1975. A convenient summary is found in *The Annenberg Collection*, Philadelphia Museum of Art, 1989, exh. cat., pp. 33–5 (plus notes), which discusses Murer in relation to his 1877 portrait by Renoir.

7 Murer on Sisley, in Gachet, 1956, p. 193; Sisley's brief letters to Murer are printed in Gachet, 1957, pp. 123–6 and cover the years 1878–9. They mingle gratitude with suspicion, e.g. My dear Murer. I have received your letter and the enclosed paper. I will not sign it before seeing you; it appears to contain clauses which I did not see in the one I signed at your house. Until then. Yours. A. Sisley' (Sèvres, 24 October 1878). Another letter (undated, *c*.1879) mentions a note received by Sisley from his uncle, 'Ce mot . . . vous fera voir que ce n'est pas sans peine'. The reference is obscure but it is all there is to give any indication that Sisley remained in touch with a member of his family during these years. Presumably Charles Denis Sisley is referred to (who died in 1880) or possibly Thomas Sisley (who died in 1882).

8 The *procès-verbal* of the sale as given by Bodelsen (see n. 4 above) lists Georges Petit as the purchaser. Petit was

also the adviser for the sale and may have been bidding on behalf of a client. But Daulte (D239) gives the purchaser as Durand-Ruel, through whose hands it passed in later years. Among the other collectors who found bargains at the second Hoschedé sale were J.-B. Faure, Henri Hecht and Théodore Duret, all familiar names in the early history of collectors of Impressionism.

9 Daulte, 1959, assigns the painting to 1881 but it was probably done in spring 1877; the château was sold the next year, following Hoschedé's bankruptcy.

10 The letter is given in full by Duret in *La Revue Blanche* (see n. 5 above).

11 The letter appears in English in Huyghe, 1931, p. 152; the original was part of the Moreau-Nélaton bequest to the Louvre, which included letters to A. Tavernier as well as several to Charpentier.

12 Richard Thomson in 'A Sisley Problem', *The Burlington Magazine*, 123, November 1981, p. 676, gives irrefutable reasons for adding *The Seine at the Point-du-Jour, 14 July* (assigned by Daulte to 1873) to the group of four paintings of the Point-du-Jour (D295–8) all dated 1878. He suggests that the pictures show the scene on 30 June that year, a national holiday to mark the success of the Exposition Universelle. The building was in fact decorated throughout the exhibition (held near by). *Le quatorze juillet* was not instituted as *a fête nationale* until 1881. This leaves us with another problem – Sisley's *The Fourteenth of July at Marly-le-Roi* (Plate 58); more than likely the flags mark the fête day dedicated to St-Pierre which took place in many *communes* in the first week of August until superseded by Bastille day.

13 Shortly after the Third Impressionist Exhibition four of its participants – Monet, Pissarro, Sisley and Caillebotte – again arranged a public auction (28 May 1877). No *procès-verbal* survives, and the catalogue gives no sizes for the works. Sisley's eleven lots all appear to have been very recent paintings and seven are certainly of the Seine in the Sèvres/St-Cloud area. This shows that Sisley had moved to Sèvres around the turn of the year, rather than in autumn 1877 as given in Daulte, 1959, p. 30. According to Duret (1922 edn., p. 96), Sisley's eleven works fetched 1,387 francs, a very low average price of 126 francs each.

14 S. Mallarmé, 'The Impressionists and Edouard Manet', *The Art Monthly Review*, 30 September 1876 (translated

from the author's French, written in late July or early August 1876); quoted in *The New Painting*, 1986, p. 32. For Mallarmé's visit to Sisley, see p. 165.

15 R. Brettell, 'The "First" Exhibition of Impressionist Painters', *The New Painting*, 1986, p. 189. Manet's refusal to join his friends in any of the Impressionist exhibitions did not preclude a keen interest in the shows themselves. To the 1877 exhibition he lent Sisley's 1872 painting *The Bridge at Argenteuil* (D30; Memphis Brooks Museum of Art, Memphis, Tennessee).

16 G. Rivière, *L'Impressionniste*, no. 2, 14 April 1877, as quoted in Venturi, 1939, II, p. 318.

17 Renoir's earlier portrait of Monet (*c.*1872, Musée Marmottan, Paris) shows the same design of chair on which Sisley sits, back-to-front, when posing for Renoir. At the very end of his life Monet mentions the portrait in a letter to the Galerie Durand-Ruel: 'C'est celui qu'il [Renoir] fait chez moi à Argenteuil, représenté à cheval sur ma chaise' (letter dated 4 May 1926, as quoted in Venturi, 1939, I, p. 464).

18 G. Rivière, *L'Impressionniste*, no. 1, 6 April 1877, as quoted in Venturi, 1939, II, p. 310.

19 'Since I decided to expose at the Salon I find myself more isolated than ever. You are my only hope.' Sisley to Charpentier, Sèvres, 28 March 1879 (in English translation in Huyghe, 1931, p. 152).

Chapter 8

1 See Venturi, 1939, II p. 60; Sisley's first substantial group of sales to Durand-Ruel, under the new arrangement, were made in June and July 1880.

2 The sequence of paintings as given in Daulte, 1959, is confusing and it is possible that Sisley unintentionally confused matters further by clearly dating D341 '1879'; this could have been an error, probably for 1880, perhaps introduced when he sold the painting to Durand-Ruel in February 1882. Furthermore, Daulte places under 1879 two undated Moret paintings (D335, *Autumn Sun*; and D336, *Morning by the Loing*) which appear to belong within a date span between spring 1880 and autumn 1882, when Durand-Ruel purchased the latter (31 October 1882). A group of paintings (D337–40) of springtime floods on the Loing at Moret is more likely to belong to early 1880 (when there was heavy flooding of the river) than to 1879, the year to which

Daulte assigns them.

3 This is *The Seine at Suresnes* (D379), part of the Richmond-Traill bequest to the National Gallery of Scotland (1979). The catalogue to this exhibition, *French and Scottish Paintings*, by Hugh Brigstocke, National Gallery of Scotland, 1980, rightly points to similarities between the Sisley (no. 8) and Boudin's *Bridge over the Touqués at Deauville* (no. 1), painted fifteen years earlier; Sisley's debt to Boudin can perhaps be overestimated, though the similarities of composition and handling are obvious. But the conceptual spirit of the two painters (who died within a year of each other) is distinctly different, as the more fruitful comparison with the work of Corot immediately makes clear.

4 The identification of the house has only recently been made by Sisley enthusiasts in the Moret area (see, for example, *Alfred Sisley à Moret-sur-Loing, Veneux, St-Mammès*, Moret, 1989). The house, now known as the Villa Bellevue, is at 2 rue Victor Hugo, Veneux-Les-Sablons; in Sisley's time the street was simply called rue de By, one of only two main streets in Veneux-Nadon. The January 1881 census for the Moret district lists Sisley (aged 41) as head of the household, Eugénie, 'sa femme', (40), their son Pierre (14) and daughter Jeanne (13); all are given as of English nationality. (See 'Recensement 1881 du canton de Moret', Archives départementales de Seine et Marne, 10M 284.)

5 Ardouin-Dumazet, *Voyage en France*, 44 (*Gatinais français et Haute-Beauce*), Paris, 1906, p. 71.

6 Several works of 1885, for example, depict this view from both the left and right banks of the Seine (e.g. D629, Musée d'Orsay, is taken from the left bank). To reach the right bank to paint such a work as *St-Mammès* (D442; Plate 99), Sisley was either ferried across or went to St-Mammès itself, crossed its bridge and walked a few yards downstream to view the village spread along the left bank.

Chapter 9

1 Sisley to Durand-Ruel, Isle of Wight, 6 June 1881, in Venturi, 1939, II, p. 55.

2 After Feder's bankruptcy, Durand-Ruel continued to support Sisley (he purchsed over twenty of his works in 1882 and ten in 1883; see under those years, and 1884, in Daulte 1959), but the resulting income remained at a low level. When Feder died, a few years later, he apparently owed Durand-Ruel large sums of money. See Venturi, 1939,II, p.121.

3 Details of Durand-Ruel's purchases from Sisley are found in the provenances to paintings of this period, as recorded in Daulte. Further details are found in Monneret, 1987, in entries under *Sisley*, I, and under *Ventes*, II.

4 No address has been discovered for this year in Moret, which lasted from September 1882 to September 1883. See letters from Sisley to Durand-Ruel (14 September 1882 and 24 August 1883), Venturi, 1939, II, p. 55.

5 Sisley to Durand-Ruel, Moret, 24 August 1883, ibid.

6 R. Huyghe, 1931, p. 153. It is not, however, quite clear at what date Sisley was helped by this friendly 'sheriff'.

7 The church appears in D499; the outskirts and buildings of Les Sablons were studied in groups of works in 1883 and 1884 (e.g. D489–92 of 1883, and D533 and D536–7 of 1884). D583–4 of 1885 show the same outlying farm in spring and summer sunshine.

8 In the local museum in Moret-sur-Loing there is a turn-of-the-century photograph of the Robinson. It may have borne some relation to other Robinson cafés/inns originating at Robinson, near Arcueil in the southern suburbs of Paris. The stone grange still stands (Grange des Graillons); remains of the boat-yard (mentioned by Robert Louis Stevenson in *The Inland Voyage*, 1878, as being run by M. Mattras [sic], 'the accomplished carpenter of Moret') and the Robinson can be found in the undergrowth, and the bank is used by fishermen. Sisley painted from here on numerous occasions – there are nearly thirty paintings of the view to the left towards Moret, several of the yard and grange in the winter (D715–20), and several looking directly across the river (e.g. D801–3 of 1892); D813 (Bührle Foundation) is probably the last painting made from this vantage-point.

9 Caillebotte's admiration for his fellow exhibitors in the Impressionist exhibitions, combined with his extensive private income, enabled him to assemble a huge collection of their paintings. His bequest of these works to the Louvre in 1894 caused a tremendous scandal. In the end a greatly reduced gift was accepted (seven only of the eighteen works by Pissarro, five of the nine works by Sisley, for example), and shown in an annexe of the Musée du Luxembourg. Among Caillebotte's Sisleys are

Regatta at Molesey (D126; Plate 40) and *St-Mammès* (D629).

10 In the early 1930s the painter Dunoyer de Segonzac worked in Moret. A conversation between the artist and Pierre Joffroy (*Paris Match*, 6 July 1957) records the following exchange between Segonzac and '*un vieux paysan du Loing*': 'You don't work at all as Sisley did,' said the old man. 'So you knew Sisley, then?' 'Quite well, I think. One day when it was very cold – not far from here – I asked him: "Why are you using pink for the snow? I thought that snow was white." "Half close your eyes," he told me, "and you'll see that the snow is pink." Actually, monsieur (and I don't know whether you'll believe me), Monsieur Sisley was right and the snow was pink.'

11 The quotations are from *C. Pissarro*, 1943, p. 108 (14 May 1887) and p. 110 (15 May 1887).

12 Letter to O. Maus, 3 December 1897, quoted in Venturi, 1939, II, p. 242.

13 Sisley to Durand-Ruel, Les Sablons, 17 November 1885, in Venturi, 1939, II, p. 60.

14 Further late groups of pastels concentrate on the view of St-Mammès from across the Loing (e.g. *The Loing at St-Mammès*, shown in *Important XIX and XX Century Works on Paper*, Lefevre Gallery, London, April 1977); some of these contain animals (e.g. a donkey with geese, in the Burrell Collection, Glasgow; cows, as in Plate 156) and at least eight study geese with an attendant goose-girl, either by the river Loing or by a small pond (e.g. Plate 158, and *The Goose-Girl*, Sotheby's, New York, 20 April 1966, lot 9). Sisley's coloured lithograph *The Riverbank* (*The Goose-Girl*) made for Ambroise Vollard (1897) is close to these riverbank pastels. One of the finest of the series is *The Loing at Moret* (in fact, the Seine at St-Mammès), shown in *Les Impressionnistes et leurs Précurseurs*, Galerie Schmit, Paris, 17 May to 17 June 1972. Almost none of Sisley's pastels is dated but those mentioned above appear to date between *c.*1892 and 1897–8; six were included in the sale of Sisley's work after his death.

15 Sisley lists six pastels in a letter to Durand-Ruel of May 1888, but as the works have changed titles since then, their identity is unclear. I have, however, seen, (or found reproductions of) eight, and the listing of two further contenders. No doubt François Daulte's long-promised catalogue of Sisley's pastels will clarify the extent of the

series and their whereabouts.

16 Cézanne to his son, Aix, 8 September 1906, in *Paul Cézanne. Letters*, ed. J. Rewald, rev. edn.,1976, p. 327. There is almost nothing to document any friendship between Sisley and Cézanne, though they were fellow exhibitors and obviously knew each other. It is sometimes said that Sisley was present at Giverny when Cézanne fled from a gathering of friends expressly organized by Monet to give him encouragement (see, for example, J. Rewald, *Cézanne*, London, 1986, p. 188, and R. Shone, *Sisley*, Oxford, 1979, p. 12); no evidence for such a meeting has emerged. But proof of Cézanne's friendship was shown by his donation of a painting, *L'Estaque, environs de Marseille*, to the benefit sale for Pierre and Jeanne Sisley after their father's death (lot 43; see Sisley Sale, 1899) where, according to the *procès-verbal*, it was bought by Vollard for 2,300 francs (Archives de Paris, D48E³ 83, Chevallier dossier no. 8306). A letter from Jeanne Sisley to Georges Petit, dated 3 May 1899, asks Petit to forward a note of thanks to Cézanne whose address she does not have (Fondation Custodia (F. Lugt coll.), Institut Néerlandais, Paris). Although the two painters are so different in approach and achievement, there are striking affinities in choice of landscape motif, and it might be said, in their solitary single-mindedness and sometimes farouche behaviour. No doubt they had news of each other in the 1890s through their friend in common, Gustave Geffroy.

17 Sisley to de Bellio, Moret, 18 April 1883 (Durand-Ruel Archives), quoted here from R. Niculescu 'Georges de Bellio, l'ami des Impressionnistes' (pt. II), *Paragone*, 248, 1970, pp. 40-85. This interesting article is in two parts, the first in no. 247, 1970, pp. 25-66. De Bellio owned a springtime landscape with blossoming apple trees painted in 1879 (D305), now in the Musée Marmottan, Paris.

18 See Alexandre, Appendix D.

19 See *C. Pissarro*, 1943, p. 162 (13 April 1891); see also below, Chapter 10, pp. 00 and n.18.

Chapter 10

1 Although I have written here in the past tense, Moret remains much the same in its general aspect. The greatest change since Sisley's time was made by the almost total destruction of the three main mills along

the bridge in 1944. But many buildings, if ruthlessly restored, remain, including the old Epicerie Millet to the left of the Porte de Bourgogne (renovated as apartments) and the low, timbered house to the right. Sisley's several views of the town looking along the bridge (D656-60; Plate 137) were painted from an upper room overlooking what is now the place de la Division Leclerc. Running out of the town, the rue du Peintre Sisley continues to the Ecluse de Bourgogne on the Loing Canal (Plate 140), a route Sisley must have frequently travelled.

2 François Daulte gives November 1889 and may well have firm evidence for this; but it should be noted that after the exceptionally lean year of 1887 and the pastels made in early 1888 at Les Sablons, Sisley made Moret itself the subject of nearly all his works in 1888 and 1889. This suggests that he was already in residence, but it is by no means proof of it.

3 Once more the census details for 1891 are incorrect. Sisley, Eugénie and Jeanne are this time all listed as of French nationality and their ages are given as 50, 50, and 20 respectively ('Recensement 1891 du canton de Moret', Archives départementales de Seine et Marne, 10M 325).

4 A pencil drawing by Sisley, signed and dated, of the front of his house (and including the two-storeyed side wing or 'grange') was reproduced in Bibb, 1899, p.155 (here Plate 125, present whereabouts unknown). I would read the date as 1892, though 1897 is possible. D807 and D808, assigned by Daulte to 1892, offer further evidence that Sisley lived in the rue Montmartre for longer than has generally been accepted. Both show the view from the back of the house, the rue Montmartre running alongside at the left.

5 Some internal alterations have taken place since Sisley's occupation and a larger window in the roof has replaced one of the skylights; the house has been given the name 'Villa Sisley' and is privately owned. I have been unable to discover who was the owner of the house when Sisley was the tenant. The garden was tended by Sisley himself – see his letter to Tavernier, Moret, 6 June 1895, in which he writes of his struggle against ants and weeds, and of the training of his vine (Fondation Custodia (F. Lugt coll.), Institut Néerlandais, Paris, 1973-A5).

6 Geffroy, 1923, p. 7; Bibb, 1899, p.155.

7 I am grateful to Madame Hulbert of the Cheval Blanc, Moret-sur-Loing, for helping me to identify the site of

this painting. Sisley appears to have positioned himself in the forecourt of the old school (now an open space called the Place de Kulsheim). Another view of the interior of Moret (D833; City Art Gallery, Glasgow) is less easy to identify but I would suggest that it is the Place de Samois, with the Porte de Samois into the town just out of the picture at the left. The rue des Fosses leads out of this square.

8 Sisley's letter to Monet (Veneux-Nadon, 31 August 1881; Braun, 1933, p. 7) was written at a time when Monet was searching for somewhere to settle outside Paris. It is given here in full:

My dear Monet
If you are set on finding the right school in the area where you settle, Moret won't do, there's only a state boarding school here. The countryside's not bad – a bit pretty pretty – as you no doubt remember. As for me, when I arrived there were plenty of nice things to do, buit since then they have been building the canal, chopping down trees, constructing walkways, straightening the banks.
Moret is 2 hours from Paris, with plenty of houses to rent from 600-1000 francs. There's a market, once a week, very pretty church, quite picturesue scenery, anyway if you are thinking of moving there, come and have a look. Veneux-Nadon is 10 minutes from Moret station.
Very best wishes
A. Sisley
Greetings to Caillebotte

9 Albert Lebourg was in Rouen with Sisley on 11 February 1893 (see Monneret, 1987, I, p. 895); Monet had resumed work in Rouen by 16 February 1893 (see D. Wildenstein, *Claude Monet*, Lausanne, 1974-85, III, letter 1175, to Alice Hoschedé).

10 This element is enlarged upon by Reuterswaerd, 1952, pp. 194–6, but the author overstates Sisley's bitterness about his lack of success and acclaim compared with Monet's and Renoir's.

11 *The Correspondence of Berthe Morisot*, ed. D. Rouart, London, 1957, p. 179.

12 Sisley to Tavernier, Moret, 6 June 1895 (Fondation Custodia (F. Lugt coll.), Institut Néerlandais, Paris,

1973-A5). Certain names have been scored through in this letter (by Tavernier) but it is obvious that Monet is one and Durand another.

13 Monet to Caillebotte, 12 May 1890 (in M. Berhaut, *Caillebotte, sa vie et son œuvre*, Paris, 1978, p.xx). Caillebotte and Sisley appear to have maintained friendly relations to the end of Caillebotte's life (1894). One (undated) letter from Sisley to Caillebotte survives (in Berhaut, p. xx): My dear Caillebotte, I left a basket of morels at Moret Station this evening. It will be at Argenteuil Station tomorrow morning. Greetings. A. Sisley.

14 C. Pissarro to Lucien Pissarro, 11 April 1895, and 24 February 1895, in *C. Pissarro*, 1943, pp. 266, 261.

15 Tavernier's words at Sisley's funeral as quoted by Bibb, 1899, p. 155.

16 In 1861 the conductor Jules Pasdeloup initiated an annual series of concerts of classical music; he hired the Cirque Napoléon, boulevard du Temple, which could hold 5,000 people; seat prices were cheap and the concerts were immensely popular. Sisley may well have gone to these concerts in the 1860s with Bazille who loved music and is known to have attended the Pasdeloup concerts. See G. Liebert, 'Mallarmé et la vie musicale de son temps', in *Quarante-huit/Quatorze*, Conférences du Musée d'Orsay, no. 2, 1990, pp. 53–4; also Poulain, 1932, p. 48.

17 Murer on Sisley, in Gachet, 1959, p. 193.

18 *Journal de Julie Manet*, Paris, 1979: 31 January 1899, pp. 214–15. Sisley's signature appears alongside those of Pissarro, Renoir, Boudin, Charpentier, Raffaelli, Zandomeneghi, Puvis de Chavannes, etc., under the date 3 May 1883, on one of seven pages filled with the signatures of those paying their respects to Manet's family after his death (Manet Family Notebook in the Pierpont Morgan Library, New York).

19 *Journal de Julie Manet*, Paris, 1979: 22 April 1899, p. 227.

20 An unpublished letter from Sisley to Gabriel Mourey (Moret, 3 June 1893) thanks him for an amiable paragraph in his recent account of the collection of the actor Ernest Coquelin; sold in 1893, the collection contained four Sisleys (Fondation Custodia (F. Lugt coll.), Institut Néerlandais, Paris).

21 Lionello Venturi's phrase, in Venturi, 1939, I, pp. 97–100; chapter 5 of Venturi, *Impressionists and Symbolists*,

London, 1950, is devoted to Sisley and quotes Mirbeau's Figaro review.

22 Sisley to Tavernier, Moret, 1 June 1892, quoted in Huyghe, 1931, p. 153.

23 See two letters of Sisley to G. Charpentier (Moret, 2 March 1895; and Moret, undated) in Huyghe, 1931, p. 153. '*Pris de Rhum*' is a pun on the Prix de Rome, the famous competition for students at the École des Beaux-Arts.

24 Sisley to Tavernier, Moret, 6 June 1895 (Fondation Custodia (F. Lugt coll.), Institut Néerlandais, Paris, 1973-A5).

25 Much of François Depeaux's enormous collection was sold in Paris at the Galerie Georges Petit on 31 May 1906. Thirty-two paintings by Sisley from all periods were auctioned. In 1909 Depeaux gave a collection of paintings to the Musée des Beaux-Arts, Rouen, including eight Sisleys (e.g. *Flood at Port-Marly* D237; Plate 76), which Depeaux had sold in 1906 and re-acquired from Durand-Ruel). A further six Sisleys from Depeaux's collection were sold in 1921, a year after his death.

26 Sisley to Tavernier, Moret, 7 November 1897, quoted in Huyghe, 1931, p. 154.

27 A Miss Harriet Hallowell and a Miss Marie Hallowell, both American, exhibited miniatures in 1898 and 1899 with the Société Nationale des Beaux-Arts; one of them, conceivably, was Sisley's influential visitor. It is worth noting here that in the 1899 exhibition there were works by two other American women, Miss Ethel Sands and her friend Miss Anna-Hope Hudson, the latter showing *Bord de Seine à Saint-Mammès* (no. 776). Later, both were greatly influenced by Walter Sickert, and became well known for their hospitality to English and French painters and writers at their houses in England and near Dieppe.

28 Claude Sisley, 1949, p. 252.

Chapter II

1 Sisley to Tavernier, Moret, 23 December 1896 (Fondation Custodia (F. Lugt coll.), Institut Néerlandais, Paris, 1973-A8).

2 Among the reviewers were: G. Geffroy in *Le Gaulois*, 22 February 1897 (reprinted with additions in Geffroy's *La Vie artistique*, 6th series, 1900, pp. 200-8); A. Alexandre in *Le Figaro*, 7 February 1897; A. Tavernier

in *L'Argus*; and Baron Maizeroy in *Gil-Blas* (the last two mentioned by Sisley in a letter to Tavernier, Moret, 6 March 1897 (Fondation Custodia (F. Lugt coll.), Institut Néerlandais, Paris 1973-A9)).

3 It should be stressed here that it was another twenty years at least before Impressionism gained wide public acceptance. In 1905, for example, at Durand-Ruel's exhibition of Impressionist painting at the Grafton Galleries, London, a show of outstanding quality, not a single work was sold. The Trustees of the National Gallery, London, eventually purchased a Boudin that had been in the exhibition, but a Sisley, also considered for purchase, was still regarded as too 'advanced'. For a summary of the exhibition, see J. Rewald, 'Depressionist Days of the Impressionists', in *Studies in Impressionism*, 1985, pp. 203–8.

4 Vincent van Gogh to Theo van Gogh, *Letters of Vincent Van Gogh*, London, 1958, III, p. 31.

5 Sisley's consistency as an Impressionist as well as his limitations are encapsulated in Pissarro's reply to the young Henri Matisse's question, 'What is an Impressionist?': 'An Impressionist is someone who paints a different picture each time. Sisley, for example.' (See A Barr, *Matisse, his Art and his Public*, 1951, p. 38)

6 Sisley to Tavernier, Penarth, 9 July 1897 (Fondation Custodia (F. Lugt coll.), Institut Néerlandais, Paris, 1973-A10).

7 Ibid.

8 Sisley to G. Geffroy, 16 July 1897, in Daulte, 1959, p. 36.

9 Not Sully Island, as given in *The Impressionists in London*, Arts Council of Great Britain, 1973, p. 61. Anthea Callen's excellent notes in the catalogue contain the first authoritative account of Sisley's Welsh visit. Confusion over the sites depicted still persisits, e.g. the title 'Lady's Cove, Hastings' for the Fuji Museum's recently acquired *Lady's Cove, Langland Bay* (Plate 153).

10 Sisley to Tavernier, Osborne Hotel, Langland Bay, 18 August 1897 (Fondation Custodia (F. Lugt coll.), Institut Néerlandais, Paris, 1973-A11).

11 Acte de Reconnaissance d'Enfants, 3 August 1897, Consulat de France, Cardiff (records now held in the Consulat de France, London). The entry in the ledger is signed by Eugénie Lescouezec in the presence of Adolphe de Trobriand, Chevalier de la Légion d'honneur, Consul de France à Cardiff. Certificate of Marriage,

Regsitration District of Cardiff, 5 August 1897, no. 146.

12 Sisley was the second of the Impressionist group to have married in Britain. Camille Pissarro had married Julie Vellay at the Croyden Register Office in 1871.

13 Such recommendations hold good today (1991); the Osborne Hotel, though greatly enlarged and altered, still presides over the charming bay. All Sisley's motifs are recognizable but Rotherslade Bay beach is disfigured by an abandoned arcaded structure built into the cliff.

14 Sisley to Tavernier, Osborne Hotel, Langland Bay, 18 August 1897 (Fondation Custodia (F. Lugt coll.), Institut Néerlandais, Paris, 1973-A11).

15 Sisley to Tavernier, Moret, 16 October 1897 (Fondation Custodia (F. Lugt coll.), Institut Néerlandais, Paris, 1973-A12).

16 In the first months of 1897 Monet had been painting at Pourville on the Normandy coast, mainly views of the sea from a cliff-top; again, his 'programme', rather than the resulting works may have motivated Sisley's coastal paintings later in the year.

17 In Sisley's letter to Tavernier of 16 October 1897 (see n. 15), he states that he has returned to Moret with twelve canvases, all views of the sea at Penarth and Langland. In fact, about twenty paintings from this visit are recorded (seventeen in Daulte, 865-81, plus *English Coast* (Landesmuseum, Hanover), *Langland Bay, Wales: Morning* (Sotheby's, New York, 4 November 1982), and a Penarth view, similar to D868, known in a photograph in the Witt Library, Courtauld Institute of Art, London). This clearly indicates that Sisley worked on the series once he had returned to Moret, very likely using drawings and notes made in Wales. Three of the paintings were shown at the Société Nationale des Beaux-Arts exhibition, Paris, in May 1898 (D866, 873, 877).

Chapter 12

1 Renoir, recorded in J. Renoir, 1961, p. 110.

2 Hôtel de Ville, Moret-sur-Loing, Acte de Décès, 8 October 1898 (no. 92).

3 Sisley to Tavernier, Moret, 6 November 1898 (Fondation Custodia (F. Lugt coll.), Institut Néerlandais, Paris, 1973-A6). It would appear from the symptoms described by Sisley in his letters that he in fact had cancer of the larynx, almost certainly attributable to pipe-smoking throughout his life.

4 Sisley to G. Viau, Moret, 28 November 1898, in Daulte, 1959, p. 37.

5 Sisley to G. Viau, Moret, 11 December 1898 (Fondation Custodia (F. Lugt coll.), Institut Néerlandais, Paris, 6738a).

6 Sisley to G. Viau, Moret, 31 December 1898, in Braun, 1933, p. 8.

7 Sisley to G. Viau, Moret, 1 January 1899, in Braun, 1933, p. 9.

8 C. Pissarro to Lucien Pissarro, Paris, 22 January 1899, in *C. Pissarro*, 1943, p. 334.

9 See Daulte, 1959, p. 37.

10 A. Dunoyer de Segonzac in conversation with Eardley Knollys, *c.*1949 (relayed to the author, December 1978). It is not certain how this detail came to be known by Segonzac, but it may have been learnt by the artist on one of his visits to Moret.

11 Hôtel de Ville, Moret-sur-Loing, Acte de Décès, 29 January 1899 (no. 10).

12 See Déclaration de Succession d'Alfred Sisley, 26 June 1899 (Archives départementales de Seine et Marne, 222 Q65).

13 Monet to G. d'Espagnat, Giverny, 1 April 1899, in B. d'Espagnat, *Georges d'Espagnat*, Paris, 1990, pp. 122-3.

14 *Journal de Julie Manet*, Paris, 1979: 1 May 1899, p. 229.

15 See Vente Succession Sisley in *Procès-Verbaux*, Archives de Paris, D48E 3 83, Chevallier dossier no. 8306.

20 The leaflet announcing the *Comité du Monument Sisley* is reproduced in 'Sisley à Moret', *La Revue de Moret et de sa Région*, 111, 20 March 1989, p. 27; Jeanne Sisley's letter to G. Geffroy, Moret, 7 July 1905, was acquired in 1990 by the Fondation Custodia (F. Lugt coll.), Institut Néerlandais, Paris.

17 See *La Revue de Moret* (n. 16), p. 14, in a reprint of a 1930 article by E. Déborde de Montcorin.

Appendices

Appendix A

Jeanne and Pierre Sisley

The subsequent history of Sisley's children – the young girl and boy in *The Lesson* (Plate 19) and in several drawings (Plates 94, 95 and 96) – is worth a valediction. They retained contact for a few years with the Monet/Hoschedé household at Giverny; they were there for the wedding, in 1900, of Marthe Hoschedé and Théodore Butler, and appear in the inevitable family photograph (see page 225); Jeanne was there again in 1901, accompanying Monet to Lavacourt to paint. In 1908 she married a jeweller, Fernand Dietsh, who, a year later, was responsible for the final sale of paintings from Sisley's studio. No more is heard of her until her death in Paris, on 4 February 1919, just after her fiftieth birthday; her husband died a fortnight later. No cause of death is known, but it is probable that the couple died from Spanish influenza, an epidemic which ravaged Europe in the winter of 1918–19.

Pierre Sisley did his military service in France and, though described as a 'décorateur' at the time of his father's death, is given as a 'dessinateur' in subsequent documents. It has been recorded that in 1900 he wished to marry Monet's stepdaughter, Germaine Hoschedé (in the wedding photograph referred to above, she is on the right) Monet apparently discouraged the union,

feeling that Pierre was an unambitious day-dreamer and no guarantor of Germaine's future happiness.

Thereafter Pierre disappeared into obscurity. He left central Paris and worked for a firm of technical draughtsmen and illustrators. At the time of his death, 21 June 1929, he was living in the Levallois-Perret quarter of Paris, just south of the Île-de-la-Grande-Jatte. A few days later the following extraordinary news item appeared in the London *Morning Post* under the headline 'Great Artist's Son Dies in Penury':

A shudder ran through artistic Paris to-day when it was reported that Pierre Sisley, the son of Alfred Sisley, the famous Impressionist painter, had died of starvation. Any work by Alfred Sisley now fetches hundreds of pounds. Pierre Sisley lived alone in a tiny flat in a Paris working man's suburb. He was 62 years old and his seclusion was such that he is said never even to have opened his window shutters.

But he went out occasionally and when his concierge noticed that twenty-four hours had passed without his being seen, she fetched the police who found him dead upon his bed. A doctor diagnosed the cause of death as want.

It seems, however, that the circumstances of the death of Sisley's son were not so gruesome as was supposed and that the poor man's misery partly at least arose from

pronounced hypochondria.

It is at least certain that Pierre Sisley had in his lodgings a number of his father's pictures for which he could have obtained a large sum of money and that the last time he was seen he was in possession of enough cash to stave off hunger, for he changed a 100 franc note (16 shillings) at a neighbouring shop.

Appendix B
Letter from Sisley to Adolphe Tavernier, Moret-sur-Loing, 19 January 1892
(Fondation Custodia (F. Lugt coll.), Institut Néerlandais, Paris, 1973-A1).

Cher Monsieur Tavernier,

Voici les quelques notes que vous m'avez demandées. Je suis ne à Paris en 1839 le 30 oct. J'entrais à l'atelier Gleyre en 1860. J'y restais 2 ans; en le quittant j'allais à Chailly, aux environs de Fontainebleau, puis à Marlotte, de l'autre côté de la forêt. Ce furent des années purement d'étude. Ce n'est qu'en 1866 que j'envoyais au Salon 2 toiles qui furent reçues. Comme j'avait mis quelques femmes dans une de mes toiles, un critique spirituel me traita d'animalier!

J'exposais aussi 2 vues du Canal St martin, dans Paris, au Salon de 1870.

Apres avoir perdu tout ce que je possédais au Bougival au moment de la guerre, et m'être refugie dans Paris, Je revins dans ces mêmes environs, à Louveciennes, en 1872.

Puis je passais quelques mois à Hampton Court aux environs de Londres où je fis quelques études importantes. Je ne sais si vous le connaissez, c'est un endroit charmant.

Quittant Louveciennes je me fixais pendant 2 ans à Marly, à deux pas de Louveciennes, où je fis quelques études de l'abreuvoir et du Parc entre autres.

Comme vous le voyez sauf une ou 2 fugues je n'ai guère peint que les environs de Paris.

Je passais ensuite 2 ans à Sèvres et en 1880 je vins me fixé à Moret.

Dans cette période de 1872 à 1879, j'exposais à presque toutes les expositions organisées entre nous, Impressionistes [sic].

Je suis donc depuis bientôt 12 ans à Moret ou aux environs. C'est à Moret devant cette nature si touffue, ses grand peupliers, cette eau du Loing si belle, si transparente, si changeante,

c'es à Moret certainement que j'ai fait le plus de progrès dans mon art; surtout depuis 3 ans.

Aussi quoiqu'il soit bien dans mes intentions d'agrandir mon champ d'études, je ne quitterai jamais complètement ce coin si Pittoresque.

Maintenant, entre-t-il dans votre programme que je vous parle un peu peinture? J'aimerais mieux pas. Vous me renseignerez à cet égard. Est-ce bien ce que vous attendez de moi? En tout cas si vous avez besoin d'un renseignement je me ferai toujours un plaisir de vous satisfaire.

Jusqu'au revoir je vous serre bien cordialement et bien sincèrement la main.

A. Sisley.

Mor\et 19 Janv. /92.

Dear Monsieur Tavernier,

Here are a few notes you asked me for.

I was born in Paris on 30 Oct. 1839. I entered Gleyre's atelier in 1860. I stayed there two years; when I left I went to Chailly, near Fontainebleau, then to Marlotte, on the other side of the Forest. These years were devoted entirely to study. It was only in 1866 that I submitted to the Salon two canvases which were accepted. Since I had put several women in one of my canvases, a witty critic called me an animal painter!

I also exhibited two views of the Canal St Martin, in Paris, at the Salon of 1870.

After losing all that I possessed at Bougival during the war and taking refuge in Paris, I returned to the same area, to Louveciennes, in 1872.

Then I spent some months at Hampton Court near London, where I did several important studies. I am not sure if you know it, it is a charming place.

Leaving Louveciennes, I made my home for two years at Marly, a stone's throw from Louveciennes, where I made some studies of the watering-place and the Park.

You can see that apart from one or 2 trips I have virtually painted only in areas close to Paris.

Then I spent 2 years at Sèvres and in 1880 I went to live at Moret.

In the period from 1872 to 1879 I exhibited at *almost all* the exhibitions organized by us, the *Impressionists*. So I have lived in Moret or near by for nearly 12 years. It is at Moret – in this thickly wooded countryside with its tall poplars, the waters of the river Loing here, so beautiful, so translucent, so

changeable; at Moret my art has undoubtedly developed most; especially in the last 3 years. Although I certainly intend to extend the range of my subjects, I will never really leave this little place that is so Picturesque.

Now, did you imagine I would speak to you about painting? I would much rather not. You can tell me about that. Was this what you were expecting from me? In any case if you need any information, I shall always be pleased to supply you with it. Until we meet again I shake your hand most cordially and sincerely.

A. Sisley
Moret 19 Jan. /92

Appendix C
Introduction by Adolphe Tavernier to the catalogue of the exhibition of Sisley's paintings *L'Atelier de Sisley* held at Bernheim Jeune, 15 rue Richepanse, Paris, from 2 to 14 December 1907.

L'Atelier de Sisley
Sollicités, à diverses reprises, de céder les œuvres qui garnissaient l'atelier du maître de Moret, ses héritiers avaient toujours décliné les offres les plus séduisantes.

C'est que cet atelier renfermait – outre les études précieuses où la pensée de l'artiste se décelait en quelque sorte toute nue, avec un captivant frisson d'intimité – nombre de toiles maîtresses, de ces toiles si parfaitement bien venues qu'elles sont exigées, pour naître à la vie surnaturelle de l'art, non seulement le génie du peintre lui-même, mais encore tout un concours de circonstances rares et de conditions heureuses, l'accord exquis du motif lumineux et de l'émotion,– de ces toiles où la nature semble, en fait, s'offrir toute palpitante à une communion directe. Dans ce sens on a pu justement dire qu'un beau paysage était un état de l'âme.

Ces correspondances subtiles et cette exceptionnelle maîtrise s'affirment dans la plupart de la vingtaine de toiles que MM. Bernheim Jeune ont la joie de présenter aujourd'hui dans leur galerie au public d'élite conquis depuis longtemps par le plus délicat, le plus charmant, le plus poétique des impressionnistes.

C'était bien à eux qu'il appartenait, en effet, de présenter les œuvres de ce maître trop longtemps dédaigné et auquel l'indépendance de son caractère valait naguère encore la sourde inimitié de quelques-uns et la méconnaissance du plus grand nombre. Et je suis heureux pour ma part que les possesseurs de

ces œuvres jusqu'alors inconnues les laissent exposer dans cette galerie qui, depuis longtemps, s'est fait la réputation – qu'elle garde toujours – d'être ouverte à toutes les originalités, à toutes les tentatives audacieuses et nouvelles.

On a pu dire, lors de la dispersion de la collection de mon ami A. de Saint-Albin, que c'était là le dernier 'nid' des Corots. On en pourrait dire autant des toiles d'aujourd'hui, car du millier et demi de peintures dues au magistral pinceau de Sisley, presque toutes sont maintenant classées dans les musées ou dans des collections particulières très fermées. Et puisque le grand nom de Corot est venu sous ma plume, pourquoi ne pas écrire que Sisley nous apparaît – avec un apport nouveau bien étendu – comme le digne héritier de ce beau maître, en ces toiles exquises où la force le dispute à la grâce, la poésie à la distinction de la facture, surtout dans cette période de 1872 à 1876, où il produisit des chefs-d'œuvre? On en retrouvera ici quelques-uns: tableaux qui ne séduisent pas seulement les yeux par la beauté du motif choisi, la splendeur d'une matière rare et comme dorée par le temps, la légèreté mouvante de ciels impondérables, mais qui vont jusqu'à toucher l'âme par ce qu'on sent en elles d'émotion, par ce qu'on devine en elles de l'intimité de celui qui les a conçues et réalisées.

Il aimait profondément son art, celui qui, sollicité par un ami de donner son sentiment sur la façon dont il l'entendait, lui écrivit en janvier 1892, ces lignes sans prétention, mais si révélatrices:

> *. . . Coucher sur le papier des aperçus de ce qu'on appelle aujourd'hui son esthétique, me paraît joliment scabreux et lorsque je suis tenté de le faire je pense toujours à Turner et à l'anecdote qu'on m'a contée sur lui.*
> *Il sortait de chez des peintres amis où l'on s'était pas mal chamaillé à propos de peinture – chacun préférant la sienne naturellement – mais chacun s'efforçant de dissimuler cette préférence sous de grands mots et de belles théories pompeuses. Pendant la discussion, Turner n'avait pas soufflé mot. Arrivé dans la rue et se tournant vers l'ami qui l'accompagnait: 'Drôle de chose que la peinture, hein!'*
> *La répugnance que Turner éprouvait à faire de la théorie, je l'éprouve aussi, et je crois qu'il est beaucoup plus facile de 'parler' un chef-d'œuvre que de le réaliser par le pinceau –ou autrement.*
> *Mais, sans avoir la prétention de vous faire une manière de cours de paysage dont vous vous passerez bien, je vais vous dire tout bonnement ce que j'en pense*

217

. . . mais vous savez que j'aime mieux peindre qu'écrire et tant pis pour vous si je vous ennuie.

L'intérêt dans une toile, vous le savez, est multiple. Le sujet, le motif, doit toujours être rendu d'une façon simple, compréhensible, saisissante pour le spectateur.

Celui-ci doit être amené – par l'élimination des détails superflus – à suivre le chemin que le peintre lui indique et voir tout d'abord ce qui a empoigné l'exécutant.

Il y a toujours dans une toile un coin aimé.

C'est un des charmes de Corot et aussi de Jongkind.

Après le sujet, une des qualités les plus intéressantes du paysage, est le mouvement, la vie.

C'est aussi une des plus difficiles à réaliser. Donner la vie à une œuvre d'art est certes une condition indispensable pour l'artiste digne de ce nom. Tout doit y contribuer: la forme, la couleur, la facture. C'est l'émotion de l'exécutant qui donne la vie et c'est cette émotion qui éveille celle du spectateur. Et quoique le paysagiste doive rester maître de son métier, il faut que la facture, en de certains moments plus emballés, communique au spectateur l'émotion que le peintre a ressentie.

Vous voyez que je suis pour la diversité de la facture dans le même tableau. Ce n'est pas tout à fait l'opinion courante, mais je crois être dans le vrai, surtout quand il s'agit de rendre un effet de lumière. Car le soleil, s'il adoucit certaines parties du paysage, en exalte d'autres et ces effets de lumière qui se traduisent presque matériellement dans la nature doivent être rendus matériellement sur la toile.

Il faut que les objets soient rendus avec leur texture propre, il faut encore et surtout qu'ils soient enveloppés de lumière, comme ils le sont dans la nature. Voilà le progrès à faire.

C'est le ciel qui doit être le moyen (le ciel ne peut pas n'être qu'un fond). Il contribue au contraire non seulement à donner de la profondeur par ses plans (car le ciel a des plans comme les terrains), il donne aussi le mouvement par sa forme, par son arrangement en rapport avec l'effet ou la composition du tableau.

En est-il de plus magnifique et de plus mouvementé que celui qui se reproduit fréquemment en été, je veux parler du ciel bleu avec les beaux nuages blancs baladeurs. Quel mouvement, quelle allure, n'est-ce pas?

Il fait l'effet de la vague quand on est en mer; il exalte, il entraîne. Un autre ciel: celui-là plus tard, le soir. Ses nuages s'allongent, prennent souvent la forme de sillages, de remous qui semblent immobilisés au milieu de l'atmosphère, et peu à peu disparaissent, absorbés par le soleil couchant. Celui-là est plus tendre, plus mélancolique; il a le charme des choses qui s'en vont – et je l'aime particulièrement.– Mais je veux pas vous raconter tous les ciels chers aux peintres, je ne vous parle ici que de ceux que je préfère entre tous.

J'appuie sur cette partie du paysage, parce que je voudrais vous faire bien comprendre l'importance que j'y attache. Comme indication: Je commence toujours une toile par le ciel . . .

. . . Quels sont les peintres que j'aime? Pour ne parler que des contemporains: Delacroix, Corot, Millet, Rousseau, Courbet, nos maîtres. Tous ceux enfin qui ont aimé la nature et qui ont senti fortement . . .,

N'est-ce pas que ces notes (qui n'étaient pas destinées à la publicité et dont j'ai respecté le laisser-aller savoureux et charmant) font encore plus aimer l'artiste d'élite que fut Sisley?

A côté des vingt et une toiles peintes à toutes les époques de sa vie, et dont quelques-unes sont capitales, comme les *Coteaux Saint-Niçaise*, les *Bords du Loing* (le matin), l'*Orvanne* (en hiver), les *Coteaux de la Bouille* et la *Vague de Longland* [sic], on trouvera ici trois œuvres exquises de Renoir, dont un prestigieux portrait d'Alfred Sisley.

Adolphe Tavernier.

Sisley's Studio

Sisley's heirs were asked on any number of occasions to relinquish the works which furnished the studio of the master at Moret, but they always declined even the most attractive offers.

For apart from the precious studies in which the artist's intention reveals itself quite bare, as it were, with an entrancing thrill of intimacy – this studio contained a number of canvases of major importance, so perfectly conceived that, in order to be born into the supernatural world of art, they required not only the genius of the painter himself, but also a whole blend of exceptional circumstances and propitious conditions, an exquisite harmony between luminous subject and feeling – paintings where joyful, quivering nature seems to offer herself in direct communion. In this sense it has rightly been asserted that a fine landscape is an expression of the soul.

These subtle correspondences and this exceptional mastery are revealed in most of the twenty or so canvases

that Messieurs Bernheim Jeune have pleasure in displaying in their gallery today to a select public, who have long been won over by this most delicate, most charming and most poetic of impressionists.

It is in fact undoubtedly their responsibility to present the work of this master, who has too long been spurned and whose independent character resulted in muted intimacy with a few, and misunderstanding by the majority. And for my part I am happy that the owners of these hitherto unknown works have allowed them to be shown in this gallery, which has long had the reputation – long may it remain so – of being open to all forms of originality and to novel and daring experiment.

It could have been said, when my friend A. de Saint-Albin's collecton went for sale, that that was the last cache of Corots. That would be still more true of the canvases you see today, for of the one and a half thousand or so paintings that issued from Sisley's magisterial brush, almost all now belong to museums or form part of very inaccessible private collections. And since I have mentioned the great name of Corot why not write – especially in the light of substantial new evidence – that Sisley seems the worthy heir of that great master, in these beautiful paintings where strength vies with grace, poetry with technical distinction, above all in the period from 1872 to 1876 when he produced such masterpeices. Some of them are to be found here: pictures that not only delight the eye with the beauty of the subject, the brilliance of an exceptional theme, almost gilded by time, the fluid lightness of inscrutable skies, but which touch the very soul with the emotion sensed in them, because the onlooker discerns the inner depths of the man who conceived and realized them.

He was deeply attached to his art, this man who, when asked by a friend to communicate his opinion on the way in which his work should be understood, wrote these unpretentious but extraordinarily revealing lines in January 1892:

'. . . I find it really difficult to put on paper my perception of what is today called one's aesthetic, and when I am tempted to do so, I always think of Turner and an anecdote I was told about him.
He came out of a gathering of painter friends of his where they had been having a good argument about painting – each of course preferring his own work – but each forcing himself to conceal this preference behind grand words and

fine, pompous theories. During the discussion, Turner did not breathe a word. When he was in the street, he turned towards the friend who was with him: 'Funny old business, painting!'
I share Turner's dislike of theorizing, and I believe that it is much easier to chatter about a masterpeice than to create it with a brush or in any other way.
But, without presuming to set you a kind of course in landscape in which you would do well, I am going to tell you quite simply what I think about it . . . but you know that I would rather paint than write and it is too bad if I bore you.
A canvas, you know, has more than one focus of interest. The subject, or theme, should always be represented in a simple and comprehensible form, which grips the spectator.
The latter should be drawn – by the elimination of superfluous details – along the road the painter shows him and should see first whatever caught the artist's eye.
There is always a favourite corner in every painting. This is one of the charms of Corot and also of Jongkind.
After the subject itself, one of the most interesting aspects of the landscape is movement, life.
It is also one of the most difficult to achieve. Giving life to a work of art is certainly an indispensable criterion for any artist worthy of the name. Everything should play a part: form, colour, treatment. It is the painter's emotion which brings it to life and it is that same feeling which awakens the emotion of the spectator.
And although the landscape painter should be a complete master of his art, more intense treatment of some areas should communicate to the spectator the emotion that the painter experienced.
You see that I am an advocate of a diversity of treatment in the same picture. This is certainly not a generally held opinion, but I think I am right, especially when it is a question of rendering the effect of light. For although sunlight softens some parts of the landscape, it highlights others, and these light effects which express themselves almost physically in nature should be rendered physically on the canvas.
Objects should be painted with their own texture, moreover – and above all – they should be bathed in light just as they are in nature. That's what has to be achieved.
The sky must be the means of doing so (the sky cannot be

a mere background). On the contrary, it not only helps to add depth through its planes (for the sky has planes just as the ground does), it also gives movement through its shape, and by its arrangement in relation to the effect or composition of the picture.

Is there anything more splendid or thrilling than that which is frequently found in summer, I mean the blue sky with beautiful clouds, white and drifting. What movement, what allure they have! It has the effect of a wave at sea; it exalts you and carries you along. Another sky: this one at evening. Its clouds stretch out, often looking like the wash of a ship, eddies suspended in the atmosphere, and gradually disappear, absorbed by the setting sun. This sky is gentler, more melancholic; it has the charm of things which are passing – and I have an especial fondness for it. – But I do not want to describe for you all the skies that painters like, I am only telling you about those which I prefer above all.

I have stressed that part of the landscape, because I want to make you understand the importance I attach to it. As evidence: I always start a painting with the sky . . .

. . . . Which painters do I like? To confine myself to contemporaries: Delacroix, Corot, Millet, Rousseau, Courbet, our masters. All those who loved nature and felt it deeply . . . ',

Surely these notes (which were not designed for public consumption and whose charming and distinctive informality I have respected) make us admire this superb artist even more?

Side by side with these twenty-one canvases painted at all stages in his life, and some of which are outstanding, such as *Coteaux Saint-Niçaise* (Hillside at Saint-Niçaise), *Bords du Loing* (Banks of the Loing) (in the morning), *Orvanne* (in winter), *Coteaux de la Bouille* (Hillside at la Bouille) and *Vague de Langland* (Sea at Langland), there are also three fine works by Renoir, including an important portrait of Alfred Sisley.

Adolphe Tavernier.

Appendix D
Preface by Arsène Alexandre to the catalogue of the sale of Sisley's studio, 1 May 1899. (Paris, Bibliothèque Nationale, Cabinet des Etampes)

Lendemains de Luttes

Sisley a vécu fier et est mort pauvre.

Elle est arrivée souvent cette histoire, bien qu'heureusement l'indépendance n'ait pas toujours, pour les artistes, entraîné comme conséquence fatale la pauvreté. Mais la vie est une étrange loterie, où le plus souvent on s'exténue pour gagner de mauvais lots. La chance de Sisley fut particulièrement assidue. Presque sans interruption, il gagna. Avec des dons riants, il vécut la tristesse à ses côtés; malgré un talent qui présentait tout ce qu'il faut pour plaire, il ne connut une grande partie de sa vie que le souci et même l'angoisse.

Sa vie et son œuvre font entre elles un étrange contraste, sauf durant les années du début. Au commencement, elles sont en harmonie et également heureuses. Dans le petit groupe laborieux et insouciant, épris de lumière, que forment à Fontainebleau Monet, Renoir, Sisley, Bazille, il représente la gaieté, l'entrain, la fantaisie. Renoir se souvient et nous a souvent parlé de l'intrépide bonne humeur de Sisley, à cette époque exempte d'argent et de mélancolie.

Mais, dès 1870, tout cela change. L'œuvre continue à être pleine de fraîcheur et d'éclat, tandis que le caractère bifurque; il devint ombrageux et farouche. L'artiste continue à donner la joie aux passants, tout en devenant de plus en plus sombre pour son propre compte. Sa peinture, comme par le passé, est sans aucune arrière-pensée, tandis que son esprit en tout est rempli.

Il voit peu ses amis, qui le plaignent et ne lui en veulent point. Il souffre moralement et physiquement – entre autres mauvaises fortunes, des froids attrapés en peignant dehors en plein hiver, lui causèrent une paralysie momentanée de la face; – mais il se crée lui-même bien d'autres chagrins, souvent imaginaires. Il est irritable, mécontent, agité. Il saisit avec une avidité poignante et touchante les marques de sympathie qui lui viennent d'inconnus, de nouveaux venus, et tout aussitôt il s'éloigne encore avec défiance de ces nouvelles amitiés. Arriva un moment – c'est alors que je l'ai connu et que j'ai éprouvé personnellement ce que je dis – où il devint tout à fait malheureux et éprouva d'extrêmes difficultés pour vivre.

Pendant ces heures noires, ses arbres demeuraient aussi verts, ses rivières aussi transparentes, sa peinture aussi gaie et dorée. Il voyait successivement toutes les joies l'abandonner, sauf la joie de peindre, qui ne le quitta jamais.

Il y a plus de dix ans de cela! Il me semble qu'alors j'ai eu la clef de sa nature comme homme et comme artiste.

Comme homme, je l'ai vu, en l'espace de quelques mois, ardent à l'espoir et prompt au découragement, méconnaissant les

intentions les plus dévouées, et revenant par de brusques attendrissements à ceux qu'il avait traités avec des amertumes inattendues.

C'est une phrase musicale qui, comme de son propre aveu, m'a fait compréhendre pourquoi l'artiste n'avait jamais été en proie à la même inquiétude que l'homme.

Il me conta, un jour que nous devisions de choses d'art, que dans sa jeunesse il avait fré-quenté les 'Concerts populaires', les concerts Pasdeloup, et qu'une des choses qui l'avaient le plus frappé, qui lui avaient procuré un ravissement ineffaçable, c'était le 'trio' du scherzo, dans le Septuor de Beethoven.

'Cette phrase, si gaie, si chantante, si entraînante,' me disait-il, 'il me semble que, depuis la première fois que je l'ai entendue, elle fait partie de moi-même, tant elle répond à tout ce que j'ai toujours été au fond. Je la chante sans cesse. Je me la fredonne en travaillant. Elle ne m'a jamais abandonné . . .'

Et c'est bien cela l'explication! La vie avait beau être pleine d'embuches imaginaires et de difficultés, helas! trop réelles; au travail, une sorte de scherzo secret l'avait préservé dans son œuvre du même trouble que dans sa maison. Il l'emportait dans son esprit et pour ainsi dire dans sa boîte à couleurs, à travers les printemps et les étés, et les moissons et les hivers. Ce fut la bonne obsession.

Malheureux homme troublé et tourmenté! Sa fin a été bien triste, après un succès relativement bien court, j'entends un succès tangible pour lui, car, dès que sa mort fut certaine, le succès devint si grand que la dixième partie eût largement suffi pour dissiper, peut-être complètement, pendant sa vie entière, toutes les brumes qui s'accumulaient à chaque instant autour de son pauvre scherzo!

Dès qu'on apprit qu'il n'allait plus pouvoir peindre, sa peinture monta de prix . . . c'est même comme cela que, ne le voyant plus beaucoup, la nouvelle de sa grave maladie me parvint . . . Seulement il n'avait plus rien, ou presque rien chez lui, et il laissait les siens sans ressources . . .

S'il avait pu deviner ce qui se passe en ce moment, son cœur bon et sensible au fond sous son enveloppe de défiance acquise et de trop explicable misanthropie, se serait fondu de gratitude et de douceur.

Il aurait vu les compagnons anciens lui apportant les souvenirs émus des jours de vaillance et de jeunesse. Il aurait vu

Claude Monet, se dépensant avec le plus grand zèle, pour que ceux qu'il laissait fussent sauvés des stérilisantes angoisses, et recrutant, infatigable, ici des souscriptions, là des appuis, là des œuvres, organisant cette vente, enfin, qui a quelque chose de plus émouvant qu'une vente ordinaire.

Tout ce qui a été récolté ainsi, je ne le connais pas encore à l'heure où j'écris: je sais que Renoir, Degas, Pissarro, Zandomeneghi, Lebourg, Guillaumin, Miss Cassatt, se sont empressés de se ranger aux côtés de Claude Monet et de seconder son vœu en faveur de leur ancien compagnon aux jours héroïques de ce que l'on a baptisé 'l'impressionnisme'; que Mlle Manet a offert une œuvre de Mme Berthe Morizot [sic] et M. Martial Caillebotte une œuvre de son frère. C'est à dire, d'une part, que tous les combattants d'autrefois sont représentés. D'autre part, des artistes qui, à ces titres divers, et sans faire partie du même groupe, eurent aussi à affronter les indifférences ou les colères et à se tailler leur route dans le roc avant d'arriver à la célébrité, comme Fantin-Latour, Cazin, Roll, Carrière, Raffaelli, Besnard, Helleu, Aman-Jean, Thaulow, Lerolle, René Menard, Vuillard ont tenu à honneur de montrer qu'ils savent au prix de quelles épreuves se paie le succès. Il y en a sans doute encore d'autres qui m'excuseront d'autant mieux de ne pas les citer que ce n'est pas pour cela qu'ils ont envoyé leur offrande, et que ceci n'est pas un compte rendu d'exposition, mais un simple hommage d'émotion en présence d'un acte de solidarité humaine.

Quelles belles choses ils ont tous donnés! Comme ils ont eu à cœur de fournir de leur meilleur!

Ces lendemains de luttes ont quelque chose de consolant et de poignant à la fois, et vraiment de presque solennel. Ceux qui triomphent par leurs propres forces, et aussi un peu avec le consentement de la vie, viennent accomplir les souhaits non exaucés des vaincus, qui, ainsi, ne s'en iront pas dans une accablante solitude. Comme dans les contes d'autrefois, on fait des choses pour assurer la paix à leur âme, qui fut inquiète. La tâche de l'amitié et de l'assistance ne s'arrête point aux regrets et aux condoléances; elle veut être active et apporter au foyer du disparu le secours matériel que sa fierté, tant qu'il était sur la brèche, lui eût interdit d'accepter.

Les amis, les camarades, les confrères de Sisley ont tenu à ce que leur offrande fut large et brillante, pour que le public fût généreux. C'est à vous qu'il appartient de compléter leur œuvre, amis de qui l'on ne sait point les noms, mais de qui les sympathies certaines assistent perpétuellement les artistes dans leurs revers, comme dans leurs victoires chèrement gagnées.

Arsène Alexandre.

Days when the struggle is past

Sisley lived proud and died poor.

This has been a recurrent theme, although fortunately artistic independence does not invariably entail the fatal consequence of poverty. But life is a strange lottery, where men most frequently strive for unlucky numbers. Sisley's lot was particularly hard. He worked almost without ceasing. Endowed with smiling gifts, he lived with sadness at his side; depite a talent that did all it could to please, for a large part of his life he knew only cares and even torment.

His life and work were strangely contrasting, except for the first few years. To begin with, they were in harmony and equally happy. In the small hard-working and carefree group, besotted with light, which Monet, Renoir, Sisley and Bazille formed at Fontainebleau, he was the embodiiment of gaiety, high spirits, fantasy. Renoir remembers Sisley's intrepid good humour, in that period without either money or melancholy, and has often told us about it.

But after 1870, all that changed. His work continued fresh and radiant, while his character split: he became gloomy and unsociable: the artist continued to be charming to passers-by, while his temperament became increasingly black. His painting was as lacking in suspicions as ever, while his own mind was full of them.

He seldom saw his friends, who complained about him and did not want to see him. He suffered mentally and physically – among other misfortunes he had temporary paralysis of the face as a result of catching cold while painting out of doors in the middle of winter – but he brought many other troubles upon himself, often imaginary. He was irritable, dissatisfied, restless. He fell with pitiful and touching eagerness upon any sign of sympathy from strangers and new-comers, and then immediately distanced himself from these new friendships. There came a time – and it was then that I knew him, and I have had personal experience of what I relate – when he became utterly wretched and experienced extreme difficulty in staying alive.

During these dark hours, his trees remained as green, his rivers as limpid, his painting as bright and golden. He watched each pleasure leave him in turn, except for the joy of painting, which never departed.

That is all more than twelve years past! It seems to me that then I had the key to his nature as both a man and artist.

As a man, I saw him in the space of a few months, eager to hope and just as quickly cast down, scorning the kind

intentions of the most devoted friends, and returning with rough affection to those whom he had treated with unexpected harshness.

It was a snatch of music that made me realize why the artist had never been prey to the same anxieties as the man.

He told me, one day when we were chatting about art, that when he was young he had gone to Pasdeloup's 'Popular Concerts', and one of the things that had moved him most, and produced a sensation of unforgettable ecstasy was the trio of the scherzo in Beethoven's Septet.

'This phrase was so lively, so catchy and stirring,' he told me, 'that it seemed as if, ever since the first time I heard it, it was part of myself, it answered so exactly to everything at the very depths of my being. I sang it continually. I hummed it as I worked. It has never left me . . .

And that is undoubtedly the explanation! Life had been only too full of difficulties, some imaginary and others, alas! only too real; at work, a sort of secret scherzo had saved his painting from the worries of his domestic life. He carried it in his heart and, as it were, in his paint box, through successive springs and summers, harvest-times and winters. This was a benign obsession.

Unhappy man, troubled and tormented! His death was very sad, after such a relatively short success. I anticipate his palpable success, for, once his death was certain, his success became so great that even a tenth part would have been sufficient to disperse, perhaps completely, for the rest of his life, the fogs that constantly gathered round his poor scherzo!

As soon as it became known that he would never paint again, the price of his paintings rose . . . I even felt the same about the fact that I would never see him again when the news of his serious illness reached me . . . Only he had nothing, or virtually nothing of his own, and left his children without means . . .

If he could have guessed what would happen at that juncture, his good and tender heart that lay beneath the assumed mantle of defiance and his only too explicable mis-anthropy, would have melted with gratitude and sweetness.

He would have seen his former companions bringing him tender memories from the courageous days of their youth. He would have seen Claude Monet putting himself to endless

222

trouble so that those whom he [Sisley] left would be spared fruitless misery, and indefatigably enlisting subscriptions here, support there, lastly organizing this sale, which has been infinitely more touching than any ordinary sale. At the time when I wrote this, I had not learnt about everything that had been garnered in this way: I know that Renoir, Degas, Pissarro, Zandomeneghi, Lebourg, Guillaumin, Miss Cassatt all rushed to Claude Monet's side and seconded his vote of approval for their former companion from the heroic days of what we now know as 'impressionism'; that Mademoiselle Manet gave a work of Madame Berthe Morisot [sic] and Monseiur Martial Caillebotte a work by his brother. That is to say, on the one hand, all the combatants of the past were represented. On the other hand, artists who, in various respects, and without being part of the same group, had also to endure lack of interest or hostility and cut their path through the rock before achieving renown, such as Fantin-Latour, Cazin, Roll, Carrière, Raffaelli, Besnard, Helleu, Aman-Jean, Thaulow, Lerolle, Rene Menard, Vuillard all held it an honour to demonstrate that they knew that such trials were the price of success. There are undoubtedly some others who will excuse me all the more for not mentioning them, since it was not for that that they sent their offering, and since this is not a review of an exhibition, but a simple act of homage in the presence of an act of human solidarity.

What beautiful things they have all given! They have put their hands where their hearts were and given their very best!

There is something at once both consoling and moving, indeed almost solemn, about these days when the struggle is past. Those who triumph in their own strength, with a little help from life, have fulfilled the unrealized desires of the defeated, who will not therefore pass into overwhelming isolation. As in the stories of long ago, we do things for the peace of their unquiet souls. The task of friendship and assistance does not stop with expressions of regret and condolences; it should be active and bring to the home of the departed the material help which his pride, while he was still in the breach, would have forbidden him to accept.

Sisley's friends, his comrades and fellow-artists, have ensured that their offering was abundant and brilliant, so that the public would be generous. It is up to you to complete their work, friends whose names are yet unknown but whose undoubted sympathies will perpetually help artists in times of trouble, as in their hard-won victories.

Arsène Alexandre.

Chronology

A chronology of Sisley's life and professional career is inevitably indebted to the one published by François Daulte in Alfred Sisley (1959). Additions and corrections have been made here only when documentary sources confirm them (references are either given here or at the appropriate place in the notes to the main text). A fuller listing of Sisley's exhibition history is found in Daulte (1959), Rewald and Lloyd (see bibliography). But it ought to be pointed out that the publication of numerous facts concerning Sisley's life, given here for the first time, considerably alters the hitherto received chronology.

1839 30 October
Birth in Paris of Alfred Sisley at 19 rue des Trois Bornes, 11th *arrondissement*. His father William Sisley (1799–1879), merchant, and his mother Felicia Sell (1808–66), both of British nationality, had married in Dover in 1827 and had moved to Paris in the late 1830s. There were three other children, all born in England, Henry, Aline-Frances and Elizabeth-Emily

1841 27 April
Registration in Paris of William Sisley et Cie, operating from 3 passage Violet, 10th *arrondissement*. By 1848 the business is at 1 passage Violet, dealing in imported luxury goods, a predominant trade of the district (Porte St-Denis).

1854 24 July
William Sisley et Cie re-registered; he is named as sole director of the business, with a capital of 50,000 FF in cash. His private and company address is given as 1 passage Violet.

1857–1860
AS sent to London to study commerce. Almost nothing is known of this period, save that he perfected his English and admired the work of Turner and Constable.

c.1860–1863
Attends the Paris studio of Swiss painter Marc Charles-Gabriel Gleyre (1806–74); lives with family

160 **Giverny, 31 October 1900. Marriage of Marthe Hoschedé and Theodore Butler. Pierre Sisley is seated on the ground (at right); his sister Jeanne stands directly behind him; Germaine Hoschedé (standing far right); Paul Durand-Ruel (standing far left); Claude Monet (top row, left). Collection Jean-Marie Toulgouat, Giverny.**

160

225

at 43 rue des martyrs, 9th *arrondissement* (Archives de Paris D1P4.704 rue des Martyrs, 1852).

1861 Autumn
Stays briefly at the Auberge Ganne, Barbizon, Forest of Fontainebleau.
November
Renoir attends Gleyre's studio.

1862 November
Claude Monet and Frédéric Bazille attend Gleyre's studio.
31 December
Recorded as dining with Bazille, Renoir, Monet and Louis-Emile Villa, also a student of Gleyre, in Bazille's studio.

1863 Easter
Stays at the Auberge du Cheval-Blanc, Chailly, Forest of Fontainebleau; companions include Monet, Bazille and Renoir.

1864 Renoir paints portraits of AS and William Sisley.

1865 February
In Forest of Fontainbleau with Renoir and Jules Le Cœur.
March–April
In Marlotte with Renoir and Jules Le Cœur; meetings there with Pissarro and Monet.
July
Renoir writes letter from 'chez Sisley', 31 avenue de

Neuillly, Porte Maillot (no other confirmation for this studio address).

1866 May
Two works accepted for the Salon: *Village Street in Marlotte* and *Village Street in Marlotte – Women Going to the Wood.* Fellow exhibitors at Salon include Bazille, Renoir, Monet, Morisot. AS's address in Salon catalogue is 15 rue Moncey, 9th *arrondissement*, his parents' home in 1866–7 (Archives de Paris, D1 P4.741 rue Moncey, 1862).
August
With Renoir, Charles Le Cœur and others at Berck on the Normandy coast.
17 August
Death of mother, Felicia Sisley, at 2 rue de Chartres, Neuilly *'son domicile momentané'* (registration of death, Archives communales Neuilly-sur-Seine).

1867 Spring
Submission to Salon refused; signs petition demanding a Salon des Refusés along with Renoir, Cézanne, Pissarro, Bazille.
17 June
A son, Pierre, born to AS and Marie Louise Adélaïde Eugénie Lescouezec at 27 cité des Fleurs, 17th *arrondissement*, an apartment registered in Eugénie's name. At the time of the birth, AS painting at Honfleur.

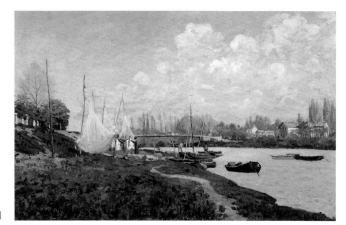

161

226

October

Painting in Forest of Fontainebleau (letter
from J. Ware to J. Woodwell, 17 October 1867,
Woodwell Papers, Archives of American Art,
Smithsonian Institution, Washington, DC).

1868 May

Avenue of Chestnut Trees at la Celle-Saint-Cloud
accepted by Salon; AS's catalogue address given as
9 rue de la Paix, Bazille's studio from 1868 to 1870
(Archives de Paris, D1P4.592, rue la Condamine,
the name given to the street in late 1868).

Late Summer

Works in Forest of Fontainbleau and parc de
Courances.

1869 29 January

A daughter, Jeanne Adèle, born to AS and Eugénie
Lescouezec at 27 cité des Fleurs, 17th *arrondissement*.
Submission to Salon refused, as is Monet's; Manet,
Pissarro, Degas, Bazille accepted.

1870 May

Two works accepted for Salon: *Barges on the Canal
St-Martin* and *View of the Canal St-Martin*. AS's
address in catalogue given as 27 cité des Fleurs.

Autumn

Living in Bougival, west of Paris, at the time of the
Franco-Prussian War; lost all his possessions
(see Appendix B).

1871 In Paris during Prussian Siege and the Commune.
Deterioration of William Sisley's health and the ruin
of his business; he moves (*c.*1871–2) to Congy,
near Epernay.

1872 The dealer Paul Durand-Ruel begins to buy and
show AS's work, e.g. includes four paintings in
summer exhibition of French artists at 168 New Bond
Street, London.

Autumn

Moves with family to 2 rue de la Princesse, Voisins,
a hamlet adjoining Louveciennes, west of Paris.

Winter

Exhibits two paintings, both Seine-side subjects, in
Durand-Ruel's winter exhibition of French artists at
168 New Bond Street, London.

4 December

'Gentlemen: Messrs. Pissarro, Sisley, Monet and Manet
request the pleasure of your company at dinner on
Wednesday the 11th instant.
7 o'clock Café Anglais. R.S.V.P.' (letter from Manet
to Emile Zola, 4 December 1872, in *Manet*, exh. cat.,
1983, p. 524).

1873 Exhibits three paintings in Durand-Ruel's
spring/summer exhibition at 168 New Bond Street,
London, and two paintings in the winter exhibition.

May

Submission refused by the Salon.

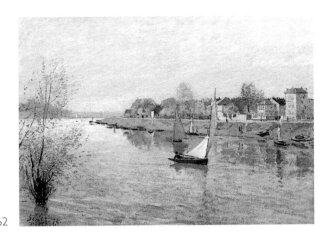

162

161 **Fishermen Drying their Nets. 1872.**
50 x 73 cm. Kimbell Art Museum, Fort Worth.

162 **The Seine at Argenteuil. 1872.**
50 x 65 cm. Thomas Gibson Fine Art, London.

Closely involved in the foundation of the Société
Anonyme des Artistes Peintres, Sculpteurs, Graveurs,
etc..

1874 **13 January**
Exhibits three works in sale of the collection of
Ernest Hoschedé, at Hôtel Drouot, Paris.
Spring
Durand-Ruel shows three paintings by AS in his spring
exhibition and two paintings in the summer exhibition
at 168 New Bond Street, London; fellow exhibitors
include Manet, Monet, Pissarro, Degas, Renoir.
15 April–15 May
Exhibits six paintings with the Société Anonyme (first
Impressionist Exhibition), at 35 boulevard des
Capucines, Paris.
July–October
Painting in England at Hampton Court and East
Molesey on the Thames west of London.
Winter
Moves with family at end of year (or very early 1875)
to 2 avenue de l'Abreuvoir, Marly-le-Roi, close
to Louveciennes.

1875 **24 March**
Participates with Renoir, Monet and Morisot in public
auction of their work at Hôtel Drouot; 21 paintings
by AS are sold.

?Summer
Exhibits one work in Durand-Ruel's last exhibition at
168 New Bond Street, London.

1876 Exhibits one work in spring exhibition, 'French and
Other Foreign Painters', under auspices of Emile
Deschamps at 168 New Bond Street, London.
April
Exhibits eight paintings included in the Second
Impressionist Exhibition at 11 rue le Peletier,
11th *arrondissement* (Durand-Ruel's premises).

1877 **?January/February**
Dines with Degas, Monet, Manet, Renoir, Pissarro at
the house of Gustave Caillebotte to discuss plans for
the Third Impressionist Exhibition.
c.February
Moves with his family from Marly-le-Roi to 7 avenue
de Bellevue, Sèvres.
April
Exhibits seventeen paintings in the Third
Impressionist Exhibition in premises rented by the
participants at 6 rue le Peletier, 11th *arrondissement*.

1878 **5 and 6 June**
Thirteen paintings included in the second sale of the
collection of Ernest Hoschedé at Hôtel Drouôt.
Chapter on Sisley included in Théodore Duret's
pamphlet *Histoire des peintres impressionnistes*.

163

1879 **5 February**

Death of William Sisley at Congy.

Abstains from the Fourth Impressionist Exhibition.
Submission to Salon refused.

April

In dire financial straits, forced to move to apartment
at 164 Grande-Rue, Sèvres.

Autumn

Visits Moret-sur-Loing on the edge of the Forest of
Fontainebleau.

1880 **?February**

Moves with family to rented house in rue de By,
Veneux-Nadon, a village near Moret-sur-Loing
(Archives départementales de Seine et Marne,
10 M.284, Census 1881, canton de Moret).
Renewed support from Durand-Ruel with whom
AS signs agreement.

1881 **Winter**

At Renoir's instigation, exhibits fourteen paintings at
premises of La Vie Moderne, run by publisher
Georges Charpentier.

June

Visits Isle of Wight but produces no work.

1882 **March**

Exhibits for the fourth and last time with the
Impressionists, at their Seventh Exhibition at 251 rue
Saint-Honoré; shows twenty-seven paintings.

September

Moves with family from Veneux-Nadon into
Moret-sur-Loing.

5 November

Writes to Durand-Ruel in favour of group rather than
solo exhibitions.

14 November

Discusses exhibitions with Monet in Paris.

1883 **April–July**

Through Durand-Ruel, paintings by AS are included
in exhibitions in London (eight landscapes at
Dowdeswell & Dowdeswell, 133 New Bond Street).

3 May

Signs the book of condolences at Manet's funeral.

June

Arranges (with help from Pissarro) solo exhibition of
70 paintings at Galerie Durand-Ruel.

September

Moves with family from Moret to large house at
35 route nationale (now route de Fontainebleau) in
village of Les Sablons, close to earlier home at
Veneux-Nadon.

November

Keeps a *livre de raison* of his work from late 1883 to
1885, a drawing book purchased at le Libraire
Bodoul, Moret-sur-Loing (now in the Moreau-
Nélaton gift, Musée d'Orsay).

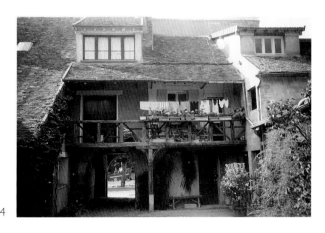

164

163 **Sisley's house in rue de By, Veneux-Nadon; Plate 91 was painted from the window at far left.**

164 **Courtyard of the house in St-Mammès today, which Sisley painted in Plate 112.**

1885 Signs letter, with several fellow Impressionists, addressed to Sir Coutts Lindsay, Grosvenor Gallery, London, paying homage to Turner: 'a great master of the English School'. (C. Bell *Landmarks in Nineteenth-Century Painting*, 1927, p. 136).
June
Included in '*Exposition de MM Degas, Monet, Pissarro, Renoir et Sisley*', organized by Durand-Ruel at Hôtel du Grand-Miroir, Brussels.

1886 March
Morisot and others fail to persuade AS to show in the Eighth Impressionist Exhibition.
April–June
Included in 'Works in Oil and Pastel by the Impressionists of Paris', organized by Durand-Ruel and American Art Association at American Art Galleries, Madison Square South, New York (10-25 April), and continued at National Academy of Design, New York (25 May–30 June).

1887 7–30 May
Exhibits in the Sixth International Exhibition at the galleries of Georges Petit, Paris.
Autumn
Australian artist John Peter Russell, staying at Moret, paints *Mme Sisley on the Banks of the Loing*.

1888 25 May–25 June
Exhibits seventeen works in exhibition of Renoir,

Pissarro and Sisley at Durand-Ruel. The French State acquires one of the exhibits, *September Morning* (1887, D. 692) given to the Musée at Agen in 1890, drawing from AS the comment '*une toile placée comme cela est perdue*'.

1889 Considers taking French nationality (letter to T. Duret, 30 May).
27 February–15 March
'Works by Alfred Sisley', Durand-Ruel Galleries, New York (twenty-eight paintings).
?November
Moves from Les Sablons into Moret (? rue de l'Eglise). Invited by the Cercle des XX ('Les Vingt') in Brussels to exhibit at their annual exhibition; accepts for January 1890 exhibition and is listed in the catalogue, but Georges Petit fails to send paintings.

1890 6–26 March
Exhibits with the Société des Peintres Graveurs, Galerie Durand-Ruel.
February
Elected to membership of the Société Nationale des Beaux-Arts and shows six paintings in its first Salon at the Champs-de-Mars, Paris (15–30 May).

1891 January
Exhibits with Les Vingt, Brussels.
17–28 March
'Paintings by the Impressionists', 7 Hamilton Place,

165 **Sisley's tomb in the cemetery of Moret-sur-Loing.**

166 **Memorial to Sisley in Moret-sur-Loing, unveiled in 1911.**

Boston, organized by Durand-Ruel – Sisley, Monet, Renoir.

12 April

Pissarro meets AS in Paris whom he had not seen for at least two years; AS suggests that Durand-Ruel was the Impressionists' 'worst enemy.' Sells his work through several dealers as well as privately.

Installed with his family in his last home at 19 rue Montmartre, Moret-sur-Loing (Archives départementales de Seine et Marne, IOM 325, census of 1891 canton de Moret).

15–30 May

Exhibits seven works in the Salon of the Société Nationale des Beaux-Arts.

1893 **mid–February**

Visits his patron François Depeaux in Rouen.

March

One-man exhibition at Boussod et Valadon, Paris.

10–30 May

Exhibits six works in the Salon of the Société Nationale des Beaux-Arts.

c.22–23 September

Visited in Moret by Berthe Morisot, her daughter Julie, and Stéphane Mallarmé.

1894 **January**

Exhibits with Les Vingt, Brussels

25 April–10 May

Exhibits eight works in the Salon of the Société Nationale des Beaux-Arts.

Summer

Visits Rouen, staying at the Hôtel du Dauphin et d'Espagne, run by his friend and collector Eugène Murer; afterwards, stays as guest of François Depeaux at the Maison du Mesnil-Esnard, outside Rouen; paints several Normandy landscapes.

Autumn

Visited in Moret by the critic and writer Gustave Geffroy.

1895 Exhibits eight works in the Salon of the Société Nationale des Beaux-Arts.

1896 Increasingly unreliable health limits his visits to Paris.

1897 **January–February**

Spends the month preparing for large retrospective of 146 paintings and six pastels from all periods of his career, held throughout February at the Galerie Georges Petit, rue de Sèze.

Early July

Embarks on three-month visit to England with Eugénie, first visiting Cornwall, then Penarth, near Cardiff, and later Langland Bay, near Swansea; paints about twenty views of Welsh coast.

165

166

3 August

AS legally recognized as father of Pierre and Jeanne in document signed by Eugénie at the French Consulate in Cardiff.

5 August

Marriage of AS and Eugénie in Cardiff Register Office.

c.1 October

Returns to Moret-sur-Loing.

Autumn

Visited by several painters and collectors including Edmond Décap.

1898 Once more wishes to adopt French nationality but missing documents prevent him (AS to A. Tavernier, 28 January).

1–15 May

Exhibits four works in the Salon of the Société Nationale des Beaux-Arts.

June

Exhibits eight works in *Tableaux de Sisley*, Galerie Durand-Ruel.

Summer

Colour lithograph produced for Ambroise Vollard included in International Society Exhibition, London (one painting is posthumously exhibited in the Society's 1899 exhibition).

October

Death of Madame Sisley, Moret-sur-Loing.

1899 29 January

AS dies at his home and is buried on 1 February in the cemetery of Moret-sur-Loing.

1899 16 February–8 March

Twenty-one works in exhibition at Galerie Georges Petit of paintings by Monet, Sisley, Besnard, Cazin, Thaulow.

1 May

Sale of works by AS and his friends and contemporaries, at Galerie Georges Petit, to benefit Pierre and Jeanne Sisley.

1907 2–14 December

Twenty-one works by AS and three paintings by Renoir in *L'Atelier de Sisley* at Bernheim Jeune, 15 rue Richpanse, Paris.

1908 23 July

Marriage of Jeanne Sisley to Fernand Dietsh (1856–1919).

1909 18 May

Fourteen paintings by AS from his estate sold by Fernand Dietsh at public auction, Hôtel Drouot.

1911 11 July

Unveiling of memorial to AS in Moret-sur-Loing.

1919 Death of Jeanne Dietsh in Paris (4 February) and Fernand Dietsh (17 February).

1929 21 June

Death of Pierre Sisley in Levallois-Perret, Paris.

Bibliography

Selected Bibliography

A comprehensive bibliography is found in F. Daulte *Alfred Sisley*, Lausanne, 1959. I have listed here those books, exhibition catalogues and periodical literature that have been of particular use in writing this book, including several items not mentioned by Daulte. The first section, of literature directly pertaining to Sisley himself, is arranged by date of publication; the second section, of more general works, is alphabetically arranged. Items marked with an asterisk (*) contain material directly related to Sisley such as letters, first-hand accounts, etc. The few monographs on Sisley published since Daulte (1959), contain almost no new material.

First Section

*TAVERNIER, A. 'Sisley', *L'Art français*, 18 March 1893

*LECLERCQ, J. 'Alfred Sisley', *Gazette des Beaux-Arts*, Paris, March 1899

*DURET, T. 'Quelques Lettres de Manet et Sisley', *La Revue Blanche*, 15 March 1899

*BIBB, B. 'The Work of Alfred Sisley', *Studio*, London, December 1899

*GEFFROY, G. AND ALEXANDRE, A. 'Tableaux...par Alfred Sisley', studio sale catalogue, Galerie Georges Petit, Paris, 1 May 1899 (see Appendix D)

*TAVERNIER, A. 'L'Atelier de Sisley', exhibition catalogue, Bernheim Jeune, Paris, 2–14 December 1907, (see Appendix C)

ANON. 'Les Sisley de Bernheim', *La Revue Blanche*, Paris, January 1908

'Paintings by Alfred Sisley', Independent Gallery, London, November–December, 1927

FRY, R. 'Sisley', *Nation and Athenaeum*, London, 3 December 1927 (review of exhibition at Independent Gallery, London, 1927)

*GEFFROY, G. *Sisley*, Paris 1923 (enlarged second edition, Paris, 1927)

*HUYGHE, R. 'Lettres Inedites de Sisley', *Formes*, Paris, November 1931 (article and letters in English)

*'Sisley', *Bulletins des Expositions*, Galerie d'Art Braun, Paris, January 1933 (illustrated catalogue of published and (at the time) unpublished letters from Sisley, marking exhibition at Galerie d'Art Braun, 30 January–18 February 1933).

BESSON, G. *Sisley*, Paris (n.d; c.1934)

*Déborde de Montcorin, E. 'Alfred Sisley, 1839–1899', *La Revue de Moret et de sa Région*, Moret-sur-Loing, October 1930

COLOMBIER, P. DU, *Alfred Sisley in the Musée du Louvre*, London, 1947, English translation of *Sisley au Musée du Louvre*, Paris/Brussels, 1947

JEDLICKA, G. *Sisley*, Berne, 1949

*SISLEY, C. 'The Ancestry of Alfred Sisley', *The Burlington Magazine*, London, September 1949

REUTERSWAERD, O. 'Sisley's "Cathedrals". A Study of the *Church at Moret* series', *Gazette des Beaux-Arts*, Paris, March 1952

DAULTE, F. 'Découverte de Sisley', *Connaissance des Arts*, Paris, February 1957

ROGER-MARX, C. 'Alfred Sisley 1839–1899', exhibition catalogue, Galerie Durand-Ruel, Paris, 29 May–20 September 1957

BROOKNER, A. 'Sisley', *The Burlington Magazine*, London, July 1957 (review of exhibition at Galerie Durand-Ruel, Paris, 1957)

DAULTE, F. AND WAGNER, H. *Alfred Sisley*, exhibition catalogue, Kunstmuseum, Berne, 16 February–13 April 1958

WILDENSTEIN, G. 'Un carnet de dessins de Sisley au Louvre', *Gazette des Beaux-Arts*, Paris, January 1959

DAULTE, F. *Les paysages de Sisley*, Lausanne, 1961

ROGER-MARX, C. AND MURA, A.M. *Alfred Sisley*, Milan/Paris, 1966

SCHARF, A. *Sisley* (The Masters no. 24), Bristol, 1966

DAULTE, F. *Alfred Sisley*, exhibition catalogue, Wildenstein, New York, 1966

LANES, J. 'Current and Forthcoming Exhibitions', *The Burlington Magazine*, London, December 1966 (review of exhibition at Wildenstein, New York, 1966).

PICKVANCE, R. *Alfred Sisley (1839–1899). Impressionist Landscapes*, exhibition catalogue, University Art Gallery, Nottingham, 6–27 February 1971

Alfred Sisley, Galerie Durand-Ruel, Paris, 10 February–30 March 1971

*ANGRAND, P. 'Two Unpublished Letters of Sisley', *Gazette des Beaux-Arts*, Paris, July–September 1971, supplement 33

DAULTE, F. *Alfred Sisley*, Milan, 1972; English edition, London 1988 (contains reproductions of all sixty pages of Sisley's *Carnet* whose existence was first announced in Wildenstein, 1959; see above)

COGNIAT, R. *Sisley*, Naefels, 1978

SHONE, R. *Sisley*, Oxford, 1979

NATHANSON, R. *Alfred Sisley 1839–1899*, exhibition catalogue, David Carritt Ltd., London, 16 June–11 July 1981

GACHE-PATIN, S. AND LASSAIGNE, J. *Sisley*, Paris, 1983

LLOYD, C. *Retrospective Alfred Sisley*, exhibition catalogue, Tokyo, Fukuoka and Nara, Japan, March–June 1985

BABIN, A. *Alfred Sisley*, Leningrad, 1988 (works by Sisley in the Hermitage, Leningrad, and the Pushkin Museum of Fine Arts, Moscow)

*'Sisley à Moret', *La Revue de Moret et de sa Région*, Moret-sur-Loing, March 1989 (new and reprinted articles from the Revue concerning Sisley)

Alfred Sisley à Moret-sur-Loing. Les Amis de Sisley, Moret-sur-Loing, 1989 (illustrated guide to Sisley in Veneux-Nadon, Les Sablons St-Mammès, and Moret).

REED, N. *Sisley and The Thames*, London, 1991

Second Section

ALEXANDRE, A. 'Isaac de Camondo Collection', *Les Arts*, Paris, November 1908

ARDOUIN-DUMAZET, *Voyage en France, 44e série. Gatinais français et Haute-Beauce*, Paris, 1906

ARDOUIN-DUMAZET, *Voyage en France, 47e série. L'Yveline et le Mantois*, Paris, 1907

BARRON, L. *La Seine*, Paris, [?1907]

BELLONY-REWALD, A. *The Lost World of the Impressionists*, London, 1976

*BERHAUT, M. *Caillebotte*, Paris, 1978

BOMFORD, D. et al. *Impressionism. Art in the Making*. Exhibition catalogue, National Gallery, London, 1990

BOUILLON, J-P. et al. *La Promenade du critique influent. Anthologie de la critique d'art en France 1850–1900*, Paris, 1990

*COOPER, D. 'Renoir, Lise and the Le Cœur Family: A Study of Renoir's Early Development. Part I Lise.

Part II The Le Cœurs.' *The Burlington Magazine*, London, May 1959 and September–October 1959

CALLEN, A. 'Jean-Baptiste Faure', MA Report (University of Leicester), 1971

CALLEN, A. *Techniques of the Impressionists*, London, 1988

DAULTE, F. *Auguste Renoir. Catalogue Raisonné de l'œuvre peint*, I, Lausanne, 1971

A Day in the Country. Impressionism and the French Landscape. Exhibition catalogue, County Museum of Art, Los Angeles, 1984

DELTEIL, L. *Camille Pissarro, Alfred Sisley, Auguste Renoir. Le Peintre-graveur illustré*, XVII, Paris, 1923

*DURET, T. *Histoire des Peintres Impressionnistes*, Paris, 1923 (an amalgamation of Duret's 1878 pamphlet on the Impressionists and his 1906 *Histoire des Peintres Impressionnistes*)

FINK, L. M. *American Art at the Nineteenth-Century Paris Salons*, Washington DC, 1990

FLINT, K. (ed) *Impressionists in England. The Critical Reception*. London, 1984

*GACHET, P. *Deux amis des impressionnistes – Le Docteur Gachet et Murer*, Paris, 1956

GACHET, P. *Lettres Impressionnistes au Dr Gachet et à Murer*, Paris, 1957

GEFFROY, G. *La Vie artistique*, 1–8, Paris, 1892–1903

HARTLEY, M. *Adventures in the Arts*, New York, 1921

HERBERT, R.L. *Impressionism. Art, Leisure & Parisian Society*, New Haven & London, 1988

HOUSE, J. *Impressionism*. Exhibition catalogue, Royal Academy of Arts, London, 1974

HOUSE, J. 'Monet and Pissarro in London', *The Burlington Magazine*, London, October 1978

HOUSE, J. *Monet. Nature into Art*. New Haven & London, 1986

Impressionists in London. Exhibition catalogue, Arts Council of Great Britain, London, 1973

JOANNE, P. *Environs de Paris* (*Itinéraire Général de la France*), Paris, 1889.

JOYES, C. et al. *Monet at Giverny*, London, 1975

LAÿ, J. and M. *Louveciennes Mon Village*, Paris, 1989

LECOMTE, G. *L'Art impressionniste d'après la collection privée de M. Durand-Ruel*, Paris, 1892

LLOYD, C. AND THOMSON, R. *Impressionist Drawings*. Exhibition catalogue, Arts Council of Great Britain, London, 1986

LURIE, P. *A Guide to the Impressionist Landscape*, Boston, 1990

Manet 1832–1883. Exhibition catalogue, Metropolitan Museum, New York, 1983

*MANET, J. *Journal (1893–1899) de Julie Manet*, Paris, 1979

De Renoir à Vuillard. Exhibition catalogue, Musée Promenade de Marly-le-Roi – Louveciennes, 1894

MONNERET, S. *L'Impressionnisme et son Epoque*, 1–4, Paris, 1978–81; 2 vol. edition Paris, 1987

MOFFETT, C. (ed) *The New Painting. Impressionism 1874–1886*. Exhibition catalogue, Fine Arts Museum of San Francisco, 1986

Catalogue sommaire illustré des peintures, Musée d'Orsay, 1–2, Paris, 1990

NICULESCU, R. 'Georges de Bellio, l'ami des Impressionnistes', *Paragone* 247, 1970 and 248, 1970, pp. 25–66 and pp. 40–85

*PISSARRO, C. *Letters to his son Lucien*. Rewald, J. (ed). London, 1943

Camille Pissarro 1830–1903. Exhibition catalogue, Arts Council of Great Britain, London and Museum of Fine Arts, Boston, 1980

POULAIN, G. *Bazille et ses Amis*, Paris, 1932

REIDEMEISTER, L. *Auf den Spuren der Maler der Ile de France*, Berlin, 1963

*RENOIR, J. *Renoir My Father*, London, 1962

Pierre Prins et l'Epoque Impressionniste. Par son fils, Paris, 1949

Pierre Prins 1855–1913. Exhibition catalogue, Wildenstein, London, 1975

REWALD, J. *The History of Impressionism*, New York, 1961 (revised edition of 1946 publication)

RIVIERE, G. *Renoir et ses Amis*, Paris, 1921

ROUART, D. (ed) *Correspondance de Berthe Morisot et de sa famille*, Paris, 1950

SHIKES, R. E. AND HARPER, P. *Pissarro. His Life and Work*, London, 1980

THOMSON, R. *Camille Pissarro. Impressonism, Landscape and Rural Labour*. Exhibition catalogue, South Bank Centre, London, 1990

TUCKER, P.H. *Monet at Argenteuil*, New Haven & London, 1982

*VENTURI, L. *Les Archives de L'Impressionnisme*, 1–2, Paris/New York, 1939

VENTURI, L. *Impressionists and Symbolists*, London, 1950

Acknowledgements

When I was more than half way through writing this book, certain papers came into my hands which suggested several new lines of enquiry into the facts of Sisley's life. If corroborated or followed through, I saw that such facts would mean the recasting of much of what I had written. I was lucky enough to be put in touch with Robert M. Parker, who was working in Paris for the Metropolitan Museum, New York. His immediate enthusiasm and natural accuracy, combined with his familiarity with a number of French archives, quickly transformed my conjectures and unconfirmed facts into hard evidence. I am deeply grateful to him. A good deal of the new material in this book is directly attributable to his tact, tenacity and clear-headed absorption in the real, as opposed to the received, life of Sisley and his family. Several people thanked in the following list were most helpful to him and I join him in acknowledging them: Françoise Aujogue, Philippe Grand and Brigitte Laine of the Archives de la ville de Paris; Evelyne Anaman, Vice-Consul, French Consulate, London; Olivier Berggruen; Catherine Bernard for her invaluable encouragement and epistolary skill; Richard Brettell, Dallas Museum of Art; Melanie Clore, Sotheby's; Jean-Luc Carré of the Hôtel de Ville, Moret-sur-Loing; Michael Clarke, National Gallery of Scotland; Caroline Elam, Duncan Bull and my colleagues at *The Burlington Magazine* for their help and patience; Mark Evans, National Museum of Wales; Lois Marie Fink; the late Sir Lawrence Gowing; John House; Mme Hulbert of the Cheval Noir, Moret-sur-Loing; Patrick Kennedy; the late Eardley Knollys; Jeanne Lecomte of the Archives de l'enregistrement, Saint-Sulpice, Paris; Christopher Lloyd; the London Library for its forebearance; John Lumley; Ian Lumsden, Beaverbrook Art Gallery, Fredericton; Catherine Marion of the Archives départementales de la Marne, Chalons-sur-Marne; Molesey Rowing Club, East Molesey; Musée Promenade de Marly-le-Roi, Louveciennes; Christian Neffe and JPL Fine Arts, London; the Office de Tourisme, Moret-sur-Loing; the director of the Pierpont Morgan Library, New York; Emmanuel Pierre for his enlightening company on visits to Moret, Marly and Montmartre and unrivalled knowledge of French cemeteries; Stuart Preston, guide to old Marly; le Procureur de la République, Parquet du Tribunal de Grande Instance, Nantes; Nicholas Reed for his knowledge of Sisley in London; John Rewald; Docteur Jacques Rufin of *Les Amis d'Alfred Sisley*, Moret-sur-Loing, who gave me much useful local information; Denis A. Sisley; Molly Sisley; Jane Shone; Robert Stoppenbach, Stoppenbach & Delestre; The Tate Gallery Library; Maggie Thornton, Redfern Gallery; Gary Tinterow, Metropolitan Museum of Art, New York; David White; Juliet Wilson-Bareau; the Witt Library, Courtauld Institute, London; the staff of the Archives of American Art, Washington DC.

I am particularly grateful to Carlos van Hasselt, Director, and to Maria van Berge-Gerbaud and Hans Buijs of the Fondation Custodia, Institut Néerlandais, Paris for their kind reception and permission to quote from Sisley's letters in the F. Lugt Collection. Penelope Marcus, late of Phaidon Press, originally commissioned me to write this book and heroically saw it through its metamorphosis; I thank her warmly. I am also grateful to Robyn Ayers, editor, and Philippa Thomson, picture researcher, for their hard work and enthusiasm on my behalf.

Photographic Acknowledgements

Ruedli Fischli, Baden: 133; the collection of Rowland G.M. Baker: 34, 36, 38; Musée départementale de l'Oise, Beauvais. Bequest of Mme Georges Filiberti © Service photographique des archives de l'Oise: 98; courtesy of Galerie Kornfeld, Bern: 136; courtesy of Museum of Fine Arts, Boston. Bequest of John T. Spaulding: 33; Albright-Knox Art Gallery, Buffalo, New York. General Purchase Funds, 1956: 13; Art Institute of Chicago. Mr and Mrs Potter Palmer Collection: 138, Mr and Mrs Martin A. Ryerson Collection: 61; Rheinisches Bildarchiv, Cologne: 17; Columbus Museum of Art, Ohio. Gift of Howard D. and Babette L. Sirak, donors to the Campaign For Enduring Excellence and The Derby Fund: 113; C. Devleeschauwer: 144; Scala, Florence: 84; Museum and Heritage Centre, Kingston upon Thames: 43; photographed from *La Seine*, by Louis Barron (?1907): 63; courtesy of Christie's, London: 57, 117, 123; courtesy of the Lefevre Gallery, London: 3, 47, 62, 65; reproduced by courtesy of the Trustees, The National Gallery, London: 55; Noortman (London) Ltd: 102; courtesy of Marlborough Fine Art, London: 71; courtesy of Sotheby's, London: 1, 89, 91, 92, 107, 108, 137, 156; Yale University Art Gallery, New Haven. Gift of Henry Johnson Fisher, B.A.1896: 83; courtesy of Christie's, New York: 154; Metropolitan Museum of Art, New York. Gift of Mr and Mrs Henry Ittleson, Jr: 35; Bequest of Miss Adelaide Milton de Groot (1876-1967), 1967: 60; courtesy of Sotheby's, New York: 5, 86, 122, 134, 151; Norfolk Museums Service: 26; Allen Memorial Art Gallery, Oberlin College. Gift of Norbert Schimmel, 1952: 146; All rights reserved. © Archives Durand-Ruel, Paris: 22, 103; Photographie Giraudon, Paris: 70, 76, 129, 157; Musée

de la Ville de Paris © by SPADEM 1992: 8, 16, 73, 130, 145, 152; © R.M.N., Paris: 2, 7, 20, 24, 28, 40, 48, 64, 69, 78, 93, 96, 104, 106, 112, 115; Collection Viollet, Paris: 121; CAP-Viollet, Paris: 25; Harlingue-Viollet, Paris: 52; ND-Viollet, Paris: 90; Roger-Viollet, Paris: 155; The Wildenstein Institute, Paris: 11; Artothek, Peissenberg/ Joachim Blauel: jacket 45; Philadelphia Museum of Art. Mr and Mrs Carroll S. Tyson Collection: 109; Carnegie Museum of Art, Pittsburgh. Purchase, 99.7: 99; Virginia Museum of Fine Arts, Richmond. Mr and Mrs Paul Mellon Collection: 56; Toledo Museum of Art. Gift of Edward Drummond Libbey: 50; Art Gallery of Ontario, Toronto. Gift of Mr and Mrs R. Fraser Elliott, 1989: 59; National Gallery of Art, Washington. Ailsa Mellon Bruce Collection: 23, Mr and Mrs Paul Mellon Collection: 75.

Index

General Index

Italic numbers refer to plates.

238